Encounters with

Modern Art

The Reminiscences of Nannette F. Rothschild

Works from the Rothschild Family Collections

Introduction by Anne d'Harnoncourt

Edited by George H. Marcus

Philadelphia Museum of Art

National Gallery of Art, Washington
September 22, 1996–January 26, 1997

Philadelphia Museum of Art
March 2–May 11, 1997

Cover: *The Muse,* after 1918, by Constantin Brancusi (pl. 7), and *Tableau No. IV,* 1924–25, by Piet Mondrian (pl. 64)

The letters and documents cited in this volume are in the archives of The Judith Rothschild Foundation, New York

Produced by the Publications Department of the Philadelphia Museum of Art
2525 Pennsylvania Avenue, Philadelphia, Pennsylvania 19130
Color photography: Graydon Wood
Designer: Phillip Unetic
Production Manager: Sandra M. Klimt
Printer: Litho Inc., Saint Paul, Minnesota

Printed and bound in the United States of America

Library of Congress Cataloging-in-Publication Data

Encounters with modern art: the reminiscences of Nannette F. Rothschild: works from the
 Rothschild family collections / edited by George H. Marcus.
 p. cm.
 Exhibitions: National Gallery of Art, Washington, D.C., Sept. 22, 1996–Jan. 26, 1997;
 Philadelphia Museum of Art, Mar. 2–May 11, 1997.
 Includes bibliographical references and index.
 ISBN 0-87633-108-8 (alk. paper).—ISBN 0-87633-107-x (pbk. alk. paper)
 1. Art, Modern—20th century—Exhibitions. 2. Art—Private
collections—New York (State)—Kitchawan—Exhibitions. 3. Rothschild,
Herbert—Art collections—Exhibitions. 4. Rothschild, Nannette F.—Art
collections—Exhibitions.
 I. Marcus, George H. II. Rothschild, Nannette F. III. National
Gallery of Art (U.S.) IV. Philadelphia Museum of Art.
N6488.5.R68E53 1996
709'.04'007473—dc20 96-32373
 CIP

To the memory of Judith Rothschild

Contents

Preface

It is an honor and a pleasure to present an exhibition of works from the collection of early modern art formed by Herbert and Nannette Rothschild, accompanied by this volume, which publishes for the first time Nannette Rothschild's reminiscences of their experiences as collectors. After a brief beginning during a trip to Mexico in 1937, when, like so many American travelers, they fell under the charm of Diego Rivera, the Rothschilds came into their own as collectors in the 1950s. Mrs. Rothschild kept journals of their visits to New York dealers and their trips to Europe, and not long before her death in 1979, she compiled her notes into a narrative that pertained to their encounters with modern art and artists, which she thought would be of interest to her three children and their families. For us, the interest in her recollections lies in their fresh and unpretentious evocation of the 1950s and 1960s, which seem as far removed from today's vast and intricate international art scene as they do from the first two decades of this century, when so much that the Rothschilds admired and sought to acquire was created.

Shown once in its entirety, at the Rhode Island School of Design and Brown University in celebration of the seventy-fifth anniversary of Pembroke College in 1966, the Rothschilds' collection was formed, as Nannette writes, as a thoroughly private quest for works of art with which they and their family wanted to live. Nonetheless, they also greatly enjoyed sharing their treasures with the public, whether as loans to exhibitions or as gifts to museums.

In their thoughtful division of their estate among three children, most of the works of art went to their daughter Judith, the artist whose warm encouragement and informed opinions had been of such importance to them along the way. Her parents' reluctance to consider themselves "collectors" was greatly magnified in the conflict that Judith felt between her love—even "need," as she expressed it—for individual paintings or drawings and the distance she was determined to keep as an artist from any designation as a "collector" herself. Her decision, in turn, to bequeath the works of art from her parents' collection, as well as those she had bought herself, to create a foundation whose largest mission is to support the legacy of under-recognized American artists of high caliber, makes a judicious balance between her parents' first love and her own.

We are deeply grateful to The Judith Rothschild Foundation and its trustee, Harvey S. Shipley Miller, and to Mr. and Mrs. Roger Michaels for their invaluable assistance with this project. In all proba-

bility this marks the last occasion upon which so many of the works in Herbert and Nannette Rothschild's collection can be gathered together, and we also thank Mr. and Mrs. Robert Rothschild for their interest in this undertaking. Several of Judith Rothschild's additions to the collection, notably drawings by Matisse whom she so admired, are also included. Since its inception in 1994, the foundation has acquired a small number of related works of art, some of which are presented here.

Herbert and Nannette Rothschild followed Judith's career with great interest and pride, acquiring a considerable number of her paintings and collages as part of their collection. In the context of the present exhibition, it seemed appropriate to include a somewhat different group, which represents a wide range of Judith's work over five decades, to give the public a fuller sense of her evolving concerns as a painter during the period when she and her parents were so regularly in touch about her work, their collection, and their mutual passion for art.

We are grateful to the curatorial team of Mark Rosenthal and Jeffrey Weiss at the National Gallery of Art, Innis Howe Shoemaker, Ann Temkin, and John Ittmann at the Philadelphia Museum of Art, and Guillermo Alonso at The Judith Rothschild Foundation, for their contributions to this project. George H. Marcus, head of publications at the Philadelphia Museum of Art, has edited Nannette Rothschild's reminiscences and shepherded this book into print with thoughtful attention to every detail. Research on works in the Rothschilds' collection owes much to the fine catalogue prepared by George Downing and Daniel Robbins for the 1966 exhibition in Providence. Thirty years later, with this opportunity to share works from the Rothschild family collections with a new generation of the public, what we most hope is that the rare combination of a fresh and unpretentious pleasure in collecting as a profoundly human activity revealed in Nannette Rothschild's reminiscences and the exciting quality of the works of art with which she and her family chose to live will inspire others to embark on the same adventure.

Anne d'Harnoncourt
The George D. Widener Director, Philadelphia Museum of Art

Earl A. Powell III
Director, National Gallery of Art

Acknowledgments

The Rothschilds' devotion to the documentation of their collection continues at The Judith Rothschild Foundation, under the concerned guidance of its trustee, Harvey S. Shipley Miller. The foundation's curator, Guillermo Alonso, has been of inestimable assistance in supplying information about the works and their provenance, which in turn has enabled us to create a fuller picture of the collecting patterns of the family. Additionally, Barbara Rothschild Michaels has answered many of the questions that have inevitably arisen since the publication of the previous catalogue of the Rothschild collection in 1966.

The following have generously provided information and access to illustrative materials: David Acton, Brigitte Adams, Diane Hart Agee, Nancy Van Norman Baer, Joseph Baillio, Vivian Barnett, Marisa Del Re, Hester Diamond, Judith Durrer, Sabina Engel, Melody Ennis, Krystyna Gmurzynska, Stephen Hahn, Brigitte Hedel-Samson, Mary Horlock, Katherine Rothschild Jackson, Carroll Janis, Joop M. Joosten, Ch. Kotrouzinis, Quentin Laurens, Joan Llinares Gómez, Stephan Mazoh, Jacqueline Matisse Monnier, Beverly A. Parsons, Sean Rainbird, Denise René, Sally Winston Robinson, Ernestine Ruben, Eleanor Saidenberg, Linda Shearer, Gale Simplicio, Darthea Speyer, Eugene V. Thaw, Dr. G. Vilinbakhov, Leslie Waddington, Allen Wardwell, Joan Washburn, Robert P. Welsh, Harry L. Winston, Jr.

At the National Gallery we would like to acknowledge D. Dodge Thompson and Naomi R. Remes in the exhibitions office, who managed important organizational details. Mervin Richard, Judith Walsh, and Catherine Metzger in the conservation department examined the works in the exhibition and prepared them for travel. Gaillard Ravenel, Mark Leithauser, and Gordon Anson helped to design and install the exhibition; Michelle Fondas was the registrar. In addition, Lisa Coldiron, staff assistant in the department of twentieth-century art, lent valuable support.

Encounters with Modern Art

At the Philadelphia Museum of Art, Suzanne Wells handled numerous details of organization and Irene Taurins attended to registraral matters. Nancy Ash and Melissa Meighan contributed their conservation expertise in anticipation of the travel of the works in the collections. Initial documentary research in the archives of The Judith Rothschild Foundation was undertaken by Jane Niehaus. In the publications department, Sandra Klimt oversaw the production of this book, which was designed by Phillip Unetic with color photography by Graydon Wood. Curtis Scott was the copy editor and Conna Clark and Jean Harvey assisted with various details. From the outset Alison Rooney was enthusiastically devoted to all aspects of this project.

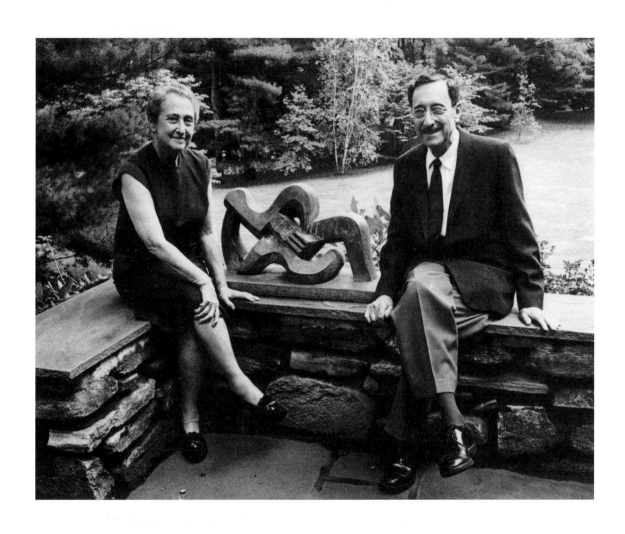

Encounters with Modern Art

F or goodness sakes stop studying about art," wrote the American painter Judith Rothschild to her parents in 1952, as they embarked, with her strong encouragement, on the adventure of collecting modern art. "I am absolutely certain you both know all you need to, intellectually, about it," she continued. "And the more you study from here on the more intellectual Dad will become about it, and the more shy Mother will be about her own judgements. I wish you would feel a little less responsibility about it. Art is to be enjoyed and felt, not understood. And if it is worth a damn it is understandable without requiring fifteen courses as a prerequisite. Believe me, the Medicis didn't take courses" (January 22–30, 1952).

In her long, articulate, and often emotionally charged letter, Judith moves from ruminations about her own sources of pleasure and inspiration as a painter to reflections on individual artists of the recent

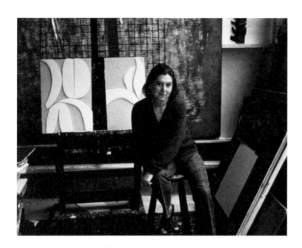

Fig. 2. Judith Rothschild in her studio, Wellfleet, Massachusetts, 1979. Photograph by Norma Holt

past whose work she admired for its "intensely sustained sincerity" (Cézanne, Matisse, Rouault) to expressions of frustration with the current "deathgrip" of art criticism in the United States. Bearing witness to a close, affectionate, and complex relationship, which nurtured one of the most carefully and lovingly chosen collections of modern art formed in the years immediately following World War II, the letter introduces us to Judith Rothschild as a widely read and deeply committed painter, who watches with admiration and occasional flashes of irritation as her parents form their collection. The reminiscences of her mother Nannette afford us rare access to the other end of the conversation: the quietly private world of collectors who shared their growing enthusiasm for art with their family and eagerly sought their daughter's opinions, and who, as it turns out, were also well able to form their own.

From the beginning of the twentieth century, the United States has been extraordinarily fortunate in the quality and range of interests of its art collectors, so many of whom were determined to enrich museums, and therefore subsequent generations of the American public, with the works of art that brought them such pleasure themselves. The history of American collecting becomes particularly exciting when the hunt is up for the work of living artists. From those few redoubtable figures who set the pace before or just after World War I (Gertrude Stein and her brother Leo, Etta and Dr. Claribel Cone, Dr. Albert C. Barnes, Albert E. Gallatin, Louise and Walter Arensberg, Katherine S. Dreier, Marjorie and Duncan Phillips, and John Quinn), the ranks of collectors of contemporary art have since swelled to magnificent proportions. It is hard to remember how modest were the beginnings of the trend, or how relatively small the world of museums, galleries, and art journals with any interest in contemporary doings in which early twentieth-century collectors moved.

Very often and not surprisingly, the passion for collecting art by living artists was (and still is) fueled by friendship with artists

themselves—Louise and Walter Arensberg's lifelong fondness for Marcel Duchamp, Dr. Barnes's friendship with his classmate William Glackens. Albert Gallatin, who looked first to the French painters Jacques Mauny and Jean Hélion, then to his old friend George L. K. Morris, for advice along the way, may have gone farthest in his quest to understand modern art at firsthand by becoming an abstract painter himself at the age of fifty-five.

By the early 1950s, when Herbert and Nannette Rothschild began to devote considerable time and resources to collecting, the artists whose work particularly attracted them were already aging: Brancusi was seventy-seven when they first visited his studio, Léger was seventy-two, Gontcharova seventy-five. However, the Rothschilds' approach to gaining familiarity with an artist's work closely resembled that of the pioneer collectors of early modernism. Largely because of their own daughter's rigorous and experienced eye, they had an artist's point of view as to what should remain fresh, even in the work of a "master." Judith wrote in that same letter of 1952 about the Cubist painter Roger de La Fresnaye, who died young "before the crippling compromises, the infatuation with his own promise, could have set in," and she urged her parents to be on the lookout for that same "sincerity" in any work of art they might acquire.

Herbert Rothschild (born in 1891) and Nannette Friend (born in 1897) were married in 1917. They were descended from assimilated families of German-Jewish origin, most of whom had immigrated to the United States in the first half of the nineteenth century. Herbert worked in the furniture business, in which his father Morris had been active; in 1934 he founded a showroom, John Stuart, and later became director of a furniture factory, John Widdicomb. He ran the showrooms of both firms with great success, handing them on to his son Robert and son-in-law Roger Michaels not long before his death in 1976. Interested in providing middle-class America with practical furnishings of good traditional and modern design, he was among the early postwar importers of Danish and English furniture, which appeared in so many households in the 1950s. His showrooms featured works by the Danish designer Finn Juhl, the Englishman Robin Day, and the American

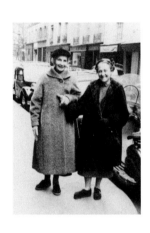

Fig. 3. Nannette Rothschild (right) with Natalya Gontcharova, Paris, 1956. Photograph by Herbert Rothschild

Introduction

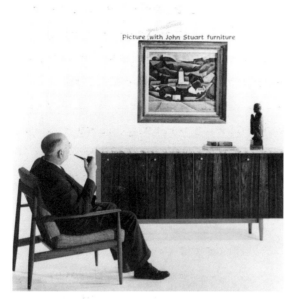

Fig. 4. Trade advertising flyer for John Stuart, 1950s, featuring La Fresnaye's *Landscape with Bell Tower* (pl. 36)

T. H. Robsjohn-Gibbings. When Herbert and Nannette Rothschild began actively to collect painting and sculpture, their works of art also made discreet appearances in advertisements for the furniture, thereby bringing fine art and good design to the public at the same time. These advertisements showed a painting hanging over a sofa or a sideboard, often contemplated by a seated man smoking a pipe, accompanied by a gentle pun: "Picture *yourself* with John Stuart furniture" (see fig. 4).

The combined impressions of economy, sobriety, comfort, and a balance of visual and intellectual pleasure suggested by the advertisements seem characteristic of the Rothschilds' approach to life as well as business. Herbert Rothschild's lifelong religious belief in the tenets of Ethical Culture gives a key to his upright, intellectual, and civic-spirited character, enhanced and softened by Nannette's kind thoughtfulness, evident in so many pages of her reminiscences. His frequent trips to Europe in the late 1940s and 1950s to see and order the latest furniture designs prepared the way for his and Nannette's equally careful scrutiny of modern art. Herbert's knowledge of wood and his admiration for its use in skillful hands also suggest a partial explanation for his instant love for *The Sorceress* (fig. 35), one of Brancusi's most complex and difficult sculptures. The Rothschilds pursued this work with persistence for several years, encouraged by Judith's enthusiasm, as she wrote in 1955: "Have you ever considered one of his wooden ones? . . . I don't think I've ever actually seen one but they appear to have a kind of inevitable hugeness which is really part of great sculpture (if not all of it)" (January 15–16, 1955). The Rothschilds' disappointment at Brancusi's decision not to sell (because of his own conviction that *The Sorceress* was of such importance that it should go to a museum) was muted by their customary public-spiritedness, as they then helped to assure that the sculptor was not mistakenly offended by the Guggenheim Museum, which eventually acquired the prize.

The New York art world in the 1940s and 1950s was at the start of a long and sustained period of growth, fueled in part by the flight of many distinguished artists from Europe to escape the terrible ravages of World War II (as a young painter Judith Rothschild met Mondrian, Miró, and Léger in New York), and in part by the establishment of new galleries by dealers who had also moved from Europe. A new generation of collectors emerged, buoyed by the tremendous increase in American prosperity that accompanied the industrial and commercial boom stimulated by the war. The Museum of Modern Art and the Whitney Museum of American Art, temporarily side by side in the block between 53rd and 54th streets in Manhattan, vied with the Guggenheim Museum on upper Fifth Avenue (not yet in the famous building by Frank Lloyd Wright) to show new work by both American and European painters and sculptors. Alfred H. Barr, Jr.'s classic 1936 exhibitions at the Museum of Modern Art, *Cubism and Abstract Art* and *Fantastic Art, Dada, Surrealism*, were already prewar memories, although Barr himself was to exert an important influence in encouraging the Rothschilds in their collecting. Judith Rothschild was not alone when she noted that attention to classic modernism such as that of the Cubists or early Mondrian was then more likely to be paid by a gallery (such as those run by Sidney Janis, Rose Fried, Eugene V. Thaw, and the Saidenbergs) than a museum.

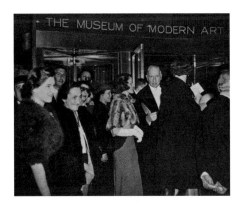

Fig. 5. Judith and Nannette Rothschild (left front) at the opening party for the exhibition "Art in Our Time," The Museum of Modern Art, New York, 1939

Marcel Duchamp seems to have played something of his customary, mysterious role as a catalyst in the Rothschild family's artistic affairs—bringing the aging collector and impresario of modern art Katherine Dreier to see Judith's work in 1947, and introducing Judith to the collages of Kurt Schwitters through the dealer Rose Fried, whose later staunch support of Judith as an artist complemented her gallery's interest in adventurous European prewar modernism.

Judith herself came of artistic age after graduating from Wellesley College in 1943. She studied music and philosophy at the New School for Social Research in New York, and painting at the Cranbrook Academy of Art and with several established artists, includ-

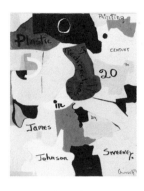

Fig. 6. Judith Rothschild's painted cover for her hand-typed copy of *Plastic Redirections in 20th Century Painting* by James Johnson Sweeney, given to her parents in 1945. The Judith Rothschild Foundation, New York

ing a stint with Hans Hofmann in 1943–44. Her most intense exposure to the New York milieu was in the short space of four years between 1943 and 1947, after which she moved to California with her husband, the novelist Anton Myrer. As her parents' interest in art strengthened, Judith was determined that they should miss nothing important to the education of their eye. In 1944–45 she even typed out a copy for them of James Johnson Sweeney's 1934 classic essay *Plastic Redirections in 20th Century Painting,* which was long out of print, creating her own abstract design for a cover (fig. 6). Her translations into English of writings by Arp, Hélion, Miró, and Mondrian must have brought new insight into European modernism to many other American artists as well as to her parents.

Until 1969, when she returned to New York, Judith observed the international art world, and her parents' increasing passion for art, from a distance—from the privacy of her studios in Monterey and then Big Sur or in Provincetown and Woodstock—but her letters bear ample witness to the intensity with which she thought, read, and talked about art, whether her own work or her parents' latest acquisitions. Judith's art evolved rapidly from her first, elegant understanding of

Fig. 7. Artists in "Forum 49" exhibition, Gallery 200, Provincetown, Massachusetts, 1949. Front row, left to right: George McNeil, Adolph Gottlieb, Kahlil Gibran, Karl Knaths, Weldon Kees, David Heron, Giglio Dante; middle row, left to right: Lawrence Kupferman, Ruth Cobb, Lillian Ames, Howard Gibbs, Lawrence Campbell, Judith Rothschild, Blanche Lazzell; back row, left to right: Perle Fine, John Grillo, William Fried, Leo Manzo, Minna Citron, Peter Busa, Boris Margo, Fritz Bultman, Morris Davidson, Fritz Pfeiffer. On the wall (left to right) are three paintings by Karl Knaths and one each by Fritz Bultman, Jackson Pollock, Weldon Kees, and Judith Rothschild

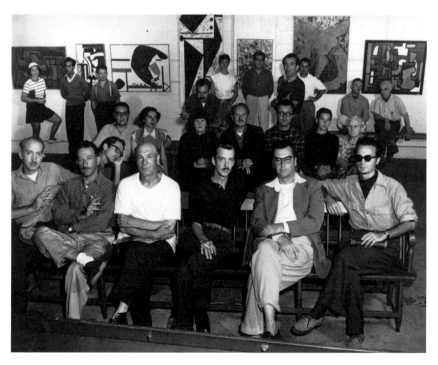

Hans Hofmann's mix of European abstract figuration with American energy (fig. 9) through her persistent fascination with collage and the use of chance and fragments of recycled materials (fig. 8), initiated in part by early encounters with the work of Schwitters, Arp, and Picabia, to find an abiding source of inspiration in landscape (fig. 11). The last two decades of her career were marked by the joyous discovery and exploration of relief as a method to work with expressive form and color (fig. 12). Judith's particular qualities as a painter—her absorption in problems of rendering observed light and landscape into abstracted but not altogether abstract compositions, carefully ordered but deeply felt—emerge in her discussion of other artists' work and in her comments on the choices made by her parents. Parents and daughter shared a passion for the collages of Gris, Mondrian's Cubist compositions and early abstractions, and the sculpture of Brancusi—all art in which the balance between represented reality and abstracted form is particularly subtle. A shared fascination with artists' working methods is also evident in the number of sketches and drawings acquired by Herbert and Nannette, in whose collection works on paper came to play an unusually important role.

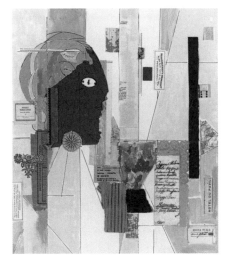

Fig. 8. Judith Rothschild
American, 1921–1993
Pocket Forecaster, 1984
Acrylic, ink, and collage
(including paper, enamel object,
and domino) on cardboard,
21 x 18" (53.3 x 45.7 cm)
Philadelphia Museum of Art.
Alice Newton Osborn Fund

The Rothschilds carried on a dialogue by correspondence with Judith in which they examined the details of especially loved works of art, she sometimes writing to request a reproduction of a painting in her parents' collection so that she could study it pinned to her studio wall. Other pictures they acquired left her less enthusiastic; while she acknowledged Kandinsky's importance and admired Gontcharova for her dedication as a less famous figure, their work fell outside her sphere of concentrated interest.

The Rothschilds built their collection with the greatest care and an enjoyment evident in every page of Nannette's reminiscences. Dealers who sold them pictures recall a soberly dressed couple, he tall and serious with a professorial air, she diminutive, modest, and warm, both of them intent on their joint mission of looking long and hard, and quietly talking over each work of art before reaching a decision.

Introduction

Fig. 9. Judith Rothschild
Grey Tangent, 1945
Oil on canvas, 29⅞ x 24⅞"
(75.9 x 62.2 cm)
The Judith Rothschild
Foundation, New York

Fig. 10. Judith Rothschild
Mechanical Personnages (III),
1945
Oil on canvas, 40⅛ x 47⅞"
(101.9 x 121.6 cm)
The Judith Rothschild
Foundation, New York

Fig. 11. Judith Rothschild
Sierra de Gredos, 1966
Oil on canvas, 30 x 40"
(76.2 x 101.6 cm)
The Judith Rothschild
Foundation, New York

Encounters with Modern Art

Fig. 12. Judith Rothschild
The Gothic XI, 1991
Relief of aluminum with
acrylic on aluminum
panel, 90¼ x 60¾"
(229.2 x 154.3 cm)
The Judith Rothschild
Foundation, New York

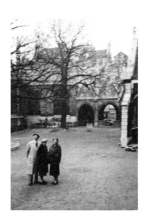

Fig. 13. Nannette Rothschild (center) with Harry and Lydia Winston at the church of St.-Séverin, Paris, 1956. Photograph by Herbert Rothschild

Their collecting adventures started in New York, visiting galleries and exhibitions assiduously, but a trip in 1951 to Paris on a quest for a painting by La Fresnaye and a chance meeting on the boat with more seasoned American collectors from Michigan, Harry and Lydia Winston, quickened the pace and their excitement. The Rothschilds were enchanted by meeting the artists themselves, and an introduction to the Winstons' French friend Claire Guilbert made many such encounters possible. There have been a number of firsthand accounts of visits to Brancusi's studio, but few are written with such attentive and charming straightforwardness as Nannette Rothschild's. Her memory of Henri-Pierre Roché's apartment house in Paris crammed with works of art stored behind closed doors affords a rare glimpse into the life of that elusive French diplomat, writer, and dealer, whose friendship encompassed such an unlikely mix of characters as Brancusi, Duchamp, and Patrick Henry Bruce.

The Rothschilds made their unpretentious way through the world of art and artists, always genuinely interested in what they saw and sure of themselves despite their ongoing eagerness to learn more. From the beginning they were generous with their newly acquired treasures, offering one of their two paintings by Bruce to the Whitney Museum the same year they bought it (1954) when Lloyd Goodrich, the director, lamented that the museum owned none. Upon hearing the grim news that Boccioni's *The City Rises* was badly damaged in the 1958 fire at the Museum of Modern Art, they instantly cabled Alfred Barr from Paris to offer *The Laugh* as a splendid consolation. They were immune, however, to other kinds of inducements to part with works, as is clear from Nannette's recollections of an encounter with the collector Joseph Hirshhorn, which she recalled much later with obvious amusement in a letter to her daughter Barbara: "Once when we were on a committee together he came up to me afterwards and said, 'I like your attitude. I hear you have a collection . . . I think I'd like to own your paintings. Maybe we could work out a deal—I'd buy everything you have for a top price.' Of course I said we owned our things because we loved them to which he replied, 'You see I was right about your attitude—that's why *I* want your collection'" (August 5, 1979).

One generation made a large difference in the scale and approach of American collecting. The vast acquisitions of Hirshhorn were beyond anything ever dreamt of by the Rothschilds. They seem never to have seen themselves in competition with others, and yet they were clearly conscious of a pressure from their own internal drive (and Judith's exacting eye) to find just the right thing by an artist they admired. The degree to which the works of art they assembled over little more than a decade even constituted a "collection" was subject to discussion—in letters to and from Judith, who saw their holdings as carrying on "a kind of Dialogue-in-Time between the paintings by different artists, and between those of one artist at different times" (July 5, 1964).

The paintings, drawings, and sculptures they owned came to occupy their home at Old Dam Farm in Kitchawan, New York, to which the Rothschilds moved in 1940. As is evident from photographs, the house was not altered for the art; instead the collection simply took on the same air of being lived with that imbued every room (fig. 14).

Fig. 14. Herbert Rothschild in the living room of Old Dam Farm, 1966. On the walls, from left to right, are Picabia's *The Procession, Seville* (pl. 65), Gleizes's untitled oil on panel of 1916, Arp's *Shell Cloud I* (fig. 73), Gris's three works for *Au Plafond du soleil* (pls. 30–32), Pevsner's *Tangential Lines* (fig. 84), and Judith Rothschild's *Byzantium* of 1955

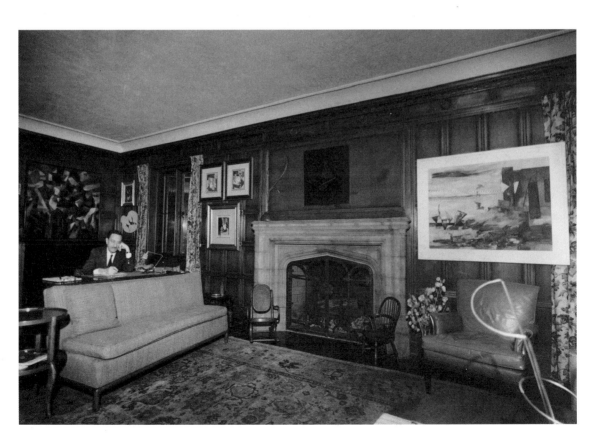

Although Judith, as the artist of the family, may have had the most personal of relationships to her parents' choice of art, the Rothschilds were conscious of each of their three children as they acquired works and made dispositions of favorites early on. The great Cubist-period Picabia and Gontcharova's lively impression of roller skaters, full of Russian zest and charm, went to Barbara and her husband Roger, while the Kandinsky and de Chirico were designated for Robert and Maurine Rothschild, who began to build their own collection with a special focus on drawings. But the lion's share was carefully discussed and chosen with Judith in mind. Few American collectors before or since have shown such a concentrated interest in structure and so finely tuned a sense of balance and composition. The Rothschilds' love of Mondrian and Juan Gris is perhaps most characteristic of this preference, and they collected works by these artists in great depth.

Throughout the twenty-five years or more during which Judith corresponded with her parents, they shared to a remarkable degree common interests in current events, literature, and art. As an artist Judith was irresistibly drawn to her parents' immersion in their own excitement over each new quest or acquisition, and her active experience as a painter rendered her responses both sensitive and, on occasion, sharply critical. It must have given Nannette and Herbert Rothschild profound pleasure to read Judith's warm words in a letter of February 1961, "I have delighted in seeing your delight in art." She concludes her thoughts with highest praise: "I think you have given me an insight, not usually allowed a painter, into the very real difficulties of building a fine collection: of being true to one's own instincts and tastes, and of not being pulled off one's course by all sorts of possibilities and temptations. Most painters naively believe that painting is hard and buying is easy . . ." (February 22, 1961).

Anne d'Harnoncourt

Encounters with Modern Art

From the 1966 Catalogue

We have been asked to write an introduction to this catalogue,[*] telling something about how we acquired our collection, and when we started to collect. The assignment has brought us unanticipated pleasure as we have refreshed each other's memories of moments in the adventure of finding and then living with our sculpture and paintings.

We don't think we ever "began to collect." We were, in fact, startled when we first heard our pictures called "a collection." We still hang the first picture we ever owned, a dry point by the Belgian artist Meunier, a wedding gift of fifty years ago. Not all our pictures of those early years have worn so well. Our interests were as limited as was our purse, and we bought etchings, a small pastel, and a few unimportant oils.

Then a time came when, in the New York galleries, we began to see modern art that puzzled and challenged us. Reading and studying gave us some clues to the artists' intentions, and led us to African primi-

[*] Reprinted by permission from Annmary Brown Memorial, Brown University, and Museum of Art, Rhode Island School of Design, Providence, *Herbert and Nannette Rothschild Collection* (October 7–November 6, 1966).

tives. These were easier to understand, for we saw in Negro art the same dignity and reverence that pervaded the familiar religious art of the thirteenth and fourteenth centuries.

The Museum of Modern Art then occupied rented quarters in the Heckscher office building on Fifth Avenue. We remember that as we stood before a painting there one day one of us experienced a flash of insight that helped us both appreciate the Cubist planes and the distortions of Picasso that had earlier seemed to block our vision. Thereafter we were regular visitors at the Museum of Modern Art, and at the apartment in the Plaza Hotel where the Guggenheim treasures had just been opened to public view.

Meanwhile, our daughter Judith was getting launched on her career as a painter. We had many sessions with her as she shared with us her expanding perceptions. It was she who nudged us into buying. "Stop taking courses. Stop reading *about* paintings. Buy some. Live with them. Grow on them." So, timidly at first, we began to buy graphics: Braque, Picasso, Arp, Léger, and others. We *did* grow on them, as Judith had predicted. We were beginning to learn how to look at modern art, and then gradually to see objects in real life differently too. Apples on a table could never look the same to us again after we had lived with a good reproduction of a Cézanne still life. An apple tree in the orchard took on new form after we had learned to love Mondrian's *Trees*.

Our first major purchase was a Léger, soon followed by a Kandinsky. Then suddenly we *had* to have a de La Fresnaye, and we had to go to France to find it. The following year we met Claire Guilbert, a charming, sensitive French intellectual who was to become a dear friend. Madame Guilbert knew every artist in France, and through her we became acquainted with many people in the Paris art world: Arp, Braque, Pevsner, Léger, Le Corbusier, Georges Hugnet, Henri-Pierre Roché, Tristan Tzara, among others. Visits with them and with the majestic Sonia Delaunay-Terk, gave us deepening insights into the art of these pioneers. Over the years we sought out for ourselves, and in a sense rediscovered, less well-known artists, some even forgotten—Pignon, Hayden, Csaky, Gontcharova, Larionov. Long philosophic discussions with Severini became high adventure. We don't think that the glamour of

visiting the artists unduly influenced our purchases any more than did those dealers here and abroad whose judgment and probity we respected.

There was usually a sense of personal discovery in our search for a particular work. In fact this is one of the special freedoms of private collectors—to follow wherever their own interests may lead. Private collectors do not have to account to a museum's board of trustees; nor need they make decisions on the basis of the picture's place in the work of an individual artist, in an art movement, or in art history. They are not obliged to consider the picture's effect on the public. And so, consulting only our own tastes and wishes, we found every work enlarging our vision. We seldom bought unless we were overwhelmed by a picture. We never sold, though once we traded pictures as part payment for one that otherwise we couldn't have afforded. We have never completely parted with most of the paintings that we have given to museums, in the sense that we still think of them as "ours."

Some works proved to be of minor importance to us as time went on, but we do not regret the things we *did* buy; we regret only things we *might* have bought, but didn't. Often we were not ready for them, but more frequently we were restrained by the limitations of our purse or the dimensions of our house.

We approach a work of art primarily for the joy and excitement that comes with being possessed *by* it, rather than with the possessing *of* it. Thus the collection has grown, until suddenly we find it is an entity. It seems to embody symbols of the revolution in seeing that took place in the early decades of this century. The artist with his new vision heralded other revolutions: in science, technology, communication, religion; in concepts of time and space. To have been alive at such a time, and to have lived with art that expressed such insights, was our good fortune, and for that we are deeply grateful.

We feel about our collection now as John Steinbeck is reported to have felt about his friend and editor Pascal Covici. It has demanded of us more than we had, and has thereby caused us to be better than we should have been without it.

Herbert and Nannette Rothschild

The Reminiscences of Nannette F. Rothschild

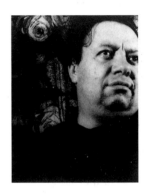

Diego Rivera

When we went to Mexico in 1937, we met Rivera and found the artist as charming and as temperamental as he was reputed to be. We had looked up an art dealer that friends had recommended in Mexico City, Alberto Misrachi, who was also Rivera's agent. Through him we bought two watercolors (pls. 70, 72) and two pencil sketches (pl. 71; the second, done on a sheet from Rivera's notebook, has since disappeared). Misrachi also arranged for us to visit the artist at his home.

Rivera was a ladies' man, and insisted on taking me by the arm, leading me around the house, and showing me every nook and corner—and every painting. As we were leaving, he called us back and showed us a package of studies for paintings, continuously asking, "Do you like them? Do you like them?" When we had looked through the pile, he selected two, rolled them up, and said, "These are a souvenir of your visit" (figs. 17, 18). Of course, we were delighted.

Because our friends the Scheuers, who were traveling with us, had not been able to come, we arranged a dinner party for the follow-

Fig. 16. Diego Rivera, 1932
Photograph by Carl Van Vechten
Philadelphia Museum of Art.
Gift of Mark Lutz

The Reminiscences of Nannette F. Rothschild

ing week so they too could meet Rivera. One of the other guests was the head of education for all of Mexico, whom we had met when we were making inquiries as to which art schools to visit. It turned out that he was a close friend of Rivera, and throughout dinner he kept the conversation going, prodding the artist to recount the famous stories that highlighted his versatility and his omniscience.

Rivera told us that when he was young he had lived in a small village in Mexico far from any city. He had never been to art school and knew nothing about art, but he was working as a peasant farmer and painting at night with colors that he made himself out of ground stones and earth. After painting a great many realistic scenes of the life around him, he began improvising pure forms and in this way invented his own version of Cubism. Subsequently he was discovered, sent to an art school, and finally made his way to Paris, where he found the work of Picasso to be along the same lines as his own. I can never forgive him for this story, because we later found it to have been made up out of whole cloth. Many of the works done in his early years in Paris show that the influence of Cubism actually came as a result of his time abroad between 1907 and 1921, and this "invention" of his was a complete fabrication.

Another of Rivera's tales was about his miraculous cure of a baffling tropical disease. He told a sufferer of a skin ailment that he had

had the same affliction and asked to be taken to his doctor. Once there, Rivera went to a blackboard in the doctor's office, drew a picture of what he thought was causing the disease, and told the doctor exactly how it should be treated, and the man was cured. Some years later Rivera read that a cure—his cure—had just been found, but credit was of course given to medical researchers.

We heard later that these stories were typical of Rivera, and he had hundreds of them. Yet there was something so very plausible about him. One could believe that by intuition he stumbled upon solutions others had to struggle to find—whatever the field.

Kurt Schwitters

We were lucky that we began to buy Schwitters's little collages at a time when they were not popular. Our daughter Judith bought some and we bought some, all at modest prices, which ranged from $115 to $1,000. Judith was also doing a great deal of work collecting and reassembling bits and pieces of our living environment ("assemblage," as it was sometimes called), and she created a number of beautiful collages. Her enthusiasm spilled over to us; hence the number of works by Schwitters that we acquired (see pl. 74).

Judith bought the first collage through a curious set of chance circumstances. It was the winter of 1945–46, and she was having her

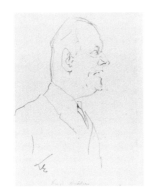

Fig. 19. Benedikt F. Dolbin
American, born Austria,
1883–1971
Kurt Schwitters, 1926
Pencil on paper, 11 x 8½"
(27.9 x 21.6 cm)
Provenance: Rose Fried Gallery,
New York; Herbert and
Nannette Rothschild, 1957;
Judith Rothschild
The Judith Rothschild
Foundation, New York

first solo exhibition at the small, cooperative Jane Street Gallery. Marcel Duchamp came to see the exhibition and admired her work very much. In talking to her, he explained that he was on his way uptown to Rose Fried's gallery, where he was to arrange for Miss Fried to buy some of the Schwitters collages that were being sold by Katherine Dreier,* and he advised Judith to go to see them. She fell in love with many of the

* In 1920, with Duchamp and Man Ray, Katherine S. Dreier founded the Société Anonyme in New York for the purpose of exhibiting and promoting contemporary art in the United States. She herself was a collector and owned a considerable number of collages by Schwitters.

The Reminiscences of Nannette F. Rothschild

Schwitters works that Rose Fried had for sale, particularly a small collage priced at $135. Judith explained that she couldn't afford one, but that since she had just sold a painting of her own for $115, she would be willing to spend that for the collage. Rose was touched by this young girl's interest and let the piece go for that price. This was the beginning of our Schwitters collection.

Piet Mondrian

Mondrian had always been Judith's love, so we tried to find representative examples of different periods of his work. Mondrian's dedication to his own austere philosophy and its integration into his life appealed to our sense of romance (although I must confess a lack of sympathy with his early commitment to theosophy).

For us, possibly because of Judith's enthusiasm, owning a Mondrian painting became a primary objective. In the early 1950s there were few around, and those that were for sale were priced low but not sought after. We finally made contact with a dealer in Holland, who sent us a painting on approval (possibly fig. 21). It was a working study on canvas with a mass of trials and re-trials in which lines had been painted and partly overpainted. We were disappointed. True, it was signed "Piet Mondriaan" on the back, and it would have made a fascinating piece for a researcher who wanted to learn how the artist worked, but it could not be our lone representation of his work.

In our perplexity about the piece, we called Sidney Janis at his gallery and asked him to look at it. He in turn suggested we show it to Harry Holtzman, whose name we had never heard but who was all interest. We learned that in 1934, Holtzman, a painter, had spent his last penny on a trip from New York to Paris to meet Mondrian. During the war Mondrian had fled to London, and it was Holtzman who had later brought him to New York, where he supported Mondrian until his death—a noble deed. Holtzman explained that this was an unfinished canvas that had been owned by Mondrian's brother, a minor civil servant in Holland, who subsequently sold it to the Dutch dealer. We thanked Mr. Holtzman for his help, and returned the canvas to Holland.

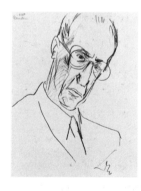

Fig. 20. Benedikt F. Dolbin
Piet Mondrian
Pencil on paper, 11 x 8½"
(27.9 x 21.6 cm)
Provenance: Rose Fried Gallery,
New York; Herbert and
Nannette Rothschild, 1957;
Judith Rothschild
The Judith Rothschild
Foundation, New York

In 1953 we proceeded to buy from Sidney Janis the 1922 *Composition with Red, Yellow, and Blue* (pl. 61), a dynamic piece that was pure Mondrian. Now our appetite was whetted. We read and studied a bit and kept our eyes open for other paintings. Our next purchases were the oil *Composition with Red, Yellow, and Blue* of 1921 (pl. 60), from Nelly van Doesburg in Meudon near Paris, and a charcoal from Sidney Janis, which he called "Eucalyptus Tree." The charcoal was soon shown to be of sunflowers (pl. 58), which seemed to us more accurate in terms of the titles of other paintings by Mondrian.

We had asked Rose Fried to watch out for us too, and in 1957 she offered us a rolled-up canvas, *Dune,* from about 1909–10 (pl. 57), which had been in the Slijper collection in the Netherlands. It was doubtless unimportant in terms of that extensive collection of the artist's work; it had never been on a stretcher, but had been carelessly thumbtacked to cardboard. For us, however, it was a great find, intended as a gift to Judith, and cleaning and a proper mounting proved to work miracles with it.

One of our crowning pieces, we thought, was the lozenge *Tableau No. IV* of 1924–25 (pl. 64). It is about forty by forty inches and stands on its point—a magnificent painting. We bought it for Judith, but to our dismay, when her husband Tony first saw it in our entrance hall, he covered his eyes and retreated, saying, "Oh no, not that!" It was too big, too brash, too overpowering for him—he couldn't see it because of its size and power. We were terribly disappointed. Eventually, we gave it to the National Gallery of Art in Washington, spurred on by Eugene Thaw, the dealer, who claimed that so monumental a piece should be part of the national heritage. Judith had had a full-size color photograph taken of it, which we loaned to exhibitions when we had to refuse to lend the painting itself because of the risks of transporting it. We hung this on our own wall to fill the hole made by the gift of the original, which we missed so much.

Meeting
the Winstons

In the spring of 1951, we were crossing the Atlantic on one of the big liners, Paris-bound. One day, when we were seated in our deck chairs studying maps and guide books, I asked a little French girl next to me if she knew what art shows were current at the Orangerie. She did not, but as we were getting up from our chairs later on, a man who had been sitting behind us came forward. He and his wife had overheard our question and from it supposed that we were as interested in modern art as they were. Would we care to take a walk around the deck together and get acquainted? He introduced himself as Harry Winston of Birmingham, Michigan, with his wife, Lydia. They, too, were Paris-bound and hoping to make some art purchases. We told them that we were looking to find a de La Fresnaye and—by coincidence—so were they! We walked then, two by two, Lydia and I constantly calling back to our husbands and they up to us, to share further similarities in our experiences. This went on for some time and we were both surprised and delighted at how our tastes and ambitions ran in the same direction.

At one point, I was telling Lydia about our interest in the Ethical Culture Society, and she replied that an old friend of her father's had been active in the society for many years. His name was Robert D. Kohn, an architect. Did we know him? Well, this was the climax. When we told them that the Kohns were very good friends and lived only a few miles from us, they made us sit down with them while they related the following story.

Lydia's father was Albert Kahn, the architect who had designed so many of the plants for Ford, General Motors, and Fisher Body. He was, in fact, the man who developed the open factory space suited for the new assembly-line automobile manufacturing. Coming from a very poor German immigrant family, he had not gone to college but had been apprenticed to an architect and then won a scholarship for travel abroad. During this trip he met Robert Kohn and another architecture student, and the three became fast friends. Kahn was living under the strictest economy in trying to stretch his modest stipend, but

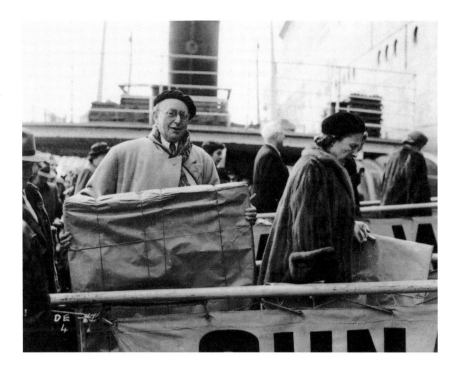

midway through the year he admitted defeat and told his friends he
had to go home. They were sensitive to what was going on, and know-
ing he would never accept assistance, concocted a plan to get him
money surreptitiously. They let themselves into his room, hid a sub-
stantial wad of francs in the pocket of his coat, and then played inno-
cent. He fell for the trick and came to them in exaltation, saying he did
not know how he had figured his finances so poorly, but there was
money he had overlooked and he could stay.

 With tears in her eyes, Lydia told us that although the three
continued to be friends when they were back home and saw a great
deal of each other, it was not until many years later, after her father had
achieved worldwide recognition, that they told him where the money
had come from. She said her father never tired of telling the story and
always admonished his children never to go to New York without tele-
phoning Robert Kohn, and also to feel his sense of indebtedness if
Kohn should ever need them. Of course, we promised that if they came
to visit us in Kitchawan, we would take them over to visit him.

 This served as an additional bond between us, and we spent
the rest of the voyage comparing itineraries and getting further
acquainted. From Paris, Herbert and I were going to Copenhagen,

and then proceeding south. The Winstons had decided to drive from Paris on a kind of van Gogh pilgrimage, stopping at all the places in the south of France that had had meaning in his life. We parted from them, not expecting to meet again until we were back at home. Each time we arrived in another city, however, a letter from Lydia would be waiting, telling us where they had been, what they had done, and where they were going next. And each letter ended with a plea to change our reservations and sail back with them on the *Queen Elizabeth*. This we were loath to do, but in the end, unexpected delays in London forced us to postpone our departure, and we booked on the *Elizabeth* from Southampton.

When we stopped at Cherbourg to await the tender from the boat train from Paris, we lined up at the rail to see whether our new friends were aboard. I shall never forget the sight of Lydia when she spotted us, jumping up and down on the deck like a two-year-old. They had gotten their de La Fresnaye, and so had we ours (pl. 36). But of course they had made more purchases than we, for we were then still very modest in our collecting ambitions.

Roger de La Fresnaye

We first became interested in de La Fresnaye through the large *Conquest of the Air* in the Museum of Modern Art (fig. 23), which without undue distortions had shown his debt to Cubism. But his Cubism was of a more realistic, even romantic, nature than that of some of his contemporaries, revealing his love of the French countryside, the French people, and French history.

It had always been de La Fresnaye's early work that most appealed to us. We bought the 1911 oil, *Landscape with Bell Tower* (pl. 36), and the two gouache compositions, *Man with a Moustache* (pl. 38) and *The Garden* (pl. 39), from the Galerie Percier in Paris in 1951. The prices were low, $2,500 for the oil and $150 for each of the gouaches, and today seem almost ludicrous. We had no idea that *Landscape with Bell Tower* had been to America and exhibited in New York in the Armory Show of 1913, but only knew that it had belonged

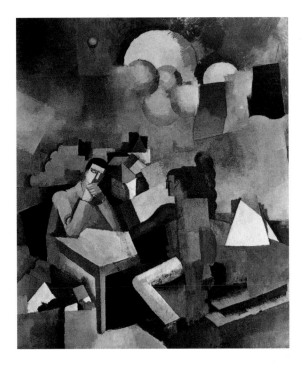

Fig. 23. Roger de La Fresnaye
French, 1885–1925
The Conquest of the Air, 1913
Oil on canvas, 92⅞ x 77"
(235.9 x 195.6 cm)
The Museum of Modern Art,
New York. Mrs. Simon
Guggenheim Fund

to de La Fresnaye's cousin, Georges de Miré, who had sold it to the Galerie Percier. The whole apartment building in which the gallery was located was devoted to storage of the famous collection of André Lefèvre (one of the gallery's original shareholders), which no one was supposed to know or talk about. We were always hoping the gallery would find us another de La Fresnaye from this hoard, but unfortunately they didn't.

In the late 1960s Daniel Robbins, director of the Museum of Art at the Rhode Island School of Design, telephoned us to say he had found two pencil drawings that were related to *Landscape with Bell Tower.* He offered us one, which we bought for just a few dollars (fig. 24). The other he kept for himself, although he promised to give us first option if he ever decided to sell it. Such documentation of an artist's working method can be invaluable to students and scholars and, we think, should be kept with the final work whenever possible.

Fig. 24. Roger de La Fresnaye
A Landscape with Bell Tower,
c. 1910
Pencil on paper, 5 x 8¼"
(12.5 x 21 cm)
Provenance: Herbert and
Nannette Rothschild, 1967;
Judith Rothschild
Private collection

The Reminiscences of Nannette F. Rothschild

Odilon Redon

Some time in the early 1950s, we bought a small pastel by Redon (fig. 25) at an auction at the Parke-Bernet Galleries. I think we were somewhat influenced to buy it because of the number of Redons that had been in the Armory Show of 1913. The work had no provenance, merely the name of the gallery in Paris from which it had come. We wrote to the gallery several times, but before we succeeded in getting a provenance from them, they had gone out of business.

The pastel is pleasing. It shows a woman in profile with a soft drapery on her shoulder looking at a flower, and we enjoyed it. But, as time went on and our field of interest narrowed, we wanted to have a wider representation of the many Cubist artists that we had come to love, and the Redon seemed less important to us. Accordingly, when we decided to make a gift of works from our collection to the Fogg Art Museum at Harvard in 1963, we included the Redon among them. The other works we offered were chosen for similar reasons: a Balla drawing, a Balla pastel, and a Jawlensky oil.

To our surprise and dismay, we had a letter from John Coolidge, director of the Fogg, saying that they considered the Redon a forgery. But he said they would be glad to accept it as such because it could be very valuable to them for teaching purposes. We dashed up to Cambridge to see Mr. Coolidge and to talk over with the curator, Agnes Mongan, her opinion of the Redon. Unfortunately, she was not there and we had to rely on Mr. Coolidge's memory of her having called it a fake. He recalled that Miss Mongan had discussed the pastel and its signature with the curator of the Louvre (whom she had just visited in Paris), and had reported the curator's verdict that neither the work nor the signature had anything to do with Redon. All, of course, without seeing the original!

It was something of a blow to us to think we had been fooled. Nevertheless, the uncertainty of the work's origins, the lack of prove-

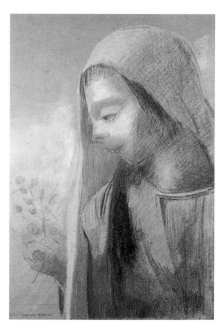

Fig. 25. Odilon Redon
French, 1840–1916
Head of a Woman
Pastel and watercolor on paper,
10¼ x 7⅝" (26 x 19.4 cm)
Provenance: Galerie de l'Elysée,
Paris; sale Parke-Bernet Galleries,
New York, October 24, 1951, lot
64; Herbert and Nannette
Rothschild, 1951; Judith
Rothschild
The Judith Rothschild
Foundation, New York

Encounters with Modern Art

nance, and the failure of the Paris gallery to furnish details seemed to add up to an unhappy confirmation of Miss Mongan's opinion. We formally withdrew our offer of the Redon, and took the pastel home with us. As it had only cost $225, there had been no great loss, except to our pride.

However, we were not inclined to let the matter rest there. We reported this encounter to Eugene Thaw, whose judgment and probity to us had no equal in New York. We brought the pastel to him and he studied it carefully, taking it out of its frame and examining the paper and all available evidence. He offered his opinion that it was a genuine Redon. However, as he did not want to rely solely on his own judgment, he asked if he might hold the pastel for a few weeks until he could show it to John Rewald, an authority on Redon. To our great delight, Rewald concurred that the pastel was genuine. It was, as he put it, "not the most beautiful Redon I have ever seen. Nevertheless, authentically a Redon." The signature, Rewald believed, was just one of the variations of Redon's signatures evidenced in the books on the artist. We had always hoped to take the pastel to Paris for someone at the Louvre to offer another opinion, or to ask Agnes Mongan to study it again, but never got around to it. In any case we never let the work be shown.

Paul Klee

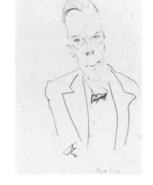

Fig. 26. Benedikt F. Dolbin
Paul Klee, 1929
Pencil on paper, 11 x 8½"
(27.9 x 21.6 cm)
Provenance: Rose Fried Gallery,
New York; Herbert and
Nannette Rothschild, 1957;
Judith Rothschild
The Judith Rothschild
Foundation, New York

Because we were spending quite a lot of time in the Galerie Berggruen in Paris in 1952 selecting lithographs and art books, Heinz Berggruen asked us if we would care to visit his apartment, where he had some beautiful original works, including a number by Alberto Giacometti. Of course we went, and were delighted with the pieces he showed us. These were from Giacometti's early days and included a chandelier and wall sconces done in collaboration with his brother. We would love to have bought these and other pieces, but they weren't for sale. We were offered, however, several of

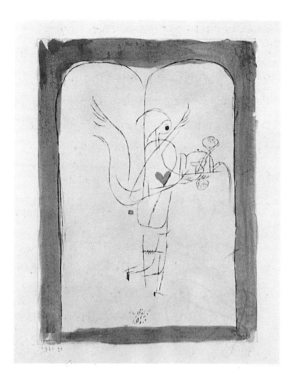

Fig. 27. Paul Klee
Swiss, 1879–1940
*The Angel that Makes Wishes
Come True*, 1920
Hand-colored lithograph, 9 x 7"
(22.9 x 17.8 cm)
Provenance: Charles Ratton;
Galerie Berggruen, Paris; Herbert
and Nannette Rothschild, 1952

the original drawings and prints that were hanging on the wall. From these we chose a small, colored etching by Paul Klee, about which Berggruen told us the following story.

One of his very good customers for books, then a major part of their business, was Charles Ratton, a noted collector of African sculpture. Once, when Ratton was in the gallery, he selected some important books that he very much wanted, but didn't have enough money to pay for them. He asked if Berggruen would take a "watercolor" by Paul Klee in exchange. Klee had originally given Ratton an etching called *The Angel that Makes Wishes Come True*. One day when Klee was visiting Ratton's home, he saw the etching hanging on the wall and jumped up to remove it, claiming, "This should never have been done in black and white. I should have colored it. I'm going to color yours now." He laid the little frame down on the table, took out the etching, drew from his pocket a small case of watercolors, and colored it while Ratton watched.

We ended up buying this piece from Berggruen (fig. 27) and have enjoyed it ever since. He told us that later a whole series was done in aquatint of the same subject as our watercolor. Reproductions of the print have appeared in many books on Klee, and have even been used by museums as Christmas cards. We compared them with our watercolor and though barely discernible, there are differences. We asked Mrs. Gaehde for her opinion as to whether the color was applied by hand and she said that she thought it was.[*]

A few years later, when we were again at the Galerie Berggruen, we said something in passing about how much we enjoyed the little

[*] According to the catalogue raisonné of Klee's prints by Eberhard W. Kornfeld, *Verzeichnis des graphischen Werkes von Paul Klee* (Bern, 1963), no. 79 (work number 91), this is a lithograph, not an etching. Kornfeld records five proofs without color and two hand-colored proofs; one of these bears color notes and served as the model for an edition of fifty, which were all hand-colored. The print was done as the frontispiece for the first (and only) volume of the journal *Die Freude* (1920), edited by Wilhelm Uhde.

Encounters with Modern Art

watercolor. Berggruen remembered nothing of the purchase, and when we repeated the story he had told us about Ratton he denied the whole episode. We always meant to check it with Ratton, but unfortunately never managed to do so. In the face of Berggruen's denial, I suppose the Klee Foundation could give an opinion on this print, which would be far more valuable if it had been uniquely hand-colored than if it had been one of a series of aquatints.

Francis Picabia

In 1952, when we were in the Galerie Berggruen in Paris buying etchings and lithographs, we came across a very small Cubist still-life etching by Picabia. We had known only Picabia's later Dadaist works, and were surprised by the simplified forms in this composition dated 1907 (fig. 28). We bought it for a few dollars. A few years later, in New York, we were at the Rose Fried Gallery when Rose was sorting through some odds and ends that had just been brought up from her cellar storeroom. There we spotted a large gouache that Picabia had done of the same subject (fig. 29). It was very dirty and gray, but we were intrigued by the coincidence and bought the piece anyway. We asked Christa Gaehde to restore it, and she was able to work one of her miracles. She peeled off the entire back of the work, leaving a tissue-thin sheet with the drawing on it. She bleached it so that the colors

Fig. 28. Francis Picabia
French, 1879–1953
Still Life 1907, c. 1947
Etching, 7 x 5¾" (17.8 x 14.6 cm)
Provenance: Galerie Berggruen, Paris; Herbert and Nannette Rothschild, 1952; Judith Rothschild
The Judith Rothschild Foundation, New York

Fig. 29. Francis Picabia
Still Life, c. 1909?
Gouache on paper mounted on ragboard, 22½ x 18" (57 x 45.7 cm)
Provenance: Rose Fried Gallery, New York; Herbert and Nannette Rothschild, 1955; Judith Rothschild
Private collection, Germany

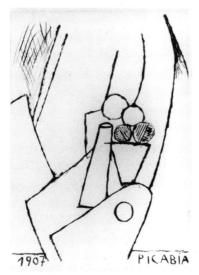

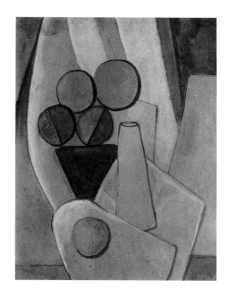

The Reminiscences of Nannette F. Rothschild

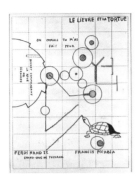

Fig. 30. Francis Picabia
The Hare and the Tortoise
Ink on graph paper, 9 x 7"
(22.9 x 17.8 cm)
Provenance: Tristan Tzara,
Paris; Herbert and Nannette
Rothschild, 1954; Judith
Rothschild
Private collection, Germany

shone forth on the light ground and then backed it with a ragboard.
The process brought out a lovely colored still life.

It was quite a stroke of good luck then to have had the chance
to buy from Sidney Janis the monumental oil, *The Procession, Seville* of
1912 (pl. 65). It had been exhibited the year it was painted at the
famous Salon de la Section d'Or in Paris, then at the Armory Show in
New York in 1913, and must have been bought by Marcel Duchamp, as
it was among the works that were sold by him in Paris in 1926. Although
we gave it to our daughter Barbara and her husband Roger, we had the
pleasure of housing it every summer for many enjoyable months.

We had already bought two other Picabias, ink drawings, from
Tristan Tzara when we visited him in Paris in connection with the pur-
chase of our de Chirico painting in 1954. He had many beautiful things
on his walls, notably some large early Picasso drawings with collage
and sand on paper. I remember that these were in very poor condition,
the paper badly wrinkled and foxed. Having asked the price of one, we
were shocked when he replied, "All I want for that is enough to buy a
home in the south of France."

Judith illustrated one of the drawings, *The Hare and the
Tortoise* (fig. 30), in her article "On the Use of a Color-Music Analogy
and on Chance in Painting," which was published in *Leonardo.** It was
always worth more to Judith than the thirty dollars we paid for it.

Gino Severini

It was the Winstons who suggested that we visit Severini in Paris in
1952, the year after they had bought their painting from him. At that
time he was living in the home of his friend, the Catholic philosopher
Jacques Maritain, in Meudon. Because we had been given the wrong
address, we were wandering about in his neighborhood and asked
some little boys playing in the street if they knew where Severini lived.
To our great amusement they replied, "The painter? The artist? Oh,
yes," and promptly took us to his house. This could scarcely have

* "On the Use of a Color-Music Analogy and on Chance in Painting," *Leonardo,* vol. 3 (July 1970),
pp. 275–83.

Encounters with Modern Art

happened in the United States, where artists are not always so well known to children or held in such high esteem.

Severini met us at the door, a very slight, gray man in a smock that reached to the floor and a little skullcap made of newspaper, which he always wore to protect his bald pate from paint splatters. We had hoped that the house itself would be inviting, but to our surprise, Maritain had told Severini that he must not touch his books, and to make certain that the artist could not, he had tacked heavy wrapping paper across all the bookshelves. Therefore not only was the "forbidden fruit" inaccessible, but the living quarters had become cold and prisonlike.

Severini was delightful, and the hours that we spent with him that day were the first of many such occasions. In spite of the fact that our communication had to be entirely in French (which was a bit of a stretch for us), we got into long discussions on subjects far removed from individual works of art but relevant to his general philosophy and his poetic approach. We met his beautiful wife and made a few dates with the family, purely for social and intellectual pleasure. It was he who first introduced Herbert to the existentialist philosopher Karl Jaspers.

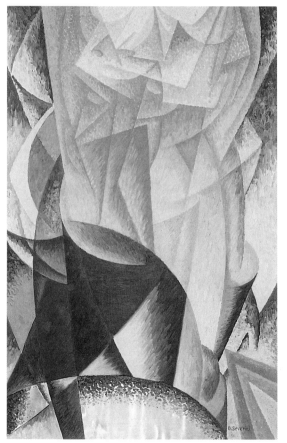

Fig. 31. Gino Severini
Italian, 1883–1966
Dancer + Sea = Vase of Flowers,
1913–14
Oil on canvas, with aluminum,
36 x 23½" (91.4 x 59.7 cm)
Provenance: Acquired from the artist by Herbert and Nannette Rothschild, 1952; Judith Rothschild
Staatliche Kunsthalle,
Karlsruhe, Germany

As his works were not in demand at the time, Severini was very poor and thus eager to sell whatever he could. We made what was for us a significant purchase, an oil, *Dancer + Sea = Vase of Flowers,* done in 1913–14 (fig. 31). He related how he had been sitting at the seashore with his sketchbook when a troupe of dancers arrived for a rehearsal and began to dance on the packed sand, their chiffon scarves floating about them. The motion of the scarves and waves seemed to make a flowerlike composition, and it was from these sketches that he made the painting we bought. He had also added

The Reminiscences of Nannette F. Rothschild

sheets of shiny tin in the lower portion of the composition, fastened to the canvas by wire.

When the World War broke out, Severini and many other artists carried their works to whatever hiding places were available. Most of his were hidden in a cave and not withdrawn until the end of the war, by which time the dampness had caused the tin in our painting to corrode. Severini replaced the tin with sheet aluminum to good effect, but without his explanation of this, the aluminum added in 1919 would have seemed a curious anachronism in a prewar work. Luckily the rest of the painting was still in good condition.

Meeting Claire Guilbert

When the Winstons were in the south of France during their trip abroad in 1951, they sought out the Madoura pottery in Vallauris, where Georges and Suzanne Ramié were introducing Picasso to the techniques of ceramics. Lydia and Harry asked for Mme Ramié, but were met instead by Claire Guilbert, who was taking over while she was in Paris at the accouchement of her daughter. Mme Ramié had sought someone who would be reliable, understanding of the works on exhibit, and forceful enough to refuse admission to the countless visitors who hoped to meet Picasso by gaining entrance to the pottery works.

The Winstons found Mme Guilbert a charming, intelligent art lover who seemed to know every artist in France and to have close personal relationships with many of them. She was at that moment in need of money, and the Winstons suggested that she could capitalize on her acquaintances by introducing collectors to some of the artists, as she would be entitled to collect a commission if they purchased anything. She was obdurate at first, not wishing, as she put it, to "enter commerce." The Winstons wisely did not press the point, and merely arranged to meet her when they all returned to Paris.

After several purely social visits and sight-seeing outings, Mme Guilbert asked them which of her artist friends they would most like to meet. They were smart enough to choose the most difficult of all, the almost reclusive Constantin Brancusi. This was just the beginning of a

Fig. 32. Claire Guilbert,
Provence, 1957. Private collection

number of Guilbert-sponsored adventures for the Winstons, which they shared with us on our homeward voyage on the *Queen Elizabeth*. They were generous enough to write to Claire, partly for our sakes and partly to help her financial situation, and promised to have her meet us on our next trip to Paris.

From this beginning grew our friendship with Claire and, through her, many of our own art adventures and encounters with the artists of Paris. Claire came from an aristocratic family. Her maiden name was Benoist, and her father had been president of the University of Montpellier. The family friends were the likes of the du Mauriers, the Rostands, Malraux—the first families of the French intellectual aristocracy. Her husband Gilles, a composer and pianist, was charming and intelligent and fluent in many languages, which he attributed to his musical training and numerous international performances.

We actually knew little of their lives, but over a period of years stories crept into the conversation that gave us some insight into their courage and character. As they were extreme liberals and French patriots, it was natural that they had joined the French underground during the German occupation of Paris. Claire, it seems, was engaged in top-secret escapades, which she once or twice caught herself on the edge of revealing to us. Gilles took up a post as a pianist in a twenty-four-hour restaurant that was patronized by German officers, where his proficiency in German and a keen ear enabled him to overhear important disclosures. This had the effect, however, of ruining his hands for the subtleties of control required of a concert performer, and after the war he was able to get only occasional engagements in the smaller cities of Turkey, Lebanon, and Scandinavia.

Gilles and Claire were both decorated by the French and American governments. The American decoration was awarded for their service to our troops after the armistice. It was the Guilberts who conceived the idea of opening up the best of French culture to the United States troops while they were awaiting return home, instead of

The Reminiscences of Nannette F. Rothschild

leaving them to be exposed only to the honky-tonk tourist attractions. With their connections in intellectual circles, they were able to arrange visits and lectures in different areas. Lawyers, engineers, physicists, doctors, teachers, writers, musicians, and just plain GIs were given the opportunity to see and experience the finest of the cultural resources of France. This was a new approach to dealing with an occupation force, and one that the United States, as well as France, was proud to sponsor.

Constantin Brancusi

We knew that in Judith's eyes Brancusi was a great sculptor, one of the pioneers of the century, but Herbert and I had never dreamed of getting to see him. He was old and a recluse, he had no agent or gallery, and we heard that he did not welcome visitors to his studio. However, after Claire Guilbert had arranged a visit for the Winstons in 1951, she offered through them to do the same for us. We were delighted, then, when we were in Paris two years later, to have Claire make an appointment for us to meet Brancusi. This was not easy to arrange, but fortunately she had caught him in a welcoming mood.

His studio was located in Montparnasse on a tiny dead-end street, the impasse Ronsin, which opened out of the boulevard Vaugirard. He occupied what had at one time been a parking garage, a very large concrete building with quite solid walls, the light coming in chiefly from the saw-toothed glass roof. To one side of the building was a long row of metal, single-car garages. At one end of this row was a single faucet about two feet from the ground, the sole water supply for the entire community. There must have been a toilet, but we never saw it.

Some of the buildings were still in use as garages, but others had become homes or artists' studios. Two that had been opened into each other were inhabited by the Romanian couple Natalia Dumitresco and Alexandre Istrati, who were both painters. They built up a close relationship with Brancusi, no doubt because of their common nationality, and ultimately became his sole heirs.

Encounters with Modern Art

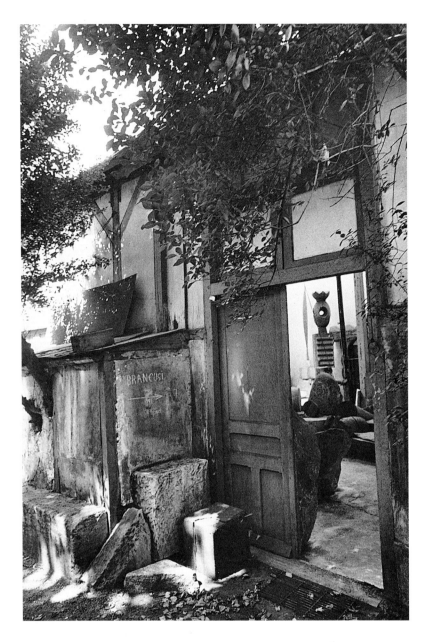

We walked about outside, taking a few photographs of the exterior since we knew we would not dare to use our camera indoors. Claire had knocked on the door and been admitted by Brancusi in the meantime, but some minutes passed before we, too, were allowed to enter. When Brancusi finally opened the door for us, we saw a little old man with a long gray-white beard, very sharp, darting eyes, dark skin, and a most kindly expression on his face. He was clad (as he always was) in immaculate white pajamas, which were similar to our blue denims and reminded us of the white uniform of Mexican workers. It was a

The Reminiscences of Nannette F. Rothschild

cold day, and we could see that he was wearing a heavy gray sweater under the pajama top.

The studio made great sense to us as a setting for the kind of work Brancusi had been doing for many years. It was in perfect order and very clean, except that everything was covered with a fine white dust. The floor was packed earth, very even and hard without a speck of paper or debris, though broken stone abounded. The huge space was filled with large, round slabs of plaster—as many as eight of them —each four to five feet in diameter and about six inches thick, which were set on pedestals at heights from two to three feet off the floor. Many of these slabs carried completed works, all carefully covered with clean, white canton flannel squares, neatly tied down so that no dust could enter.

Along one wall was a balcony of wood about ten feet off the floor. An ordinary carpenter's ladder leaned against it, and it was this ladder that Brancusi climbed daily to reach his bed, a simple wooden structure covered with countless quilts and blankets laid one on top of the other. On the same side of the studio was a doorway that opened into his kitchen and eating quarters. Here was a small oil stove, some pots and pans, a water kettle, and glasses and dishes on open shelves. There were a few wooden chairs against the wall, a very simple kitchen table, and one large, wood-framed upholstered chair, which was also covered with many layers of blankets and quilts. It seemed impossible to us that he could have found any comfort in this cold building with such crude sleeping facilities. Nevertheless, he did.

With great pride, Brancusi showed us around the studio. He uncovered one sculpture at a time, allowing us to look and consider before covering it again carefully with its flannel hood. He had several wooden sculptures in a space beyond the main workroom, which was crowded with early pieces that stood on the floor in the company of some of his well-known pedestals. Among them was the very engaging *Turtle*. It made us smile, which pleased him, but he said promptly, "This one I would not sell you. It is full of beasties." By which he meant woodworms. We fell in love with the upright *Sorceress* (fig. 35), but he advised against our buying it, shaking his

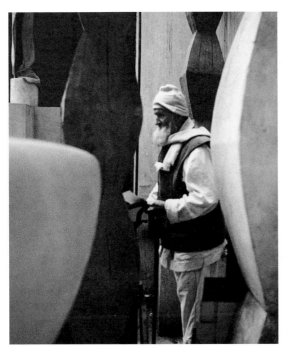

Fig. 34. Constantin Brancusi in his studio, about 1950. Photograph by Bernhard Moosbrugger

head and saying, "Wood is bad." Also in this room was the bronze portrait of *Princess X,* which Herbert seemed to like best, but Brancusi was not sure whether or not he would sell it. In the end, for one reason or another, the choices were narrowed down to two or three, and we finally decided on the polished bronze he called *The Muse* (pl. 7). He named his price and asked how we would arrange for shipment. When we told him that M. Lefebvre-Foinet* had consented to act as our agent, his eyes lit up, and he expressed confidence in our arrangements.

Once this had all been decided upon, he insisted we sit down and have something to drink. He brought out a pitcher and glasses while we sat on the edge of his round work-table pedestals. The drink was a "secret" concoction of his own making that we could barely get down (it was probably orange juice and yogurt). Later Claire told us that he was always inventing new drinks, which most people abhorred.

Brancusi chatted to Claire in French, but scarcely a word of it was recognizable to us. She later confessed that it was always all she could manage to understand him. He seemed very fond of her and was constantly retelling anecdotes from their past that made him laugh heartily and usually ended—for our benefit—with "Brancusi bad boy." They were stories Claire had heard a hundred times about his playing golf in America and about his many attempts to make a *Bird in Space* that would actually fly. He also told us of a project he had had for a huge stainless-steel sculpture for America, but when he learned that it would have to be done in a "factory" and would not be polished by his own hand, he refused to do it. The finished surface,

* Lucien Lefebvre-Foinet was a sort of man Friday for artists in Paris for over half a century. He provided them with a range of important services, from supplying paints (reputed to be superior to all others) to framing, packing, and shipping. The last was a considerable undertaking and responsibility, especially when it involved such fragile works as those by Brancusi.

The Reminiscences of Nannette F. Rothschild

Fig. 35. Constantin Brancusi
French, born Romania,
1876–1957
The Sorceress ("Diana"), 1916–24
Maple, height 38¼" (97.3 cm)
The Solomon R. Guggenheim
Museum, New York

he explained, was a very important part of the structure of his sculptures and could never be trusted to any hands but his own.* This brought him back to our piece. He had to make a base for it, in which he would mount a small turntable. He said he would call Lefebvre-Foinet when it was time to pick up our sculpture, and we left on very cordial terms.

About a week later, we had the call saying that the base was ready but we must come prepared to pay for the sculpture in cash. Lefebvre-Foinet explained that Brancusi was still a peasant at heart; he did not trust banks and would have nothing to do with a check. The amount was so large that we had to bring a little valise in which to carry the francs from the bank (then about four hundred to the dollar), which were done up in small packages held with rubber bands. When we arrived at the studio, we found Brancusi in a towering rage. Claire and Lefebvre-Foinet tried to reason with him, but Brancusi finally opened the suitcase, took handfuls of the packages of francs, threw them up in the air, and dumped the rest of the contents on the floor, exclaiming, "I will have nothing to do with this money!" At this point, Lefebvre-Foinet suggested that we leave with Claire and wait for him outside.

We learned later that Brancusi had been visited the previous day by a tax inspector, and he suspected us of reporting the impending sale to someone who had sent the official to ensure that it would be declared. In defending us, Lefebvre-Foinet made much of our friendship with Claire, whom Brancusi knew and trusted, and finally persuaded him that we had no intentions of making trouble. Brancusi accepted the francs, which Lefebvre-Foinet had gradually been gathering up from the floor and pedestals, and we arranged to come back yet another day to pick up the sculpture.

Before breakfast the next morning we had a wild call from Claire, who had just heard from Brancusi that the whole deal was off. He claimed that we hadn't given him the sum we agreed upon, that the count was forty thousand francs short. Lefebvre-Foinet hurried

* Brancusi had discussions about several possible projects for New York, Philadelphia, and Chicago during the 1940s and 1950s, but none was ever undertaken.

over to the studio and, after searching on his hands and knees, found the missing francs. Once more we journeyed to the impasse Ronsin, where Brancusi greeted us warmly at the door. He kissed me on both cheeks, all apologies and cordiality, and admitted, "Brancusi bad boy." He loved us, and we were friends. The sculpture was ready and Lefebvre-Foinet bore it off proudly in its flannel covering with the base and turntable.

On every subsequent visit to Paris, we made a pilgrimage to Brancusi's studio, Claire always asking him in advance whether there was anything he would be willing to sell. There never was. Brancusi had been selling a few pieces, but he was very wary of disposing of too many, partly, we suspected, because he did not wish to declare the sales for tax reasons, but largely because of an arrangement he had made with the French government. The occasion for this was the proposed takeover of the entire complex at the impasse Ronsin by the city of Paris. The city owned the property and wanted to convert it to quarters for its ambulance services. Brancusi, with the help of his friends, had persuaded the city to allow him to remain there with his studio intact for the rest of his life. In return, he had agreed to will to the state his studio and all the works of art in it at the time of his death, provided that the studio interior would be reconstructed in the National Museum of Modern Art in Paris, and that the bequeathed works of art be placed on permanent exhibition there. Brancusi felt, therefore, that there was a limit to the number of pieces he could sell and thus subtract from this promised bequest.

During one of our early visits, Brancusi had explained to us that he was loath to part with his pieces because the museums should have them—others besides Paris, he said. We let him know that we were planning to give *The Muse* to our daughter in California, who was an artist and would surely leave it to a museum. "What kind of artist?" he asked. "An abstract artist," we answered. His face lit up. But, we told him, she and her husband Tony were living in a garage, so we would keep the sculpture until they had a suitable place for it. He immediately went into the kitchen and brought out a dozen chocolate eggs wrapped in colored foil, saying, "Let her have these until she gets

Fig. 36. Constantin Brancusi
The Kiss, c. 1953
Painted egg, height 2¼"
(5.7 cm)
Provenance: Gift of the artist to
Herbert and Nannette
Rothschild, 1953; gift to Harry
and Lydia Winston; sale
Sotheby's, New York, May 16,
1990, lot 27

The Muse! She will know what they mean to me" (referring to his life-long preoccupation with the egg form). We put them in a little box and mailed them to California. Tony inadvertently ate some before Judith had explained to him what they were. She mailed the box back to us for safer keeping, and we held onto those that were left.

Brancusi always liked to give the ladies who visited him a memento of some kind. Once he formally presented me with an egg on which he had painted the outlines of his sculpture *The Kiss* (fig. 36). We treasured this, of course, but because our visits to Brancusi had come about through the Winstons, we felt we ought to show our gratitude by giving it to them. They were away from Paris at the time, and fearing that we might accidentally crack the shell and destroy the drawing, we roamed the streets of the Left Bank with friends who were visiting us, stopping at every shop in search of an appropriate case for the safe handling of the egg. Although we have since seen thousands of these, it seemed that Paris had none, and we had to have one made.*

On another visit, perhaps a year or two later, Brancusi still was not in the mood to sell anything. A sweet, generous man (in spite of his idiosyncracies), he realized he had disappointed us, and as we were leaving he said very tenderly, "I must give you something." Looking around the studio, he found a piece of cardboard with a barely discernible pencil sketch of a reclining nude woman. Like everything in the studio, it was covered with fine white dust. We later had Mrs. Gaehde restore the work—which was on a very poor material, like that of an ordinary commercial suit box—to its original whiteness so that the pencil drawing would show (pl. 6). It was quite an accomplishment!

At last, in 1955, Claire cabled us that Brancusi was willing to sell us another piece. After more cables and transatlantic telephone calls, we finally agreed on price, method of payment, shipping plans,

* After all the care taken to protect the egg for safe transport to the United States, Mrs. Winston came home one day to find it in the trash. According to Mrs. Winston's daughter, the housekeeper had thrown it out because Easter was over and the egg smelled bad. Horrified and frantic, Mrs. Winston retrieved the egg and, using tweezers, meticulously put it together.

and timing for our acquisition of the wooden *Sorceress* (fig. 35), which we knew as "Diana." (Brancusi called her "My Diana," or "Diana the Huntress," explaining that she was "not the Sorceress—just because of the shape of her head? No! No! She is my Diana, she leads me on!") But then another telephone call came. Brancusi was not satisfied to send the sculpture as it stood, nor did he have a suitable base for it. By this time, we were itchy, and we urged him to send it to us and to construct the base later. But he was adamant.

The next day we received another cable from Claire. The night before, Brancusi had fallen from the ladder leading up to his bed. He had broken his hip and was in the hospital. Had I not been seriously ill myself at that time, Herbert would have flown over to talk to Brancusi immediately. But before I had recovered, Brancusi was visited by James Johnson Sweeney, director of the Guggenheim Museum. At Brancusi's bedside, Sweeney arranged for a retrospective at the museum, provided Brancusi would allow the purchase of two major pieces. Our hearts sank when we heard this, for we knew how important the exhibition would be to Brancusi and how unlikely it was that any sculptures the museum really wanted to buy would be returned. It turned out as we expected: the exhibition was overpowering, and we were told that Sweeney negotiated successfully for seven pieces, including our "Diana."

When Brancusi saw the simple, inconspicuous Guggenheim catalogue, which was in keeping with Sweeney's stark museum policies —unframed paintings, pure white walls, and small, white catalogues with no illustrations but only listings in black type—he thought that Sweeney was downplaying the importance of his exhibition. We had an excited letter from Claire saying that Brancusi was very much upset and wished us to talk to Sweeney about the catalogue. We realized that Brancusi did not know that all the Guggenheim catalogues were similar, so without talking to Sweeney, we collected some of the other catalogues and mailed them off to Brancusi with a letter of explanation, which seemed to mollify him.

On our next visit to Paris, Claire again telephoned Brancusi to let him know of our arrival. He begged us to visit him early on the morning of his eightieth birthday. We arrived with some flowers, having

learned that he would never eat any of the chocolates we used to bring, for fear of being poisoned. He received us at ten o'clock in the morning with great ceremony in his kitchen-dining area; he had laid out champagne on ice, glasses, and a plate of cookies, and we drank to him in honor of his birthday. He was still using a cane but was able to walk. He apologized for the sale to the Guggenheim and was very tender and sweet with us, but of course, he had only enough pieces to leave to the museum in Paris. We accepted humbly his acknowledgment that he "owed" us one work, but he could not have realized how disappointed we really were. We had given our bronze, *The Muse,* to Judith and were counting on keeping for ourselves the more fragile wooden "Diana." Our only consolation was that we would still be able to see "Diana"— which really was a public piece—while the Guggenheim Museum would have the responsibility of fumigating it regularly against the "beasties."

Pablo Picasso

Judith had always been very selective in her approval of Picasso's works, believing that not every scrap of paper on which he experimented was pure gold. But we felt that the little drawing of a nude figure from about 1906–7 (pl. 67), which had been in the collection of Gertrude Stein, was not just an experiment but stood up as a work of art in its own right. It was tender and beautiful, and Judith and Tony could hang it without apology. Another work that spoke for itself was the collage of 1912–13, *"Le Journal" and Violin* (fig. 37), for which we paid two thousand dollars in 1953. It was small, but pure and quiet, and we knew that this too would be acceptable to Judith.

In 1956 Judith lent the nude to the Brooklyn Museum's exhibition in honor of Picasso's seventy-fifth birthday. The drawing had been sold to us as a sketch for *Les Demoiselles d'Avignon* (fig. 38) and of course one

Fig. 37. Pablo Picasso
Spanish, 1881–1973
"Le Journal" and Violin,
1912–13
Collage, oil, and pencil,
18¼ x 10¾" (46.3 x 27.3 cm)
Provenance: Mme de Mandrot, Paris; Daniel-Henry Kahnweiler, Paris; Rose Fried Gallery, New York; Herbert and Nannette Rothschild, 1953; Judith Rothschild

Encounters with Modern Art

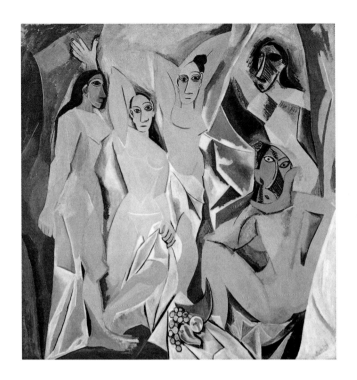

Fig. 38. Pablo Picasso
Les Demoiselles d'Avignon, 1907
Oil on canvas, 96 x 92"
(243.9 x 233.7 cm)
The Museum of Modern Art,
New York. Acquired through
the Lillie P. Bliss Bequest

Fig. 39. Pablo Picasso
Nude with Drapery, 1907
Oil on canvas, 59⅞ x 39¾"
(152 x 101 cm)
The Hermitage Museum,
St. Petersburg

could recognize its derivation from African sculpture, with which
Picasso was preoccupied at the time. But Una Johnson, then curator of
prints and drawings at the Brooklyn Museum, phoned to say she
believed it was not a study for the *Demoiselles* but instead for a painting
in the Hermitage, *Nude with Drapery,* which is dated 1907 (fig. 39). We
all rushed to the book that Miss Johnson referred us to and there it
was, illustrated in color. In the Hermitage painting, the figure's left arm
is extended out to the side, while in the similar figure in the *Demoiselles*
it hangs down. Years later, in 1970, we hoped to get a chance to see the
two works together in New York at an exhibition at the Museum of
Modern Art entitled *Four Americans in Paris,* which included works
owned by Gertrude Stein and her family, but the Soviets withdrew
their painting at the last moment.

 In 1958 we were in Paris at the same time Judith and Tony
were there. We had the chance to buy through Mme Christian Zervos a
large, monumental oil by Picasso, *Figure,* of 1928 (fig. 40), which at the
time seemed controversial. We knew Judith liked and wanted it, but we
made the mistake of taking Tony to see it, and for him it was too bold.
But we bought it anyway and housed it ourselves for a few years until it

The Reminiscences of Nannette F. Rothschild

did not seem so bizarre anymore, and by then Judith had space to hang it. The whole family enjoyed studying the Zervos catalogue raisonné in which there were many fascinating reproductions of drawings Picasso had made as he planned this work, which showed the evolution of his ideas.[*] At the time of the exhibition of the huge gift from Sidney Janis to the Museum of Modern Art in 1968, Danny Robbins telephoned us excitedly. He had suddenly realized that it was Judith's *Figure* that was depicted on the easel in Picasso's *Painter and Model* of 1928 (fig. 41). True, the parts were tossed about, Picasso fashion, but nevertheless, *Figure* it undoubtedly was.

Over the years we bought numerous Picasso graphics and gave them to our children as souvenirs of our trips abroad. Many came from an exhibition in Denmark to which Picasso had sent pieces never before shown (see pl. 68). They were priced so low (as little as $58.06 a piece) that we could afford to be lavish. Lithographs and other graphics provide a wonderful way to study an artist's works in depth, as only living with them for a while will permit. For us, books came first, then reproductions, and finally graphics—all a good preparation for appreciation and for the defining of one's tastes.

[*] Christian Zervos, *Pablo Picasso,* vol. 7 (Paris, 1955). *Figure,* 1928, is no. 141.

Reginald Butler

Rosamind and Leslie Julius, who were in the furniture business in London and became close friends of ours, knew Reg Butler and Henry Moore very well and were eager for us to meet them. They first introduced us to Butler's work by presenting us with a small copper maquette, *Reclining Woman* (fig. 42), from which a large iron sculpture in the Aberdeen Art Gallery and Museums had been made. Then, in 1953, we were invited to accompany the Juliuses on a visit to Reg Butler's garage studio-foundry in Berkhamsted, where he constructed his sculptures. He spoke to us of the immaterial and invisible forces acting upon the human figure, and we wondered how he could think of such abstract ideas surrounded by metalworking tools, blow torches, bellows, smoke, and fire. We were awed by the great challenge he faced in translating these ideas into hard metal.

We met his wife, Jo, at his lovely country house, Ash, and saw much of his finished work. We asked to buy *The Descent* of 1953, one of a series of sculptures in which he attempted to show the human body being acted upon by an outside force, rather than the body acting upon something. In this case it was a falling figure, and the force was gravity. Butler expressed his dismay at the popular interpretation of the piece as a figure being tortured. He questioned whether he would ever cast it in bronze, but we put in our bid in case it were ever to be done. We received cast number 1 in 1954 and don't know whether he ever made another.

Fig. 42. Reginald Butler
English, 1913–1981
Reclining Woman, 1950
Copper, length 9" (22.9 cm)
Provenance: Gift of Rosamind and Leslie Julius to Herbert and Nannette Rothschild, c. 1952
Private collection

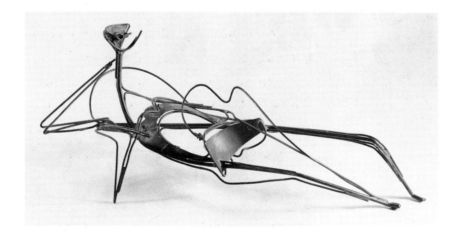

Fig. 43. Reginald Butler
Girl Removing Her Shift,
1953–54
Shell bronze, height 68⅜"
(173.7 cm) (including base)
Provenance: Acquired from the
artist by Herbert and Nannette
Rothschild, 1955
At Old Dam Farm, Kitchawan,
New York, during the 1950s,
before the sculpture was given
to the Brooklyn Museum

Soon after our visit we were in Madrid, and Leslie Julius cabled to tell us that Butler had been awarded the grand prize for his design for a monument to the Unknown Political Prisoner. (Second prizes had been awarded to Naum Gabo and Antoine Pevsner.) We were excited and sent a congratulatory cable to Butler at once. The next day we expected to read about the award in the London *Times* but instead found a story of the destruction of the maquette by an enraged viewer who was offended by the symbolic nature of the prison walls and the lack of realistic detail.

Our relationship with Butler continued to be very friendly. On our next visit to him at Ash in 1955 we contracted for a cast of *Girl Removing Her Shift,* a piece that was placed out of doors at our home (fig. 43), where it was enjoyed by all. When the Brooklyn Museum opened a new hall of sculpture in 1961 and begged us for a suitable piece, we gave them *Girl Removing Her Shift* along with Butler's oil on paper, *Study for a Lithograph* (which was really a study for a sculpture). They were delighted, Reg Butler was happy to be represented in a good American museum, and though we all missed the sculpture, we felt we had done the right thing.

Patrick Henry Bruce

The impetus for giving our Bruce painting to the Whitney Museum was meeting its director, Lloyd Goodrich, at the opening of an exhibition to which we had loaned many pieces. Goodrich was curious about our collection and disappointed to learn that we, as a family, owned

very few works by American painters. But when he heard that we did have two paintings by Bruce (pl. 9, fig. 44), his eyes opened wide, and he said wistfully, "You have two and the Museum has none." Impulsively Herbert responded, "Maybe we will give you one of ours."

There is always a tinge of regret at seeing one of your paintings go, even to a fine public institution. But perhaps we had listened more intently than usual to the poignant stories of Bruce's dejection in Paris, and how in 1933 he had burned so many of his paintings in anticipation of committing suicide. Henri-Pierre Roché, hearing of his friend's dark mood, had rushed to his home, and there, indeed, were the many canvases on fire. Roché rescued all the works that he could, and was able to persuade Bruce to go on living and to continue to paint. Thus early works by Bruce were rare.*

On our next trip to Paris in 1954, when Claire Guilbert regaled us with anecdotes about Roché, we asked to visit him, since we knew that he owned most of the Bruce paintings that might still be available.

Fig. 44. Patrick Henry Bruce
American, 1881–1936
Still Life, c. 1921–22
Oil on canvas, 35 x 45¾"
(88.9 x 116.2 cm)
Provenance: Henri-Pierre Roché, Paris; Rose Fried Gallery, New York; Herbert and Nannette Rothschild, 1954
Whitney Museum of American Art, New York. Gift of an anonymous donor [Herbert and Nannette Rothschild]

* Stories about Bruce burning canvases and attempting suicide seem to have had currency in the 1950s, but they have since been shown to be apocryphal. Roché did, however, receive the majority of Bruce's remaining early work. See William C. Agee and Barbara Rose, *Patrick Henry Bruce: American Modernist* (New York, 1979).

The Reminiscences of Nannette F. Rothschild

Roché was very dynamic, tall and broad-shouldered, living up in every way to the fabulous stories we had heard of his escapades, and yet withal a fine, sensitive person. We learned he had acted as scouting and finding agent not only for John Quinn, the renowned American collector of avant-garde art, but also for many other well-known collectors, who had relied on him to locate works by younger artists and by his contemporaries in the early decades of the century.[*]

Little by little we discovered that only a small section of the apartment house we visited, which he owned, was inhabited. He used the rest of it to store the paintings and sculptures he had amassed over the years. The compactness with which room after room was filled with works of art was unbelievable—one could scarcely open the doors. Although there seemed to be no system, Roché was able to take us upstairs and downstairs, from one room to another, as he located without error the particular piece he was seeking. One room had been reserved for Brancusi, and we could not forget our shock at seeing so many pieces—some ten to twenty of them—standing there dusty and uncovered. We were of course not permitted to enter, but from the quick glance we had it seemed as though here, there was at least enough space between the works to prevent their being damaged in any way.

Of course there were also rooms full of Marie Laurencin's work of all periods (Roché was rumored to have been romantically involved with her). He tried very hard to press on us some of her pieces and those of other artists in whom we were not interested. Finally, he assembled a number by Bruce for our consideration. We generally do not decide quickly, and the situation was further complicated because just as we would reach a favorable decision on a painting, Roché would say, "I'm not sure I want to sell this." We finally agreed upon three, and then came the question of price. We had expected to haggle with him,

[*] Henri-Pierre Roché knew virtually everyone in art and intellectual circles in Paris in the early years of the century. An art collector himself, he was also a translator, diarist, and author, writing short stories, reportage, and pieces for the little magazines. His most famous work was the autobiographical novel *Jules and Jim*, published in 1953 when Roché was seventy-four (and adapted to film by François Truffaut in 1962). See Carlton Lake and Linda Ashton, *Henri-Pierre Roché: An Introduction* (Austin, Texas, 1991).

Encounters with Modern Art

but to our surprise, his figures were modest. We had paid $165 for one of the paintings in New York and Roché was asking only $200 in Paris. We were almost sorry that we had not chosen more. But as he still was not certain that he would let them go, we arranged to come back the next afternoon.

Roché was not there when we arrived but had asked his wife to show us again the three paintings we had selected. It may be that during our first visit he had already decided that we were not to have any because we were greeted the next morning with a phone call from Claire, saying she had heard from Roché that he loved us and hoped we would come to visit him again, but he had decided not to sell any paintings. Herbert telephoned him and tried to persuade him to go through with our deal. We even promised to give one of the three paintings to the National Museum of Modern Art in Paris, since Roché had been lamenting the fact that while Bruce had done his best work in Paris, there was nothing there to represent him. This was all to no avail.

I can hardly close this account without conveying some idea of the confusion there was in the apartment house during our visits. The whole building resounded with hammer blows on pipes, materials

Fig. 45. Henri-Pierre Roché (center) and Denise Roché (far right) with friends, including Man Ray and Juliette Man Ray (both standing at right), Paris, about 1955. Carlton Lake Collection, Harry Ransom Humanities Research Center, The University of Texas at Austin

The Reminiscences of Nannette F. Rothschild

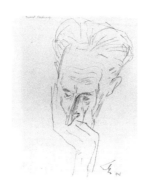

being carried up and down the stairs, and workmen coming and going. We learned from Mme Roché, who seemed rather put out about the whole business, that just a few days earlier Roché had learned that his friend Marcel Duchamp had married Teeny Sattler, the former wife of Pierre Matisse. In a burst of enthusiasm, he had cabled congratulations to Duchamp and invited him and his bride to spend their honeymoon in this building, where there was plenty of room. To his great surprise, Duchamp cabled an equally enthusiastic acceptance. Mme Roché asked, "How can we have a bride and groom stay in this dusty, ill-kept building without proper kitchen or bath facilities?" Roché waved the opposition aside, announcing "We'll have new ones installed." He thereupon brought in a squad of plumbers, carpenters, plasterers, and painters, who were commanded to install modern kitchen and bath facilities, and have the whole place shipshape in four days. We learned later from Claire that the apartment was completed in time for the Duchamps' arrival, and they lived there for some time. It was no wonder that Roché could not keep his mind on the sale to us, or that his wife could not keep the promise she made to see that he went through with it.

Giorgio de Chirico

It was through Carlo Cardazzo at his Galleria del Naviglio in Milan that we first saw a number of paintings by de Chirico. Cardazzo's were all from a slightly later period, and we were determined to seek out an earlier one. He took us to see an artist friend who owned one from the period that interested us, but although Cardazzo was very enthusiastic about the piece, there was something in the raw-green background and the too-bright-blue sky that made us question its authenticity. Both artist and dealer were crestfallen when we said no, but we have since been thankful that instinct warned us against it. At that time we were not aware of de Chirico's later, well-known custom of painting in the style of

Encounters with Modern Art

his great early period and either leaving the works undated or dating them arbitrarily to a much earlier year. The Winstons bought a de Chirico from this same gallery, which they later questioned and eventually sent back to Italy for a full refund. Fortunately, we were spared this difficulty. Meanwhile, Cardazzo, eager to sell us something in addition to the beautiful but tiny *Abstract Speed* by Balla, which we had chosen in the gallery (pl. 3), took us to the home of Romeo Toninelli in Milan. There we saw and pounced upon a superb pencil drawing of 1917, *The Return of the Prodigal* (pl. 11). There were many other works in the Toninelli collection that we would like to have bought, but no oil by de Chirico. We contented ourselves with the drawing and a small ink and gouache, *Flesh and Steel,* by Fortunato Depero.

After recounting the story about the de Chirico oil to Claire Guilbert in Paris a little later, she filled us in on some of the scandalous tales of de Chirico's "self-forgeries," and said she would inquire around for an authentic oil for us. Soon she called to say that her friend the poet Tristan Tzara knew of a beautiful oil from about 1914 that was to be had, but under unusual circumstances.

Marcel Raval, former editor of the publication *Les Feuilles Libres* and a close friend of Tzara (who had been an intimate associate of all the early Dadaists), owned a beautiful early de Chirico that he had had directly from the artist. Raval was recovering from a brain operation, still confined to bed, and very much in need of cash to pay his medical expenses. The painting, according to Tzara, hung over his mantel, where he had been accustomed to seeing it for many decades. If we were interested, he could arrange for us to look at it, but there could be no discussion about price or shipping because Raval was too ill to see anyone, even Tzara.

We set the time and met Tzara in an old but very elegant apartment building on the rue de Rivoli. We rode upstairs on the lift, and the apartment door was opened by a nurse, her finger to her lips for silence. We tiptoed into the classic living room, murky with its shades pulled down, and looked at the painting in the half-light. Not even daring to whisper, we nodded at Tzara and tiptoed out. Downstairs, before we parted, Tzara said he would arrange through the nurse to

The Reminiscences of Nannette F. Rothschild

have the painting taken down and brought to his home, where we could inspect it more closely, but the understanding was that the purchase had been made.

A few days later we went to see the painting, *Memory of Italy* (fig. 47), with its sculpture of a reclining figure set in an empty colonnaded square. We could easily believe that it had hung in one place for many decades, because resting on the back of the stretcher and against the canvas was an inch-thick mat of dust, like the felt that comes out of a carpet sweeper. Having examined the painting in good light and at our leisure, we were delighted with our purchase and went back to the hotel in fine fettle.

The Winstons were in the suite next to ours at the Hotel Berkeley. Lydia rushed out to greet us, asking, "Did you buy the painting?" We had. "Do you like it?" We did. She said she must show us something immediately. She brought out a book they had just bought,

Pittura, scultura d'avanguardia in Italia. Pictured there was what looked like our painting with a date of 1912 (ours was undated).[*] It was titled *Melanchonia* (from the lettering on the base of the marble statue in the foreground) with an owner's designation of Watson, London. Unfortunately we could not read the Italian description, and in great consternation telephoned Claire, who could better explain to Tzara in French the cause of our dismay. Tzara answered that he didn't care what had been published anywhere, he knew the work to be authentic and of the period that Raval had declared it to be.

Just by chance the owner, Peter Watson, was in Paris, and Tzara had spoken to him the day before. He said he would call Watson at his hotel and ask him to come and see Raval's *Memory of Italy* and tell what he knew of his own painting. Somehow we managed to live through the next twenty-four hours until Tzara's phone call came through to us via Claire. Tzara was completely reassuring and reported that Peter Watson was astonished to see our painting. He felt that it was a far greater work than his and unquestionably truer to the period, and had no doubts whatsoever as to its authenticity. Watson did not know the provenance of his painting and declared his intention to dispose of it immediately.

We were satisfied and had the picture shipped home. But under the circumstances, we thought we should ask Tzara to explain in writing exactly what had happened in his meeting with Watson, and what he knew of our painting that would cause him to authenticate it with his own name and reputation. Tzara made quite a production of this, doing some research on it and eventually sending us a document to settle any doubt about the painting's date and ownership. Among other things, Tzara cited the publication of a reproduction of our paint-ing in a 1926 issue of *Les Feuilles Libres,* where it was ascribed to 1914 and identified as belonging to Marcel Raval. At that time, de Chirico was still doing good work and had not yet begun to paint again in his early styles. Another significant factor was the very thin character of the oil paint in our work. In 1914, de Chirico was extremely poor and had

[*] Raffaele Carrieri, *Pittura, scultura d'avanguardia in Italia (1890–1950)* (Milan, 1950), pl. 120.

The Reminiscences of Nannette F. Rothschild

to make one tube of paint cover a large area, and as a result all his canvases of that period were characterized by this flat, thinned-out pigment. Tzara also cited the nature of the frame that Raval had had made for the painting, stating that in the early 1920s, a very popular frame maker, Serge Rache, began to incorporate narrow panels of smoky mirrors into his frames. These became a kind of craze in Paris, and since it was short-lived, this in itself helped to authenticate the picture as of truly early vintage.

As we were leaving Paris, Tzara had asked us if we would be so kind as to telephone James Thrall Soby when we arrived in New York and give him a list of paintings Tzara owned that might be of interest to him. We telephoned accordingly, and in the ensuing pleasantries told Soby that we had just bought a de Chirico through Tzara. Soby was electrified. "Who owned it? What title? What year?" We gave him the facts and he could hardly contain his excitement. He had been writing a book on de Chirico and had just received the galleys for page proofing. He confessed that he knew Peter Watson's version of the painting, but had been unable to arrange to see it. For the first time in his life, he had written about a painting that he himself had not seen and had done it this time only because of Watson's reputation. He must see our painting at once before the book went to press. Where was it?

Alas, we had to declare that the painting had disappeared. We had received a notice from United States customs of its arrival, but the customhouse could not locate it. There followed several days of scrambling to find the painting, and eventually it turned up, just the day before the deadline on Soby's book. We got it and arranged for him to come up to the farm to see it. Soby studied it with extreme care and concluded that Raval's date was justified, which now cast some doubt in his mind about Watson's painting. In the end he decided that all he could do in the book was remove the reproduction of another painting to make room for ours, and add a footnote to his description of the Watson painting that gave our *Memory of Italy* a favorable write-up.[*]

[*] See James Thrall Soby, *Giorgio de Chirico* (New York, 1955), pp. 43n, 146, 169. The dating and authenticating of early works by de Chirico continue to vex scholars and art historians today. The painting that belonged to Watson is now in the Estorick Foundation in London and is widely accepted as genuine.

Georges Braque

By the time we had appeared on the scene in a buying mood, and with enough money to consider an oil and not just a print (pl. 8), it was very difficult to find early Cubist paintings by any of the important artists. We didn't set out to confine ourselves to this period, it was that these were the works that most appealed to us and to Judith. This was particularly true of Braque, whose later, more lyrical works often seemed less well structured, or at least the structure was less apparent to our eyes.

We first bought a very small oil, *Still Life, Sorgues* (fig. 48). The painting was done in oil, which had sand strewn throughout it. It

was painted on cardboard, mounted on wood, and backed with what looked like old crating lumber. On it Braque had written in pencil, "Sur la route d'Entaygue en Souvenir de Sorgues G. Braque" (On the Entaygue Road: Remembrance of Sorgues). When Claire Guilbert told Braque of our purchase he said that he remembered very well how he had come to paint it in 1912, when he and Picasso were summering in the south of France. One day they were out in the fields sketching, and on the long walk back they passed through a tiny village and stopped at a bistro for refresh-

Fig. 48. Georges Braque
French, 1882–1963
Still Life, Sorgues, 1912–14
Oil, sand, and pencil on
cardboard mounted on wood,
12½ x 12½" (31.8 x 31.8 cm)
Provenance: Jacques Doucet,
Paris; César de Hauke, Paris;
Herbert and Nannette
Rothschild, 1956
Private collection, Germany

ment. It was there that Braque made a little still-life sketch, which he later developed into this painting.

Because *Sorgues* was so very small, we continued to search for another early Braque. We next came upon *Stout,* an oil also of 1912 (fig. 49) but done a little after midsummer of that year. *Stout* was signed horizontally on the reverse of the canvas and had been hung that way when we first saw it. Once we hung it at home, however, we were unhappy with this orientation and experimented with hanging it vertically, which really made more sense to us. But when it was returned to us from a loan to an exhibition at the American Federation of Arts it

The Reminiscences of Nannette F. Rothschild

Fig. 49. Georges Braque
Stout, 1912
Oil on canvas, 14 x 11¼"
(35.6 x 28.6 cm)
Provenance: Daniel-Henry
Kahnweiler, Paris; George
Isarlov, Paris; Galerie Gérald
Cramer, Geneva; Perls
Galleries, New York; Herbert
and Nannette Rothschild, 1957;
Judith Rothschild

had been rewired for horizontal hanging. We finally decided to ask Braque to settle the issue for us, and through Claire we received word that he would need to see the painting or a photograph of it.

Accordingly, on our next trip to Paris, we went to visit Braque with the photograph in hand. When we arrived he was working on a series of paintings showing a rowboat on the shore, and had about a dozen sketches, drawings, and small oils standing around the studio. He was polite and pleasant, but we had the feeling that he was not quite with us. He shook his head sadly and said he could not remember the painting, but if he had signed it horizontally, then he must have intended it to be horizontal, and that was that.

Early next morning we had a phone call from Claire. Braque had called to say that he had been very disturbed that he could not recall the painting and had lain awake half the night worrying about it. Suddenly he remembered when and where he painted it, and said that we were right in thinking it was meant to hang vertically. He thought he must have signed it absent-mindedly at a later date. He asked if we would bring the photograph and let him sign it for us, indicating the correct orientation, so that it would not be hung incorrectly and be misinterpreted. We did this but were sorry we hadn't brought the painting itself with us.

When we returned to New York, we hung the painting vertically and told Judith about our conversation with Braque. She began to study the painting again, looking at it from every angle. Finally, she suggested that the frame cut off the arc on the left side of the canvas, ever so slightly, but enough, she thought, to make a difference. On her advice we had it removed from the frame and found that she was right: at least a quarter of an inch of the arc, possibly more, had been covered by the frame, just enough to make the curve incomplete. We had the painting reframed so as to reveal all of the canvas, and we were delighted with the new totality she had revealed.

Encounters with Modern Art

Theo van Doesburg

Both our pencil and charcoal drawing and our oil (fig. 51) by van Doesburg were bought from Nelly van Doesburg when we visited her in her home in Meudon. The oil, which we bought for $1,200, was one she had bought back from the Dutch architect J. J. P. Oud. She remembered very well how Oud had visited them and, seeing the canvas on the easel just after her husband had finished it, insisted on taking it home with him even before the paint was dry.

Mme van Doesburg, unlike some of the well-known Paris "widows" (Léger, Kandinsky, Utrillo), was still imbued with a genuine understanding of her husband's work and its place of importance in the art world. She and her husband had gathered together an interesting collection of paintings and sculptures—works not only in the De Stijl tradition but also those from among younger artists. It was at her home that Herbert saw and fell in love with a work by the German painter Otto Freundlich, which Lydia and Harry Winston subsequently acquired. From her we bought the 1921 Mondrian *Composition with Red, Yellow, and Blue* (pl. 60) and a small early construction by Nicolas Schöffer (fig. 50), then a young unknown, whom she was helping to establish.

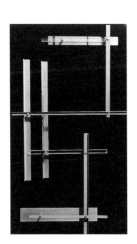

Fig. 50. Nicolas Schöffer
Hungarian, 1912–1992
Spatial-Dynamic Relief, 1951
Aluminum and plastic, 23 x 14½"
(58.4 x 36.8 cm)
Provenance: Nelly van Doesburg,
Meudon; Herbert and Nannette
Rothschild, 1955
Private collection

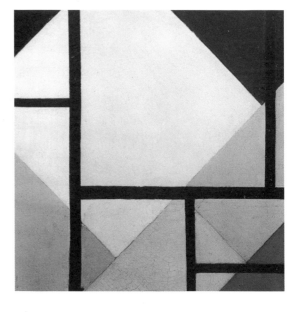

Fig. 51. Theo van Doesburg
Dutch, 1883–1931
Untitled, 1924
Oil on canvas, 11⅞ x 11⅞"
(30.2 x 30.2 cm)
Provenance: J. J. P. Oud; Nelly
van Doesburg, Meudon;
Herbert and Nannette
Rothschild, 1955; Judith
Rothschild

The Reminiscences of Nannette F. Rothschild

Juan Gris

To Judith, as well as to Herbert and me, Gris was the greatest of the Cubists. In 1956, when the Saidenberg Gallery received the series of gouaches from which the reproductions for Pierre Reverdy's book of poems *Au Soleil du plafond* (1955) were made, Judith was terribly excited about them. They had been painted in 1916 and had remained with Gris's son. We bought the book so we could study the images, and also gave a copy to Judith and Tony. Judith hoped we would buy all ten gouaches, but we couldn't. She disapproved of one of the two gouaches we did select so we exchanged it for *The Fruit Bowl.* The choice was hard because they were all so beautiful, but we wanted her to have the ones she liked best (pls. 31, 32).

We were also very much struck by the beauty of the book's frontispiece, *The Coffee Mill,* but the Saidenbergs did not have the painting for it and told us it had been lost. Suddenly Judith informed us that she had located it, but at that time we had other preoccupations and to our great regret we let it slip away. Imagine our delight then when some years later Eugene Thaw offered it to us! We wanted to complete the Gris threesome for Judith, but Thaw's price was very high. We gave him part cash and three other works in exchange: a collage by Moholy-Nagy, a Balla drawing, and a very unusual oil by Max Ernst. This was the only acquisition we ever made for which we had to surrender some of our things, and we always regretted losing all three of them.

The painting for *The Coffee Mill* (pl. 30), which was done in oil and collage on paper, had a poem by Reverdy mounted beneath it (fig. 52). Below this, either Reverdy or Gris had written something that someone had disapproved of so heartily that it had been stricken out with heavy black crayon. We were curious about what had been written there, and made a number of efforts to decipher the words under infrared and other lights, but to no avail. Although small, this ugly black area detracted noticeably from the painting, and we reclaimed the beauty of the

Fig. 52. Juan Gris
Spanish, 1887–1927
The Coffee Mill, 1916 (pl. 30),
with poem and inscription
below
Oil and collage on paper,
16½ x 9½" (42 x 24.1 cm) (sheet)
The Judith Rothschild
Foundation, New York

Encounters with Modern Art

Fig. 53. Juan Gris, illustration in *L'Assiette au Beurre,* no. 398 (November 14, 1908), p. 541. Printed in color (see pl. 29)

Fig. 54. Juan Gris, illustration in *L'Assiette au Beurre,* no. 416 (March 20, 1909), p. 831 (see pl. 28)

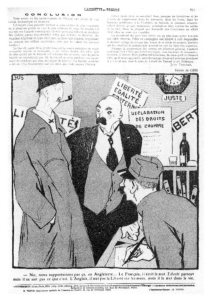

work by covering all that seemed extraneous below with a wide mat, leaving visible only the dedication in Gris's hand to Henriette Reverdy.

In 1958 we captured from the Galerie Percier two cartoons Gris did for the magazine *L'Assiette au Beurre.* One (pl. 29), published November 14, 1908 (fig. 53), shows a man about to take off in an egg-crate biplane being tapped on the shoulder by a skeptical gendarme, who says "Stop! If you were a bird you could fly, but since you are a man, you must have a proper license." The other (pl. 28), published March 20, 1909 (fig. 54), comes from an issue devoted to the outmoded system of internal customs in France. Surrounded by placards on the wall of a gendarmerie that announce "Liberty," "Justice," and "Declaration of the Rights of Man," the Englishman being questioned declares: "We would not tolerate this in England. In France you write the word 'Liberty' everywhere but don't know what it is. In England we don't have liberty on our walls but we have it in our lives."

Some years later the Saidenberg Gallery received a wonderful collection of Gris drawings from Daniel-Henry Kahnweiler. We asked Judith to look at them and choose some for us, and with the connivance of the gallery's registrar it was arranged that she wouldn't be able to tell which ones had already been sold to other clients. Eventually we made our purchases, five charcoal and pencil drawings, from the ones Judith had selected, and to her great joy—she had not sus-

pected our duplicity—we began doling them out for her birthdays and anniversaries (pls. 27, 33).

In 1956 Judith had seen a rare collage, *Bottle of Anis del Mono* (pl. 35), at the Sidney Janis Gallery. It was small but perfect, and she coveted it. It was some time, however, before we were able to persuade Janis to come down in his price from $7,500 to $6,900. Many years later, in the late 1960s, our son Bob and his wife Maurine were in an isolated spot in the mountains of northern Spain with their children and had stopped at an inn for refreshment. Peter, who had always been intrigued by this collage, came running over to his parents with a bottle of this liqueur in his hands, which he recognized from the collaged label in Judith's painting. Fancy an American product having been marketed over such a long period without either bottle or label being changed! They of course bought a bottle of the liqueur to bring home as a souvenir.

Natalya Gontcharova and Mikhail Larionov

At first we were not sure enough of Judith's and our own taste in Cubism to make heavy investments in paintings. We decided we could begin more safely with graphics, which were less expensive, trying out the works of one or another artist to see which we liked and in what direction we should make more important purchases.

One day in 1951, when we were flipping through large cases of aquatints and lithographs at the Galerie Berggruen in Paris, we were both struck by a very attractive color lithograph of a half figure of a woman (priced at ten dollars) by someone we had never heard of, N. Gontcharova (pl. 25). We took it home, framed it, hung it where we could see it constantly, and became very fond of it. We meant to look up the artist but somehow never got around to doing so. The following year, when we were in Paris at an exhibition of the work of early twentieth-century artists at the National Museum of Modern Art, we saw hidden in a dark corner a painting that we liked very much, but whose signature we could not decipher. We asked the guard to shine his flashlight on it, and to our great surprise found it to be by Gontcharova.

Fig. 55. Natalya Gontcharova
Russian, 1881–1962
Untitled, c. 1956
Oil on canvas, 8¾ x 7¾"
(22.2 x 19.7 cm)
Provenance: Gift of the artist to
Herbert and Nannette
Rothschild, 1956
Private collection

On one of our visits to M. Lefebvre-Foinet, we asked if he knew this artist. Oh, certainly, he said, she and her husband Larionov were very poor, living in tiny quarters, almost forgotten despite the rising art market of the early fifties. He offered to give us the address if we cared to go and see her. Not wanting to take her by surprise, we asked Claire Guilbert to write to Mme Gontcharova and see if she would receive us. She responded that she would.

Gontcharova and Larionov lived in a tall old house on the rue Jacques Callot. We climbed five or six flights of stairs to the top floor and were ushered into a tiny two-room apartment. The entire space was not more than fifteen by eighteen feet, most of it occupied by the stacks of canvases that were their most precious possessions. Gontcharova was a delightful person, with a slender, tight little figure, a face of great beauty, and magnificent, snappy black eyes. She was overwhelmed at the thought that Americans had discovered her and were seeking her out, and we found her enthusiasm very touching. We communicated in German since we could not understand each other's French.

Larionov, we learned, had suffered a paralytic stroke during the war, and the small pension that they received was used up for food and medicines for him. Mme Gontcharova went daily to a nearby restaurant to buy a bowl of soup to take home to him. The kindly proprietors there, realizing that she ate next to nothing herself and was wasting away to a shadow, asked if she wouldn't join them in their midday meal, paying for it by telling them stories of her prewar life in Russia. This truly saved her life, as she could not leave her husband long enough for her to stand in line at the soup kitchen, which would have been her only other recourse.

We asked if any of her work was for sale. She told us there was some in storage, but she could not get at it because it would mean leaving her husband alone too long. She did, however, have a few pieces in the apartment. Thumbtacked to the wall were bits of canvas, about eight inches by eight inches, on which she was doing paintings for quick sale in a Rayonnist-Expressionist style. We selected one of these

The Reminiscences of Nannette F. Rothschild

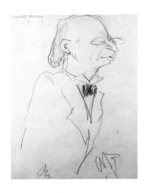

Fig. 56. Benedikt F. Dolbin
Herwarth Walden, 1928
Pencil on paper, 11 x 8½"
(27.9 x 21.6 cm)
Provenance: Rose Fried Gallery,
New York; Herbert and
Nannette Rothschild, 1957;
Judith Rothschild
The Judith Rothschild
Foundation, New York

(fig. 55), but asked if she had any early work. She was quite feeble, so we searched through the canvases stacked in the corner and found several, from which we chose our *Skating Rink* of 1912 (pl. 23).[*]

We learned that when Gontcharova and Larionov had left Moscow for Paris in 1914, they took many of their early paintings with them, which were shown in a joint exhibition at the Galerie Paul Guillaume. After the close of the exhibition, these paintings, *Skating Rink* among them, were sent to Herwarth Walden, publisher of *Der Sturm,* for a show at his gallery in Berlin. Following the exhibition there, the paintings were being shipped back to Moscow when war broke out. They had just arrived at the German border and were about to be confiscated when Walden stepped in and claimed them as his own (since his name appeared as the shipper). He stored the works for the artists and sent them back when the war was over. It was on these paintings that Gontcharova and Larionov were still living so meagerly, trying to sell one at a time for food.

Meanwhile, she asked how we had come to know of her. Through her lithograph, we answered. But she had never done a lithograph, she said, and could not imagine what it was that we had bought from Berggruen. We explained to her that we had come to love the work and had been calling it "Portrait of Gontcharova." Still she could not recall it. But as Herbert was helping her shift canvases, he suddenly discovered a drawing of our "Mme Gontcharova" (pl. 24) and we exclaimed, "There's our lithograph!" She replied, "Oh, that. I had forgotten all about it. This is a drawing I made to give to the Bauhaus when it first opened." She was one of eleven artists who provided drawings for a portfolio of prints to be sold for the benefit of the Bauhaus. Of course we bought the drawing at once and have continued to love both the original and its lithograph.

Gontcharova showed us a trunk in another corner of the room that was filled with paintings, drawings, textiles, and packages of scripts

[*] In a letter to Herbert in 1957, Gontcharova explained that the X in the lower right, suggestive of the circular skating rink, "represents the four cardinal points in the circle of the horizon. The crossing of the two straight lines is the position of the eye of the spectator. In the Steppes, the line, or rather, the circle of the horizon is often entirely visible. As for the circles in the left corner of the painting, they are the lines of rotation, of rapid change in direction, which give to the skater the sensation of moving on wheels."

Encounters with Modern Art

related to her work for the Ballets Russes. She told us how she came to be involved in painting ballet sets and designing costumes. In Moscow she and Larionov were part of a set of intellectuals who met frequently and were wont to criticize everything. One night after a ballet performance, Diaghilev joined them and asked, "How did you like my ballet?" Gontcharova answered, "*Yours*? It was Bakst's; everything you do is Bakst. There are plenty of good artists in the world besides Bakst. Why don't you ask someone else to do a ballet for you?" "Very well," said Diaghilev, "you shall do the next one." "No, not I," she said, "I don't know enough about ballet to do one myself." "Maybe that's just the reason you should try," he replied. And so she began to work on *Le Coq d'or*.

She threw herself into the work (fig. 57) and enjoyed it tremendously, but was fearful lest she should prove inadequate. On the night of the opening, May 24, 1914, she was afraid to attend the performance and remained in her apartment to await the public's verdict. Meanwhile, at the theater, the ballet was received with thunderous applause and demands that the artist be presented. Diaghilev stepped before the curtain and explained that Mme Gontcharova had been afraid to come to the performance. "Fetch her here, fetch her," the audience cried, and while they waited, Diaghilev sent a cab to bring her to the theater. In her excitement Gontcharova had been pac-

Fig. 57. Natalya Gontcharova
Stage set design for Act I of
Le Coq d'or, 1914
Pencil, watercolor, and gouache
on illustration board,
19⅜ x 27⅛" (49.2 x 68.9 cm)
The Fine Arts Museums of San
Francisco, Achenbach
Foundation for Graphic Arts,
Theater and Dance Collection.
Gift of Mrs. Adolph B.
Spreckels

The Reminiscences of Nannette F. Rothschild

ing the floor and nervously rubbing at a little sore on her cheek. By the time the cab came to get her, the spot was quite inflamed. She knew this would never do for a public appearance, so she quickly took a piece of black court-plaster, cut from it a small flower, and pasted it over the offending red spot. Thus she went to the theater and proudly received the acclaim that awaited her. The next day, she told us, every fashionable woman in Paris was wearing a black court-plaster rose on her cheek. (Actually she told us that all this had happened in Moscow, but the record indicates that it took place in Paris.)

Mme Gontcharova took us to Larionov's bedside and showed him the two Rayonnist works that we had selected to buy. He sat up in bed to sign them, as well as a third, which he gave us. They explained that these early paintings were from a period when they were both very poor. They had been done on gray paper, which a butcher in Moscow would give to them, a huge stack at a time. This was, in fact, one way by which they knew for sure when the paintings had been done. One of them had a color outline drawing on the reverse. This drawing, a bold abstraction of a dancing figure, was done in vivid blues

Fig. 58. Natalya Gontcharova, Paris, 1956. Photograph by Herbert Rothschild. Private collection

and reds. Having been very much impressed by the vigor and vim of Mme Gontcharova, and having seen Larionov only as an aged, sick, bed-ridden man, we decided that this vibrant dancing figure had surely been done by her—on the reverse of one of her husband's paintings. In 1970, to our great surprise, Judith showed us an auction notice in which several of Larionov's paintings were being offered. Among them was a fully worked-up figure identical to the sketch that we were attributing to Gontcharova, which proved that the drawing was also by Larionov. We asked Judith to cable a bid for the painting, but lost it.

It is hard to convey the joy and excitement that our visit seemed to bring to these two people, who had not sold any major works for

Encounters with Modern Art

years. As we left the apartment, tears rolled down Larionov's cheeks. We shall never forget the image of Gontcharova, leaning over the balustrade, waving good-bye as we walked down the many flights of stairs.

We returned to visit them once more, but the stairs were really too much for us. We met Gontcharova one time by chance on her street corner (fig. 58), and she threw her arms around us both rapturously. Luckily, they were rescued by exhibitions of their work in Paris. Several magazines carried articles about them, and there was a revival of interest in the Russian art of their early period, so that when she died in 1962, they had at least been relieved of the extreme poverty to which they had earlier been reduced. In 1963 Larionov married a friend who had been kindly nursing him after Mme Gontcharova's death, and he died himself the next year.

Two Visits

On one of our visits to Paris, Claire Guilbert revealed to us that many of her old family friends felt she was losing caste by having dealings involving money, even though they were in the art world. She was eager to show them that her American friends, for whom she was acting as art *commissionnaire,* were pleasant people who were both interesting and presentable, that is, *gens gentils.* With this in mind, she asked if we would be willing to be received by Mme Rostand and M. and Mme Jacques Jaujard. We of course agreed, and two dates were arranged.

Mme Rostand was the younger sister of the poet and playwright Edmond Rostand. Having married a mere banker, she retained her maiden name and was loath to change it, while he preferred to adopt hers, which was so well known the world over. Her home was on the rue du Bac, in a tall building with shops on both sides, its shutters closed to the street, looking quite barren and uninteresting. However, the building backed on a convent with large, open grounds and beautiful gardens, all visible from the rear windows of her apartment. The two floors she occupied were breathtaking, hung as they were— crowded, in fact—with beautiful paintings (some even hanging on doors), from the Impressionists to contemporary works.

The Reminiscences of Nannette F. Rothschild

With many apologies, we were asked to greet Mme Rostand in her bedroom. The maid explained, to our great embarrassment, that Madame had fallen that morning and injured her head, and was thus unable to leave her bedroom. We naturally asked her to say that we would come another day, but Mme Rostand, hearing this, called out that she was well enough to see us. We entered her bedroom and saw before us a majestic figure, her head swathed in bandages. She had slipped on a rug and had a bad fall that required several stitches. She was probably well into her seventies at this time and really should not have made the effort to see us. Nonetheless, we had a delightful visit, with Claire doing a great deal of interpreting because Mme Rostand's French was so rapid and mine so poor. She was curious about our interest in Paris and French art and was eager to know to what extent we were typical Americans, and in particular New Yorkers, who evidently did not have a good reputation with her. We had a suspicion that she used "New Yorkers" as a euphemism for "Jews," and we tried to answer soundly for both categories.

We were served a lovely tea, but we cut our visit short because of her injury. She urged us so warmly to look upon her as a friend, and to come again even if we should be in Paris when Claire was not there, that we felt we had passed the test and been accepted. I sent her, as a remembrance of our visit, a package of non-slip adhesives to apply to her rugs to avoid future accidents. It took a long time for her to recover from the injury, and unfortunately we were not able to visit her again before her death a few years later.

By the time we were to meet the Jaujards, the Winstons had joined us, and we all went together to tea. We enjoyed our hosts and their conversation, which was largely in English and thoroughly cosmopolitan, but what was most memorable about this visit was the location of their apartment. At that time, M. Jaujard occupied a position similar to that of André Malraux, I believe head of the ministry of cultural affairs, whose province was the directorship of the museums of France.* This entitled him to an apartment in the Louvre. We never

* Jacques Jaujard (1895–1967) became director of the French museums in 1939, and secretary general of the ministry of cultural affairs in 1959.

dreamed that in this huge museum there was a private elevator leading to a two-story apartment with living quarters overlooking the clock tower. This in itself was a great thrill for us. The apartment, furnished with traditional French pieces that were beautiful although not distinguished, had a dining room that particularly intrigued us because it had once been the kitchen of Louis XIV. It was huge, and formal state dinners were now often held there. In the end, Lydia and Harry and Herbert and I seemed to have defended Claire's position with our acceptance by the Jaujards as cultivated people in their world.

Henri Hayden

Fig. 59. Henri Hayden
Polish, 1883–1970
Mandolin Player, 1920
Oil on canvas, 43½ x 19¾"
(110.5 x 50.2 cm)
Provenance: Jacques Ulmann;
Galerie Rive Gauche, Paris;
Herbert and Nannette
Rothschild, 1956
Private collection

Our business associates and friends from Denmark, Miquette and Fearnley France, joined us for several days on one of our visits to Paris. We were searching for paintings, and they were hoping to learn more about modern art by sharing our experiences. At this time there was quite a bit of interest in the early work of Jean Metzinger, who was one of the original Cubist group, active in the Section d'Or and recognized as an important member of the inner circle. We saw many of his early Cubist works in the galleries, but to us they seemed too raw and fresh, and too repetitive to be authentic.

We had the opportunity to visit Metzinger in his studio, and there on the easel was a 1914 painting. He told us that part of the painting was not dry because he was cleaning it. This, of course, confirmed our suspicions that he was, like a number of other painters in the 1950s, trying to capitalize on his best period by painting new works in his earlier manner and signing them with an early date.

It turned out that Fearnley was hoping to buy one of these. We felt too responsible for his choices of art in our company to permit him to make what we felt was a mistake in acquiring it, and we earnestly tried to steer him away from it. Instead of the Metzinger he was considering, we offered to let him have a beautiful Cubist still life by Henri Hayden, which had been shown to us at the Galerie Rive Gauche. We knew nothing about Hayden, but we had no doubt about the integrity of his work. Fearnley liked the Hayden and bought it,

The Reminiscences of Nannette F. Rothschild

Fig. 60. Henri Hayden
Three Musicians, 1919–20
Oil on canvas, 70⅞ x 70⅞"
(180 x 180 cm)
Musée National d'Art Moderne,
Centre Georges Pompidou,
Paris

Fig. 61. Pablo Picasso
Three Musicians, 1921
Oil on canvas, 80½ x 74⅛"
(204.5 x 188.3 cm)
Philadelphia Museum of Art.
A.E. Gallatin Collection

promising us that if he ever wanted to sell the painting, he would offer it to us first. (Incidentally, he bought the Metzinger as well, and whenever we visited the Frances we felt confirmed in our original opinion of both paintings.)

Thereupon, we set out to find another Hayden still life for ourselves, but with no success. However, a few years later the Galerie Rive Gauche notified us that they had acquired an excellent Hayden, his *Mandolin Player* from 1920 (fig. 59). It was not a still life, but nevertheless a good painting. Although we knew little about it, we liked it and bought it, but continued to look for a still life.

To our surprise, one of our friends in Paris told us she knew Hayden very well (she, like Hayden, was Polish) and would be glad to take us to visit him and ask the whereabouts of his early works. Hayden was quite weak but was still painting. His new work was colorful and pleasant but seemed feeble in its attempt to recapture his better days. It was difficult for us to depart without hurting his feelings, but we could not pretend that we wanted to buy anything he showed us.

We informed him that we had just bought his *Mandolin Player,* however, and this pleased him very much. He told us that one day he had been working on his well-known *Three Musicians* of 1919–20 (fig. 60), when Picasso came to visit him. Seeing the painting, Picasso became very excited about it and said, "I will do one on the same

theme, only mine will be better" (fig. 61). But Hayden explained, "I then decided to do my *Three Musicians* over again in three separate panels, and it is one of these panels that you have bought. Picasso was wrong," he added, "mine is better."

Many years later Eugene Thaw offered us the second of the three panels, but for some insane reason we didn't act quickly enough. By the time we went to see the painting, it had already been sold to a South American collector.

Joseph Csaky

When we were in Paris in the mid-1950s, Claire Guilbert took us to the home of one of her friends who had some works to sell. The Scheuers were with us, and Linda bought a small bronze sculpture. But the only thing that really interested us was a very small Cubist oil by an artist we had never heard of, Joseph Csaky. We fell in love with this pure Cubist painting, but alas, it was not for sale. A few days later, all four of us went to the Hôtel Drouot, where Linda Scheuer spotted another Csaky, a tiny Cubist drawing. Recognizing the name, she left a bid for the next day's auction, and in due time was notified that the work was hers at a very modest price.

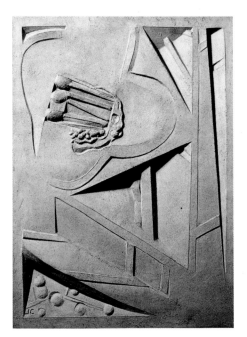

Fig. 62. Joseph Csaky
French, born Hungary,
1888–1971
The Flower, 1920
Stone, 18½ x 13½"
(47 x 34.3 cm)
Provenance: Acquired from the artist by Herbert and Nannette Rothschild, 1956
Private collection

These two experiences made us curious about the man and his work, and we began to make inquiries about him. We learned that he had been a very promising Hungarian artist in Paris before World War I, but after his service in the war, he turned largely to relief sculpture. In the hope of finding some of his early work still with him, we sought him out in his Paris studio. He was less dynamic than we had hoped, and his current sculptures looked more like the cemetery monuments that he was hacking out to support himself than the subtle but strong Cubist endeavors of his earlier career.

We bought from him an etching of a head and a pencil sketch of a figure, both from 1914, and a very del-

icate but sturdy stone relief entitled *The Flower,* from 1920 (fig. 62). But that was all he had to show us. There was, however, a pre-World War I stone sculpture in the possession of the National Museum of Modern Art in Paris to which he had the right to have casts made, and he agreed to let us buy one of these casts if we wished. We arranged through Claire and Jean Cassou, curator of the museum, to view the sculpture, which was in storage at the time. It was large and bulky, and although it was a good Cubist piece, we had some doubts as to whether it would be as effective in bronze as it was in the stone original. And so, to his disappointment (and our regret), we decided against it.

We continued to look for his early work, some of which was in Holland, but it seemed that it was mostly in museums and not for sale in galleries. As we looked back on the sums we paid for the pieces we bought—five dollars, fifty-five dollars—they seemed pitifully small. We would almost have wanted to double them, but one could not offend this elderly man. At the same time, we did not wish to burden ourselves with the casting and importing of his sculpture, with all of the difficulties of inspection, customs, and crating that accompanied the shipping of so bulky a piece.

Fernand Léger

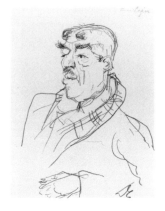

Although we were very much interested in Léger's work, his oils had already reached a price bracket that seemed too high for us. But Claire Guilbert knew Léger and offered to take us to visit him in his studio, which made us all the more eager to buy something from him. His studio was located in quite an ordinary-looking apartment building, but we had the impression that it was two or three stories high, and it had a balcony running around it, reached by a spiral staircase.

Léger was tall and thickset with a ruddy complexion and an open, frank countenance. One could easily imagine him as a cattle

Fig. 64. Fernand Léger
French, 1881–1955
Samovar, 1952
Gouache and pencil on paper,
19¼ x 24½" (48.9 x 62.2 cm)
Provenance: Acquired from the
artist by Herbert and Nannette
Rothschild, 1953; Judith
Rothschild
Waddington Galleries, London

merchant in the north. When we arrived he was at work on sketches for what appeared to be murals; two, on easels before him, had squares marked out on them. We asked what they were, but he waved the question aside and would not answer. He knew very little English, and with our halting French, it was necessary to get to the point at once. We asked if he had anything that he was willing to sell. He laughed and said, "Anything you want," waving his hands to include everything in the studio—mostly canvases facing the wall. We pretended that we would buy them without seeing them, and would just discuss prices. This idea intrigued him, and he again gave one of his resounding laughs. He explained, however, that all his oils were promised in advance to his dealer and he could not even show them to us. But he said that he had some sketches, and if we would excuse him while he went on working, we could look at these at our leisure. We thought this showed great tact because from our past experiences in artists' studios, we had always dreaded the embarrassing moment when the artist offered to sell us something that we did not want to buy.

From two tall, French bread baskets containing carefully rolled works on paper, we finally chose three pieces: the pencil sketch

The Reminiscences of Nannette F. Rothschild

Two Nudes (pl. 42),[*] the gouache sketch for *The Builders* (pl. 45), and the gouache *Samovar* (fig. 64). This last work set him off reminiscing. In 1952 he had been in the south of France learning how to coordinate his designs for murals with the techniques of ceramics. One day his new wife Nadia, a Russian, was cleaning her samovar and had all the pieces laid out on a table to dry. Léger was intrigued and begged her to leave them for him to play with before putting the samovar together again. He sketched the pieces on the table, and the resulting gouache, which he squared off, was intended to be made into a huge ceramic mural. It was never carried out, but the colorful study seems to be more than worthwhile in its own right.

When we later went to Biot to visit the pottery works, we bought Léger's ceramic *Head with One Hand* of 1952 (pl. 41), a unique piece, not one of a series.

A Swiss Interlude

It was in 1953 or 1954 that we went to England and Denmark, ultimately hoping to meet the Winstons in Milan. They had gone from Paris to Switzerland, and before we left Copenhagen, they called to urge us to make time for a short stay in Switzerland. They had found their visits to important collectors there so rewarding that they wanted us to enjoy similar experiences. When we protested that we had no contacts there and would not know where to go, they explained that they had met someone by chance who had steered them in the right direction, and this individual would be willing to give us similar guidance. They had left our name with him and told him to expect our phone call.

With all obstacles removed, it was too alluring to resist, so we changed our plans and flew to Zurich, and stayed at the Hotel Dolder

[*] Judith Rothschild was told a somewhat different version of how her parents acquired *Two Nudes*: The Rothschilds "visited Léger in Paris and bought a gouache from him. As they were leaving, my father said, 'But we still have not got a drawing for Judith.' Whereupon Léger brusquely waved towards a box full of rolls of drawings. 'Well, just take one of those on your way out.' Embarrassed, they grabbed a roll, having no idea what was inside until they opened it excitedly outside on the Paris sidewalk." From Provincetown (Massachusetts) Art Association and Museum, *By Gift or Exchange: From the Collection of Judith Rothschild* (July 1–28, 1983), no. 27.

Fig. 65. Guro, Daloa region,
Ivory Coast
Animal Mask
Wood, height 21½" (53.3 cm)
Provenance: Emile Störrer,
Zurich; Herbert and Nannette
Rothschild, 1953 or 1954; Judith
Rothschild
Portland (Maine) Museum of Art.
Gift of Judith Rothschild

Grand on the top of the mountain, reachable from Zurich only by cable car. We had barely arrived when Dr. Hans Curjel telephoned to say that he was anxious to meet us and help us on our way. We had dinner with him in a restaurant hung with beautiful modern paintings. He pointed out the table where James Joyce always sat, and told us many stories of the celebrities he knew so well.

He explained that Switzerland had many avid collectors of modern art, most of whom knew each other well and shared the desire to welcome foreign visitors into their homes to view their collections quite informally. He urged us not to hesitate to avail ourselves of this hospitality, and gave us a list of people to telephone. We found Curjel's advice to be excellent and felt that we had made a friend. For some years after the meeting, we continued to correspond with him.

We soon learned that only one of the names he gave us was necessary, for each collector whom we visited eagerly passed us along to the next. One of our first visits in Zurich was to the home of the art historian Carola Giedion-Welcker (her husband, the architectural historian Sigfried Giedion, was at Harvard at the time). Mme Giedion-Welcker then suggested that we visit Richard P. Löhse, who, as an architect, decorator, and editor of the magazine *Bauen + Wohen,* had a permanent exhibition of home furnishings in Zurich and would have much in common with Herbert. He, in turn, suggested we visit the sculptor Max Bill, who lived in the suburbs in a delightful modern house. We found his works very interesting and tempting, but we were staggered at the prices he quoted us and had to leave without buying anything. In discussing our African sculpture, he suggested we seek out Emile Störrer, who spent months of each year in Africa searching for old pieces. Since he spoke several native tongues, he often found family pieces in outlying districts that would not be accessible to ordinary dealers. We found our way to him and were able to make some beautiful purchases (fig. 65).

We were ultimately put in touch with Marguerite Hagenbach, who was then acting as secretary and companion to Hans Arp. Her collection was very exciting, as she had acquired so many early pieces through Arp. It was she who telephoned Hermann Rupf in Bern and

The Reminiscences of Nannette F. Rothschild

Fig. 66. Hermann and Margrit Rupf in their home in Bern in the 1950s, with works by Kandinsky, Léger, Braque, Laurens, and Gris. Photograph by Kurt Blum. Kunstmuseum, Bern

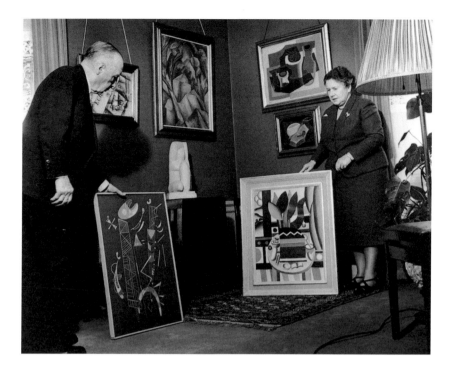

asked him to receive us. He urged us to come for lunch, saying he would take the day off from his business in order to be there when we arrived. Luckily we had declined the luncheon invitation, for when we arrived we found that Mme Rupf was ill with the flu, and more than a short visit would have been an embarrassment to us.

Herr Rupf greeted us at the door and then led us from room to room, showing us a staggering collection of works by Picasso, Braque, and Gris, among others. He then told us how he had acquired his first Picasso. As a young man, he had been working in the family's haberdashery business, and buying for this shop took him to Paris once a month. On one of these visits, he met by chance an old friend, Daniel-Henry Kahnweiler. Kahnweiler told Rupf of his parents' efforts to keep him in the banking business, but that he preferred the world of modern art. The much-interested Rupf, whose train was leaving in a short time, hurriedly explained to Kahnweiler that it was his custom to bring his wife a gift from each of his trips, but he had yet to buy her one this time. Kahnweiler said, "Why not buy a painting by one of my struggling young artists as a gift? You'll be helping one of them and maybe you will learn to like better what I like in modern art." Rupf consented and they hurried to Picasso's studio, where the artist was of course

Encounters with Modern Art

delighted to make a sale. Rupf then hurried away to make his train. By the next month, he and his wife Margrit had grown to like the painting so much, without a single clue as to its meaning, that they were determined to have another. In succeeding months, Rupf returned to Kahnweiler and made a purchase each time. Kahnweiler felt he ought to share Picasso's good fortune with his colleagues, and managed at Rupf's next visit to have a few works by Braque to show him, and later by Gris. It then became a regular procedure, with Rupf alternating the artists whose works he acquired from month to month.[*]

The collection we saw on Rupf's walls was a result of his unusual sensitivity and courage in embracing so completely the new art form. We can never forget the wealth of Gris paintings in the dining room, though the whole house was a treasure trove. In his enthusiasm, Herr Rupf took us into his wife's bedroom to see the wonderful Picassos there, only telling us later, to our great distress, that he had asked her to get out of her sick bed and rest in an adjoining room so that we need not miss the paintings that he loved so much and loved to show. The whole collection has since been given to the Kunstmuseum in Bern as a national trust.

Giacomo Balla

We brought Balla's little postcard-size *Abstract Speed* (pl. 3) to Judith as a souvenir from Milan in 1954. It seemed to contain the "lines of force" of a much larger Futurist painting. Like the picture of a motorcyclist from the Toninelli collection that escaped us, it is fiercely concentrated.

Our ten Balla drawings, dated between 1913 and 1919 (pls. 4 a–j), were bought at the suggestion of Alfred Barr at the Museum of Modern

[*] This is a somewhat romanticized version of the relationship between Kahnweiler and Rupf, but its spirit is true to the facts. Kahnweiler and Rupf had met in 1901, when they worked together in Frankfurt, and remained close friends in the following years when they were in Paris together, until Rupf returned to Switzerland in 1905. Kahnweiler opened his gallery in Paris in 1907, and Rupf was his first client. His first purchases were works by the Fauves, but he and Kahnweiler seem to have visited Picasso's studio together, and Rupf bought his first Picasso from the artist in 1907 or 1908. Rupf acquired a good part of his collection from Kahnweiler on his visits to Paris, but not so regularly as a painting a month. See Kunstmuseum Bern, *Hermann und Margrit Rupf-Stiftung* (Bern, 1969) and Pierre Assouline, *An Artful Life: A Biography of D. H. Kahnweiler, 1884–1979* (New York, 1988).

The Reminiscences of Nannette F. Rothschild

Fig. 67. Giacomo Balla
Italian, 1871–1958
Portfolio, after 1919
Cardboard, 13 x 17¹⁄₁₆"
(33 x 43.3 cm) (closed)
The Judith Rothschild
Foundation, New York

Art. They are part of a portfolio whose handmade and hand-lettered cover, entitled *Balla Futurista*, we have (fig. 67). It had originally also contained other drawings from the series, which we tried to locate. Some were with private collectors who would not sell, and even with Alfred Barr's help we were unable to complete the set. Alfred more than hinted, however, that the museum would be interested in having the portfolio if we were ever willing to make it a gift, but we made no promise. The sheets on which the drawings are mounted are 12⅝ by 16½ inches, but the compositions themselves are barely half that size. The way in which some of them broke with tradition as they burst through their borders onto the wide margins of the paper mounts shows them to be dramatically ahead of their time. Their titles are equally intriguing: *Vortex of an Automobile, Lines of Speed, Forces of a Caproni Airplane, Soft Expansion, Rhythm of Spring Fountain, Autumnal Decay, Lines of a Landscape, Interpenetration,* and *Sea Wind.*

Wassily Kandinsky

By chance in 1951 we came upon Kandinsky's *Improvisation 8* (fig. 69) at the Sidney Janis Gallery, where we were told it had been taken in on consignment from a seller whose name could not be disclosed. We must have owned the painting for eight years at least, when on a visit to Paris, Claire Guilbert asked us whether we would like to visit Nina Kandinsky with the idea of making a purchase. We were by this time sufficiently familiar with Kandinsky's work that we favored certain periods, and for quite a while had been searching for examples of his earlier work.

In fact, we had just returned from Copenhagen, where we had heard of an important Kandinsky oil painting that was for sale. We had had to make a journey to the warehouse of an auction gallery, where down

Fig. 68. Benedikt F. Dolbin
Wassily Kandinsky, 1929
Pencil on paper, 9½ x 7½"
(24.1 x 19 cm)
Provenance: Rose Fried Gallery,
New York; Herbert and
Nannette Rothschild, 1957;
Judith Rothschild
The Judith Rothschild
Foundation, New York

Encounters with Modern Art

Fig. 69. Wassily Kandinsky
Russian, 1866–1944
Improvisation 8, 1909
Oil on canvas, 48½ x 30½"
(123.2 x 77.5 cm)
Provenance: Richard Blümner,
Berlin; Kinkei Munakata,
Fukushima; Sidney Janis
Gallery, New York; Herbert and
Nannette Rothschild, 1951;
private collection
Private collection, Germany

in the basement, the painting was found and shown to us. It was in very poor condition, having been one of a number of pieces smuggled out of Germany just before the war. Still, it was magnificent, and we put our heads together to figure out how much we could afford to offer for it. We were warned, however, that there would be a delay in responding to our offer because of litigation over its ownership. Without recounting all the ensuing complications, this ended with the decision by the Danish government that the painting could not be sold to us but would have to be returned to Germany, where it would be offered for sale.

With this experience fresh in our minds, our offer still open but many doubts as to whether it would be accepted, we were glad to visit Mme Kandinsky in hope of finding an alternative oil. She was extremely cordial and hospitable but rather disinclined to admit the existence of any of her husband's works except those done in the years after he had married her. She showed us many examples of his later work, but none that we felt justified the prices she was quoting, which were very high in light of that year's market.

When we told her that we owned *Improvisation 8,* she asked if we would like to see Kandinsky's "house book," which we, of course, considered a privilege. She got out the neatly kept volumes in order to locate our painting, and there was the record very clearly with a 1909 date. (In spite of this, Danny Robbins thought that 1910 was its probable date.)* We made note of the fact that the sale had been made by Kandinsky to a Mr. K. Munakata of Tokyo, since Sidney Janis had not been allowed to tell us this.

Upon our return to New York, when the Scheuers were visiting us, we told them of seeing Mme Kandinsky and the opportunity we had to learn the name of the original owner of our painting. When we

* The painting itself is dated 1909, but in the 1966 Rothschild exhibition catalogue (no. 68) Robbins argued for a date of 1910 based on the sequence of the work in the house book and the fact that Kandinsky sometimes signed his works long after they were completed.

The Reminiscences of Nannette F. Rothschild

mentioned Munakata, Sidney Scheuer jumped from his chair. Munakata was in the textile business, and Sidney, who had financial dealings in textiles, knew him intimately. Some years back Munakata had notified Sidney that he needed money to pay for his son's tuition at Harvard, and had a very fine painting by Kandinsky that perhaps Sidney would want to buy. Sidney advised him to take it to a New York dealer, who could probably get more for it than he would be prepared to pay, and thus the painting had gone to Janis. It seemed strange to us that the Scheuers had seen the painting in our house all these years and this coincidence had never come to light.

As general interest in Kandinsky grew, and prices increased accordingly over time, anything we might have bought from Mme Kandinsky that afternoon would be considered inexpensive now. Yet as far as our own tastes were concerned, it was still the early period of his work that interested us most, so we had no regrets about leaving empty-handed.

Sonia Delaunay

We went to visit Sonia Delaunay in Paris with the Scheuers, partly in order to meet her and partly to buy some of her husband's works. She was tall, well built, and sturdy, with a surprising vigor for her over seventy years. Her mind and spirit were as young as her step. She received us very graciously, and we soon found that we had much in common. She spoke with impatience of the flabbiness of the work of some of the young artists, but told us at the same time of many disciplined and forward-moving people whom she was helping to establish in the Paris art world.

Her apartment was a duplex in an old section of Paris, where as is customary, the dingy outside of the building belied the beautiful

Fig. 70. Sonia Delaunay in her apartment on the rue Saint Simon, Paris, about 1974. Photograph by Elaine Lustig Cohen

Encounters with Modern Art

Fig. 71. Robert Delaunay
French, 1885–1941
Merry-Go-Round with Pigs, 1922
Watercolor on paper mounted on
canvas, 31 x 28½" (78.7 x 72.4 cm)
Provenance: Sonia Delaunay,
Paris; Herbert and Nannette
Rothschild, before 1956; Judith
Rothschild

interior. The rooms were painted a severe white, punctuated, of course, by many of their paintings as well as by beautiful plants, all extremely well cared for. The hall had a white iron spiral staircase leading to the upper floors, and one hallway was devoted to shelving on which stood row upon row of perfectly bound and labeled files containing their documents. It was easy to see that Mme Delaunay had all the materials concerning their two careers well in hand.

There were no oils of Robert's available, since by arrangement they were all sold through the Galerie Bing. But we were able to buy a wax on paper, *Portuguese Still Life* (pl. 15), and a water-color on paper, *Merry-Go-Round with Pigs* (fig. 71), both studies for large oils that are in the National Museum of Modern Art in Paris. We looked at some of her work, but didn't buy any at that time, although we since acquired a very early collage (pl. 16), which we immediately gave to Judith, and some prints (pls. 18, 19). We never returned to Paris without going to visit her, and after Bob and Maurine called on her at our request in the late 1960s, they reported that she was still painting and still at the center of a group of young painters.

Yaacov Agam

In the early 1950s, we began visiting the Galerie Denise René in Paris, situated on an upper floor on the rue la Boétie. It seemed to us that the gallery's artists belonged to the progressive group of younger painters and sculptors who were still tied to "structure" and not off on the new Abstract Expressionist tangent. Denise René searched out young and lesser-known talents and courageously made heavy invest-ments in promoting them. Partly because of her sound artistic judg-ment, and partly because of her reputation for sagacity and honesty,

The Reminiscences of Nannette F. Rothschild

the sponsorship of her gallery launched her artists from a good springboard.

We, too, came to regard her judgment very highly, and to respect her as a sturdy, forthright person. Diminutive in size, she had overcome unbelievable adversities during the German occupation of Paris, which could only have been expected from a giant. Her brothers distributed an underground newspaper, and their group decided that her apartment (which after the war became her gallery) would be a "safe" place in which to operate, although the area was filled with German occupants and the German propaganda offices were across the street. To her horror, the propaganda offices took over the lower floors of her building. She, of course, expected that the distribution activities would have to be moved, but the underground cell decided that this location was providential; surely the Germans would never think anyone would have the audacity to carry on so close to their quarters. Imagine her frame of mind every day when she returned to her apartment, not knowing what might have occurred, always in fear that she would be arrested! This went on, day after day, for years, seemingly without end, and the Resistance activities were never discovered.* She went in and out, continuing with her affairs unmolested until the liberation.

Among the first purchases we made from her were two small painted reliefs on wood by Agam. These were "hard edge" paintings, done on blocks of wood cut to leave vertical corrugations on the surface. On one relief (fig. 72), the sides and front of the corrugations are painted in such a way that as one walks past, the design that is apparent from one angle gradually changes to become quite another painting from the other side. As a variation on this idea, the other relief is painted on both sides of a panel and suspended in a shadow-box frame by a taut nylon cord strung so that the motion of the air causes it to revolve and reveal its changing aspects. This is really a kind of trick. The reliefs reminded us of advertisements that used to appear in our

* According to Denis René, her apartment was used in 1943 for a meeting of the leaders of the Resistance, including André Malraux, Georges Bidault, Jean-Paul Sartre, and d'Astier de la Vigerie, at which they prepared for the Normandy landing.

Encounters with Modern Art

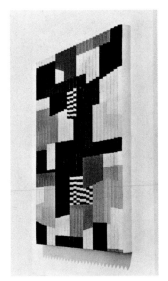

Fig. 72. Yaacov Agam
Israeli, born 1928
Plastic Games (three views),
1956
Oil on wood, 13¼ x 11¼"
(33.7 x 28.6 cm)
Provenance: Galerie Denise
René, Paris; Herbert and
Nannette Rothschild, 1958
Private collection

childhood early in the century in trains on the Sixth Avenue El. I can
remember walking through the cars and being fascinated by these ads
—I have forgotten if they advertised Sapolio or Herpicide (a hair dress-
ing)—in which picture and text changed as you walked past. In spite of
this association, we felt that there was a dynamism and a gaiety to the
works that would lighten our rather austere Cubist preoccupation.

Agam at that time was an unknown, but even then we found
him very difficult to deal with. When we bought the paintings in 1958,
we promised to let him keep them until the next year, when they would
be returned to us from several exhibitions to which they had already
been promised. When the time came, however, he was reluctant to give
them up, and although they had long since been paid for, it took grim
determination from Denise René to have them delivered to us.

After his early shows at the Galerie Denise René, Agam
became extremely popular. He blew up his works to museum size,
some over twenty feet in length, and was collected and exhibited by
museums all over the world. He may well have forgotten our poor little
$400 pieces, which nevertheless we felt represented him as completely
as did his huge compositions. They had the added advantage of being
"hangable" and proportional in size and importance to the people who
look at them.

The Reminiscences of Nannette F. Rothschild

Jean (Hans) Arp

In the mid-1950s the Rose Fried Gallery offered us Arp's *Shell Cloud I* (fig. 73). It was a wood relief done in one of his "biologic" forms— either a shell or a cloud—with cutout areas of similar shapes. Done about 1936, the relief was painted white but was somewhat soiled, and the wood had a number of cracks in it. At first Herbert was wary of the cracks, lest they expand and destroy the sculpture, but upon examining it further he decided that this was unlikely.

We bought it for Judith for $1,200, and that same year acquired the black granite *Mirr* (fig. 74), also from Rose Fried, for $2,000. When Judith and Tony returned from California in 1958, they took only the wood relief, and hung it prominently in their living room. One evening they were entertaining a group of people that included the painter Leland Bell.* When he saw the Arp on the wall he became very much excited, exclaiming, "Where did you get that? It's mine! I won't have you hanging my Arp in your home!" All efforts to calm him were in vain. He demanded that they remove it from the wall and give it to him. When they refused to do this, he and Tony almost came to blows. Tony finally ordered him to leave the apartment, and much to everyone's embarrassment, they nearly had to force him out.

Upon hearing of this, we went back to Rose Fried to question her about the ownership of the piece. We had known that it had come from the collection of Richard Huelsenbeck, one of the founders of Dada, who had been a close friend of Arp's in Europe. Huelsenbeck was living in this country, but at that time was out of town. All Rose could recall of the circumstances was that the relief had been a gift from Arp in Switzerland. We decided to write to Arp himself at once, and there ensued a correspondence with him through Marguerite Hagenbach. Arp seemed to take the whole situation rather casually. He advised us just to hold onto the piece, and said he would get in touch with us so we could discuss it further in October, when he was

* Leland Bell (1922–1991), a figurative painter, was one of the original faculty of the New York Studio School and showed in New York from 1964 at the Schoelkopf Gallery.

Encounters with Modern Art

coming to New York for the opening of his retrospective at the Museum of Modern Art.

Meanwhile, we heard from several sources that Leland Bell was in a stormy mood, not only about the Arp, but about other circumstances in the art world as well. So when James Thrall Soby approached us for the loan of our Arps for the show at the Modern, we decided it would be wiser not to exhibit *Shell Cloud I* at all. We explained to Alfred Barr and to Soby that we would rather go back on our promise to lend the piece than risk having Bell make a scene at the museum when he saw it hanging there. Barr was very much relieved, and told us that his secretary had received several somewhat irrational telephone calls from Bell, including threats to disrupt Arp's opening if certain pieces were displayed. At the time they had not known what he was referring to, but were dreading his appearance at the opening. It was a matter of some gratification to them that if this were the only piece he was concerned about, they would be able to avoid an unpleasant scene.

A few days after the opening we received a call from Marguerite Hagenbach asking us to come to their hotel and bring the wood relief with us. As soon as Arp saw it, he laughed and said he recalled the entire circumstances surrounding it. The story he told us was this: Leland Bell had bought the relief from him, I think he said in Meudon. A few years later, Bell had written to tell Arp that the relief was splitting and would soon be of little value; for him, he said, the crack destroyed the purity of the piece. Not knowing whether Bell wanted to choose another piece or merely wanted a refund, Arp continued an exchange of letters with him that ended with the agreement that Arp would duplicate the piece if Bell sent it to him to copy. As he had done originally, Arp made a tracing of its outline from a template, then reproduced the piece with his own hand and sent it back to Bell. However, Arp still liked the original, and feeling that the crack did not interfere with its aesthetics, he hung it on the wall of his

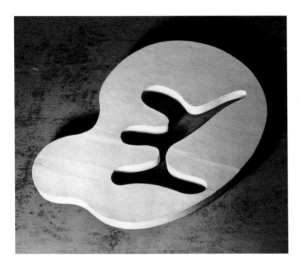

Fig. 73. Jean (Hans) Arp
French, 1887–1966
Shell Cloud I, c. 1936
Painted wood, length 21"
(53.3 cm)
Provenance: Acquired from the artist by Leland Bell; returned to the artist; gift of the artist to Richard Huelsenbeck; Rose Fried Gallery, New York; Herbert and Nannette Rothschild, 1957; Judith Rothschild
IVAM Centre Julio Gonzalez, Valencia

The Reminiscences of Nannette F. Rothschild

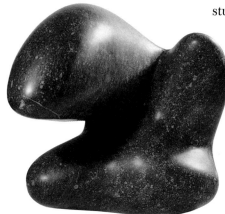

Fig. 74. Jean (Hans) Arp
Mirr, 1949–50
Granite, height 13½" (34.3 cm)
Provenance: Rose Fried Gallery,
New York; Herbert and
Nannette Rothschild, 1957;
Judith Rothschild

studio, where it remained for a long time. One day when Huelsenbeck was visiting Arp he admired it, and the artist offered it to him. Huelsenbeck was delighted and brought the sculpture with him to America.

We found ourselves asking, who was in the wrong? We were innocent, Rose Fried was innocent, and Huelsenbeck was innocent. Even Bell was innocent, actually, having assumed that the piece he ended up with was unique. This left only Arp as the guilty party. But we must say in his defense that he took it all very lightly, pointing out that both versions had been done entirely by him, and as there were always variations in the work of an artist's hand, two pieces could never actually be identical. "So," said Arp, "Let us consider Bell's piece, which I made, and he accepted and was satisfied with, as now having a life of its own. And let us regard yours as an earlier piece, which Bell had and no longer wanted because of the crack. The crack in itself makes it different from his. Therefore I consider both pieces to be unique. It is not unusual for an artist to do two or three or five studies on the same theme. However, for your sake, I would like to sign and number your piece." So saying, he took the piece, signed it on the back, and numbered it "I." He also suggested that he sign a photograph of it for the record.

Arp was gay and jovial and urged us to come and visit him when we were in France. He was appreciative of our judgment in removing the work from the retrospective, as a confrontation with Bell would have been extremely unpleasant for him as well. We did visit him once at Meudon, and had a very pleasant tour of his beautiful home, workshop, and studio. We saw many works by his late wife Sophie Taeuber-Arp, and expressed some interest in buying one. He shook his head, and said he was not yet prepared to sell any of them, but someday maybe he would. We also told him that we had bought several of his lithographs in Paris as presents for our grandchildren. He immediately went to a file drawer, took out a small lithograph, and signed it, saying, "This is for your oldest grandchild." We received a Christmas card from him every year thereafter until his death in 1966.

Fig. 75. Jean (Hans) Arp
Christmas card, c. 1962
Silkscreen, 6⅝ x 7"
(16.8 x 17.8 cm)
Provenance: Gift of the artist to
Herbert and Nannette
Rothschild, c. 1962; Judith
Rothschild
The Judith Rothschild
Foundation, New York

Encounters with Modern Art

Umberto Boccioni

In 1958 we were having an aperitif at the Café Deux Magots in Paris when we were joined by our friends the dealers Daniel and Eleanor Saidenberg, who brought us the startling news of a serious fire at the Museum of Modern Art in New York. There had been some destruction, worst of all such severe damage to the great Boccioni painting *The City Rises* that restoration seemed hopeless. They told us also of our beloved Alfred Barr's heroism in rescuing people and paintings. We knew how he treasured their Boccioni, so we decided, when we got back to our hotel, to cable him our sympathy and our promise to give our Boccioni painting, *The Laugh* (pl. 5), to the museum at once. While it could not replace *The City Rises,* it might at least be a consolation. The enthusiasm was not to be imagined! We were bombarded with letters of thanks, as much for our spontaneity as for the gift itself.

Fig. 76. Umberto Boccioni
Italian, 1882–1916
Study for *The Laugh*, 1910–11
Pencil on paper, 5 x 8⅛"
(12.7 x 20.7 cm)
Provenance: Mrs. Stanley
Branden Kearl; Herbert and
Nannette Rothschild, 1962
The Museum of Modern Art,
New York. Gift of Herbert and
Nannette Rothschild

The painting's history is vague. Legend has it that when the original version was displayed in a gallery, it had so angered a visitor that he had slashed it beyond repair.* Apparently Boccioni then painted a second version, which is the one we bought. Subsequently, the museum's curator of prints, Bill Lieberman, came across a small pencil sketch for the lost version of *The Laugh* (fig. 76), which we gladly bought and gave to the museum. (Soon after, we bought a second small pencil sketch that seemed relevant and also gave it to the museum.) Can either of the sketches help to establish the facts about this painting free from the hearsay that surrounds it?

* It is now thought that the painting, rather than having been slashed, was hung in the gallery while still wet, and smeared by an audacious visitor who was trying to make a point about "artistic freedom"; see Ester Coen, *Umberto Boccioni* (New York, 1988), p. 107.

The Reminiscences of Nannette F. Rothschild

Karl Knaths

Angie Myrer, Judith's mother-in-law, had known Knaths on Cape Cod, where she had a house, and their families had become very good friends. Judith was more or less "adopted" by Karl, who I gather treated her alternately as a daughter and as a trusted colleague. She had great respect for Knaths as a painter. This influenced us to buy *Dusk* (fig. 77), a very lyrical piece painted in 1954–55, from the Rosenberg gallery. Yet Judith didn't completely approve of it as our only Knaths because she felt it lacked the virility of some of his best work. Accordingly, when she recommended *Spearing Eel* of 1960 (fig. 78) as a strong piece that was worthy of his highest aspirations, we bought it.

Fig. 77. Karl Knaths
American, 1891–1971
Dusk, 1954–55
Oil on canvas, 36 x 50"
(91.4 x 127 cm)
Provenance: Paul Rosenberg &
Co., New York; Herbert and
Nannette Rothschild, 1955;
Judith Rothschild
Portland (Maine) Museum of Art.
Gift of Judith Rothschild

Fig. 78. Karl Knaths
Spearing Eel, 1960
Oil on canvas, 36 x 42"
(91.4 x 106.7 cm)
Provenance: Paul Rosenberg &
Co., New York; Herbert and
Nannette Rothschild, 1961;
Judith Rothschild
The Judith Rothschild
Foundation, New York

Gyula Kosice

In 1958 we saw the sculpture of Kosice at the Galerie Denise René in Paris. We were very much interested in this young Argentinean, whom we had met earlier at the home of the artist and critic Michel Seuphor. Kosice and some other young artists in Buenos Aires had founded the Madí movement. Madí exhibitions were held in South America and in Paris, and Kosice became the editor of a review called *Madí Universal.* We were very taken with his work, with its Cubist preoccupations of tension and space and its use of contrasting materials such as wood, metal, and plexiglass. We bought three pieces, including his 1957 *Homage to a Satellite*, which Kosice proudly announced had actually been executed before the launching of Russia's *Sputnik.*

We shall never forget his exuberant gesture of farewell to us as we left Paris. He was so happy to have three pieces going to America that, just as the boat train was pulling out of the station, he jumped aboard with a huge bouquet of flowers, threw them in my lap, and leaped off the already fast-moving train, leaving us quite breathless with fear.

In 1965 he came to New York with a collection of his pieces and had several offers for one-man exhibitions. But he was unable to decide which to accept, and in the meantime set up his works in a hotel suite. His English was very scant, and he fell into the hands of an enthusiastic but rather unstable admirer, who undertook to sign contracts for the artist without his knowledge, thereby creating very difficult situations for him. We enlisted the aid of a lawyer with much experience in the art world who was able to extricate him from this situation. It was in gratitude for our helping to save him from this man that Kosice gave us the little drawing by Le Corbusier (fig. 80), which had been a gift from Le Corbusier himself.

Kosice was thus able to start with a clean slate and arranged for a show at the Terry Dintenfass gallery. When his early works had been launched by Denise René in the 1950s, they sold for modest prices, generally ranging from $175 to $300, but by 1965 his prices had advanced a little. He had begun to represent time and motion in his

Fig. 79. Gyula Kosice
Argentinean, born 1924
Hydraulic Relief, 1964
Aluminum, plexiglass, and water,
27½ x 39½" (69.9 x 100.3 cm)
Provenance: Terry Dintenfass
Inc., New York; Herbert and
Nannette Rothschild, 1965
Private collection

The Reminiscences of Nannette F. Rothschild

work, and the show included several motorized pieces in which water flowed in broad, waving movements. Some were gravity controlled and some had the added element of color. The hydraulic relief of aluminum and plexiglass that we bought (fig. 79) creates waves as water is drawn by gravity through narrow channels into the large triangular areas of the plexiglass rectangle. This operates simply by turning the plexiglass on its pivot. Kosice confided to us that one couldn't trust American water, so to guard against impurities he filled his pieces with water he had brought with him from Paris.

Le Corbusier

Herbert had been intrigued by the furniture and furnishings designed by Le Corbusier, which we had seen at an exhibition of his architectural work in Switzerland. When we mentioned this to Claire Guilbert, she offered to take us to meet him at his apartment of his own design, which was at the top of a building in Paris.

Le Corbusier was a warm and charming host. He and Herbert immediately began to discuss the lack of discipline in some modern design and the need for a complete shake-up among designers. There was of course some rancor in what he was saying, because as with many pioneers, he felt his work had not been acclaimed as highly as it deserved. However, there was something of resignation in his acceptance of this jealousy and professional prejudice.

Herbert was particularly interested in a little three-legged chair that Le Corbusier had designed, which seemed that it might be a possibility for production and marketing. (Later Herbert decided that its design, though appealing, could not be adopted for practical use.) Throughout our visit we were taken with how he rethought every detail from the point of view of necessity and convenience, beginning again as though the need for them had never existed before. Many of his solutions

Fig. 80. Le Corbusier (Charles-Edouard Jeanneret) French, born Switzerland, 1887–1965
Nestlé, 1920
Pencil and crayon on paper, 7⅞ x 9⅛" (20 x 23.2 cm)
Provenance: Gift of the artist to Gyula Kosice; gift to Herbert and Nannette Rothschild, 1965; Judith Rothschild Collection of Katherine Rothschild Jackson

Encounters with Modern Art

struck us as both original and beautiful. I remember sitting in one of his other chairs that was not more than twelve inches off the floor. The seat was so angled that, besides being comfortable, it was easy to get out of. There were several of these in the room, and because they were so low, Le Corbusier had hung his beautiful modern paintings at the eye-level of the sitters. He had also hung another tier of paintings at the eye-level of those who were standing, which gave the room quite an unusual look (fig. 81).

This was the year of Expo '58 at Brussels, and Le Corbusier told us of a building he had designed for the Philips company, which was to house a continuous film performance that he had created. He felt it was a pioneering effort in the field, and would tell us nothing about it since we were going to Brussels. Unfortunately, when we arrived there soon after the opening of the fair, the pavilion was not yet complete, and, of course, we were unable to see the performance.

Fig. 81. Le Corbusier's apartment, rue Nungesser-et-Coli, Paris, 1931–34
Fondation Le Corbusier, Paris

Victor Vasarely

Vasarely's works were greatly in vogue in the 1950s, and we found ourselves questioning our conservative position about him and thinking that we were being too austere and a bit hidebound in our tastes. So, in an experimental mood when Denise René took us to visit Vasarely in his studio, we bought three pieces—what we were told was an oil on wood, *Vega II* (fig. 82), a gouache composition, and the large oil on canvas *Geometric* (fig. 83). Only the last cost any considerable amount; the others were trifling.

We found all three works amusing rather than deep, so it was not hard to part with the large oil *Geometric* when we were asked to contribute to the benefit auction for the Whitney Museum of American

Fig. 82. Victor Vasarely
French, born Hungary, 1908
Vega II, 1957
Oil on paper mounted on wood, 11 x 15½"
(27.9 x 39.4 cm)
Provenance: Acquired from the artist by Herbert and Nannette Rothschild, 1958
Private collection

The Reminiscences of Nannette F. Rothschild

Fig. 83. Victor Vasarely
Geometric, 1955
Oil on canvas, 42 x 39½"
(106.7 x 100.3 cm)
Provenance: Acquired from the
artist by Herbert and Nannette
Rothschild, 1958; sale Parke-
Bernet, New York, May 11, 1966,
lot 38

Art in 1966. The auction took place on a very stormy night, and coming late in the alphabet, our Vasarely was among the last to be put up. Since people were leaving the auction room in droves in order to get taxis, it went for a very low price, and then we regretted that we had been persuaded to part with it at all.

Vega II was quite a different issue. This was a lovely piece, an oil study Vasarely had made for a large mural that was subsequently installed in a South American building (in Valparaiso, Chile, I believe). But after we had it for a year, we discovered that it had been executed on paper that was glued to the wood, and not painted directly onto the wooden surface. We did have the paper reglued in a more workmanlike fashion. The painting itself was still a good one, but we could never look at it again without feeling a sense of dismay at why the artist had misrepresented it to us.

Antoine Pevsner

Many sculptors found themselves influenced by Cubism, but there were not many artists who contributed a distinct interpretation of volume and space to the Cubist approach. But in our opinion, Pevsner was just such a sculptor. In spite of the controversy over whether it was he or his brother Naum Gabo who had originated Constructivism, we believed that Pevsner had something of his own to say. So in 1958, when Claire Guilbert finally presented us with the opportunity to visit him in his studio, we jumped at the chance. It was the year of his show at the Biennale in Venice, and many of his works had already been taken down for packing and shipment. We were more eager to see his early work, but since he had packed his things in chronological order, we were limited in our choice to what was left hanging.

Pevsner was happy when we proposed buying a work for the United States. We had almost decided on a sculpture that very much interested us—was it called *The Black Lily*? (he often gave his abstract pieces quite realistic names)—when he told us very honestly that this was the only piece he had ever permitted to be reproduced. The cast had been made, but none of the edition had yet been produced from it. He assured us that if we took it and wished to block reproduction, we could do so. However, we felt that as much as we liked it, the existence of the cast and the possibility that someday someone might use it would always be of concern to us, so we regretfully said no. Shortly after Pevsner died, a noted dealer in New York displayed one of the edition and offered it to us as an original. We never learned whether the production took place before or after Pevsner's death, but we were, of course, glad that it was not now our problem.

We ended up buying *Tangential Lines* of 1934–35 (fig. 84) from Pevsner that day, although he would have preferred that we take a piece more typical of his later work. He was still fearful of United States customs despite the decision years before on Brancusi's *Bird in Space.** So in having our sculpture packed for shipment, he carefully and conspicuously titled it "Papillon" (Butterfly). For all the delicacy of its curves, it would take quite a bit of imagination to see a butterfly in this tightly constructed geometric bronze, but customs passed it.

* In *Brancusi v. United States,* November 26, 1928, the court sustained the artist's protest against the U.S. Customs Office, which had refused to grant his abstract *Bird in Space* the duty-free status accorded works of art. Taking the literal view that the sculpture did not look like a bird, customs officials had instead classified the work as "miscellaneous goods," and assessed a 40-percent duty on the work's declared value.

The Reminiscences of Nannette F. Rothschild

Naum Gabo

We bought our Gabo construction (pl. 21) in 1958 at the Rose Fried Gallery. They had acquired it from Harold Diamond, who claimed to have had it direct from Gabo's son in England. A little research, however, turned up Winifred Nicholson as the owner before Diamond. After we had owned the piece for about two years, the plastic band separated from the stone. Reluctant to entrust it to a restorer, we telephoned Gabo in Connecticut for his advice. He couldn't place the work, but asked us to come to his home and bring it with us for his inspection.

When we arrived, Gabo was very cordial and insisted that we come in and get acquainted before bringing the construction in from the car. But later when we showed it to him he became angry, demanding, "Where did you get this? This should never have been sold, it should never have come to this country. I want nothing to do with it." Once his wife succeeded in calming him down, he told us that this was a piece of which he was very fond. He had given it to his son in England * and had admonished him never to dispose of it. After a while Gabo realized that we could have had nothing to do with his son's broken promise, if a promise it was, and that our problem was to have the piece repaired, by his own hand if possible.

Gabo then announced that he would like to have the piece back; he said that if we would give it to him so he could repair it for himself, he would let us select another of his works to replace it. We told him that although we loved it and would like to keep it for our daughter, we might be willing to exchange it if we found one we liked as much. Then the question of price came up, as he was now working on larger sculptures that brought much more than the $2,800 we had paid for ours. Yet we felt that since ours was an earlier piece, from 1933, it had a value because of its uniqueness, while his later constructions made of plastic and plexiglass strung with nylon threads were much more easily duplicated. In the end, however, we did agree to pay whatever difference in price he asked.

* Gabo, who did not have a son, was probably referring to his wife's son Owen Franklin.

Fig. 85. Benedikt F. Dolbin
Naum Gabo, 1929
Pencil on paper, 11 x 8½"
(27.9 x 21.6 cm)
Provenance: Rose Fried Gallery,
New York; Herbert and
Nannette Rothschild, 1957;
Judith Rothschild
The Judith Rothschild
Foundation, New York

We began to look at his sculptures, one more beautiful than the next. Their prices were astronomical, but even so, after displaying each work, Gabo would decide, "No, this must go to a museum!" We assured him that since we planned to give our construction to Judith, who was an abstract artist and an admirer of his work, we could guarantee that she would never sell it and would probably give it to a college museum (as she always felt that teaching museums needed the most support). But all this went nowhere, and as it was getting late, I suggested that we leave the piece with him and let him think over our original plea to have him refasten the plastic to the stone. Meanwhile, we said we would consider separately whether we wished to purchase another of his works. This pleased him very much and we left the piece, although he made no promise to repair it.

The Gabos had expressed great interest in our farm and were eager to see how we lived and how the rest of our collection looked there. We asked them to come for dinner, set a date, and departed, all in good spirits. We recalled how we had been warned not to mention that we owned a work by Pevsner, as this would be like flashing a red flag in front of a bull, and Herbert and I immediately started thinking of where we could hide the Pevsner construction (fig. 84) when they came.

The day before our dinner date, Miriam Gabo telephoned to say that her husband was not feeling well and thought the trip would be too much for him, but wouldn't we come to them? We declined the dinner invitation but said we would come in the afternoon and bring with us one of our capons, which we had planned to have for dinner since Gabo had expressed a curiosity about the taste and an interest in the caponizing process. When we went the next day, Gabo came outside with the box containing our sculpture and said, "You needn't open it, I haven't touched it. I have decided that since my son broke his promise to me and sold it, I will have nothing more to do with it." He put the box in the car and we went in for our visit, which proved

The Reminiscences of Nannette F. Rothschild

to be a pleasant one, although Herbert and I had some misgivings about the unopened box.

We asked Gabo about another purchase, but he said that nothing was for sale except possibly some monoprints. Of these, we chose one, *Opus 5* (pl. 20). Miriam was embarrassed and apologetic, and before the afternoon was over, we sensed that even Gabo felt a little ashamed. When we left, he walked us to the car and said, "Don't forget to invite us again to dinner and then we can talk about a purchase." In spite of this and the very lovely letter Miriam wrote us in appreciation of the capon, we decided not to pursue it any further.

After we left and had driven a short distance from the house, we stopped and opened the box, and were relieved to find our sculpture — not repaired, but none the worse for its stay at the Gabo household. We took the construction to a restorer, who simply glued the plastic back to the stone. Since then the piece has been kept under a transparent plastic dome, protected from dust and curious hands.

Our Exhibition in Providence

There is perhaps a place in these reminiscences for an explanation of how we happened to lend most of the family collection to Pembroke College and the Rhode Island School of Design (RISD) in 1966. It all came about through our connection with Danny Robbins, and the story goes back several years.

In 1962 Wellesley College was having a benefit loan exhibition of paintings owned by alumnae and their families at Wildenstein in New York.[*] Judith was asked to lend, and we agreed to participate. One of the members of the selection committee was Louise Averill Svendsen, who had known Judith at Wellesley and was then curator of education at the Guggenheim Museum. She and the chairman of the committee, Phyllis Bober, from the Institute of Fine Arts, tried to find time to come to the farm to choose the loans. Our schedules conflicted, so the only

[*] Wildenstein, New York, *Masters of Seven Centuries: Paintings and Drawings from the 14th to 20th Century* (March 1–31, 1962).

Fig. 86. Living room and dining room at Old Dam Farm, Kitchawan, New York, 1966

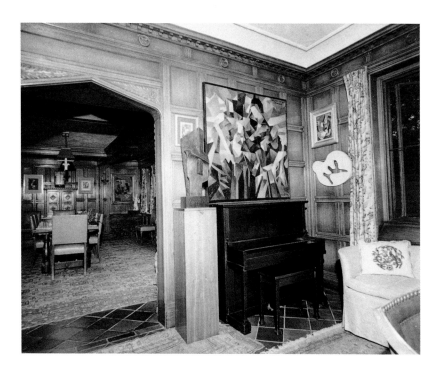

time we could agree upon was for breakfast on a Monday morning at eight o'clock.

Our visitors had trouble deciding which pictures they wanted that morning, but after their choices were made,* they confessed that they had a dilemma. Governor Rockefeller had promised to lend them a Picasso, which was to be one of the backbones of the exhibition. Meanwhile, the Rockefeller divorce had been announced and Mrs. Rockefeller, although a loyal alumna, could not be certain that the governor would agree to lend the picture in her name. If at the last minute it should be withdrawn, Mrs. Svendsen wanted to be assured of another Picasso to take its place, even if it were a less dramatic one. Perhaps it was the informality with which we had walked around the house with our coffee and toast that made us seem as if we were good friends after a very short acquaintance. Mrs. Svendsen felt she could ask if we would promise another painting on a contingency basis. We were pleased to do so with the assurance that we would not be insulted if the Rockefeller promise were ultimately kept—which was precisely what came to pass.**

* The Rothschilds lent two works, no. 49, Mondrian's *Composition with Red, Yellow, and Blue*, 1922 (pl. 61), and no. 57, Picasso's *Nude*, c. 1906-7 (pl. 67).

** The Rockefeller Picasso, no. 59, *Portrait of Dora Maar*, October 9, 1942, was lent anonymously.

The Reminiscences of Nannette F. Rothschild

When this story got about at the Guggenheim Museum, Danny Robbins, who was working as a curator there, expressed a desire to meet us. The farm happened to be near his sister-in-law in Croton, whom he was planning to visit. Before long he came to see us with his wife Genie, and we had a lovely time together as he studied the paintings. He was then preparing for the large retrospective of Albert Gleizes at the Guggenheim, and naturally was intrigued by the works of his that were on our walls. This, then, was the beginning of our friendship with Danny, who was soon after appointed director of the Museum of Art at the Rhode Island School of Design.

This brings us to Pembroke College. In celebration of its seventy-fifth anniversary in 1966, a weekend program of the arts had been planned, but somehow, because of the revolving directorship of the fine arts department, an art exhibition had not been included. Very late in the day, Professor George Downing appealed to Danny for a saving idea. Danny thought of us, recalling that our daughter Barbara was an alumna of Pembroke and that her daughter Alice was then a student there. He telephoned to ask whether we would lend a dozen or so of our paintings in honor of the celebration. We agreed, and in late spring Danny and three members of the Brown art department came to choose the works. At the time the entire family—Bob, Barbara, and Judith—was housing paintings with us, all mixed in with our own (fig. 86), and the professors had trouble deciding on only "a dozen or so." Since Danny had been looking for a project that might engage the Museum of Art and Brown University in a cooperative venture, he suggested that they take them all (or nearly all), and he offered to house in his museum any overflow that the Annmary Brown Memorial could not hold.

At first we were aghast at the idea, but then there was talk of the need for documentation and a catalogue. I saw a chance to keep Herbert, who had had a heart attack the year before and was spending too much time, I thought, at business, very quietly and pleasantly busy at the farm helping to prepare it. Little did either of us realize what we were letting ourselves in for. There was little time to pull the information together, and although we had been very proud of our documen-

Fig. 87. The Herbert and
Nannette Rothschild Collection
exhibited at the Museum of Art,
Rhode Island School of Design,
Providence, 1966

tation and files, we soon saw how many holes there were in our
records. Brown University engaged a researcher to help us, and the
weeks that followed involved thinking, eating, sleeping, and living
nothing else. It was great fun, except for the pressure, and we both
learned a great deal, but it could hardly have been called a restful
holiday from business for Herbert.

It turned out to be a cooperative endeavor for our entire
family. All of us shared the work and responsibility, although little of
the effort that went into our preparation was apparent in the show. To
facilitate identification and handling in Providence, artist names,
correct titles, and dates had to be hand-written on each piece—a job
in itself! Judith also tagged each work in coded color to indicate its
destination in Providence (either Pembroke or RISD) and its location
at home, to simplify the burden of rehanging the paintings once they
were returned to us.

The exhibition, which opened on October 7, 1966, was a great
success from the very beginning. Both Clive Barnes and Hilton
Kramer of the *New York Times* gave it good notices, although we did
find Kramer's exaggerated enthusiasm an embarrassment, calling it, as
he did, "one of the finest privately held collections in this country of
20th century painting and sculpture"*—which it certainly was not!

* *New York Times,* October 7, 1966.

The Reminiscences of Nannette F. Rothschild

Brown University and the School of Design spoke of this enterprise as the first to awaken Providence to an interest in modern art, and they continued to encourage further collaborative art projects between the two institutions.

We settled down after everything was rehung at home with some firm resolutions, none of which was kept: to make and keep current our card-catalogue file; to reorganize and keep our art books up-to-date; to coordinate our files, documents, and correspondence in connection with the paintings for more ready accessibility; and to minimize future loans, since we felt that we had now done our duty to the public. Yet in the wake of the show and its publicity, we were bombarded with more requests for loans than ever, from as far away as Australia and Japan. The insurance problem became more and more complicated, especially when works were to go out of the country. Nevertheless, we did our best to use good judgment in our decisions and often found loan invitations hard to resist.

Fig. 88. Dean Rosemary Pierrel of Pembroke College greets Herbert and Nannette Rothschild at the opening of the Providence exhibition in 1966

Encounters with Modern Art

Catalogue

Jean (Hans) Arp

1887 – 1966

Jean Arp was both artist and poet; he came of age as the Dada movement began, and led a long life of joyful and energetic devotion to the idea of freedom in art. He incorporated chance into the development of his torn-paper collages, poems made of words cut from newspaper, and freely constructed wooden reliefs. Arp's pictorial language shares with his poetry a metamorphic quality in which bird, head, torso, and egg forms mutate into one another. When he later became a sculptor, he brought to plaster and stone the same lightness of touch and whimsical sense of anatomy achieved with humble paper and wood in his earlier work. Born in Strasbourg (then part of Germany), Arp studied in Paris and Weimar, and then moved to Switzerland with his family. In 1916 he designed Hugo Ball's Cabaret Voltaire in Zurich, the birthplace of the Dada movement. He joined in the activities of the Dada artists, and later the Surrealists, with whom he shared a strong belief in collaborative practice. In 1921 he married Sophie Taeuber, a painter and sculptor, who often collaborated with him over the next two decades. Toward the end of the 1920s Arp developed the theme of "Constellations" — biomorphic forms whose relations he claimed to have found by chance. Painted all in white, they were meant to convey the natural harmony and serenity of the cosmic order (pl. 2). *Pieces to Be Arranged According to the Laws of Chance* (pl. 1), the twenty cut-out cardboard forms that Arp gave to Judith Rothschild, could be arranged and rearranged until they, too, constellated into a beautiful relationship, only to be reconfigured again and again. A T

1. Jean (Hans) Arp
Pieces to Be Arranged According to the Laws of Chance, c. 1960–66
Twenty pieces of cardboard, maximum length approximately 2" (5.1 cm) (each)
Provenance: Gift of the artist to Judith Rothschild, by 1966
The Judith Rothschild Foundation, New York

2. Jean (Hans) Arp
White on White (Constellation), 1930
Painted wood, 11½ x 9" (29.2 x 22.9 cm)
Provenance: Rose Fried Gallery, New York; Herbert and Nannette Rothschild, 1954; Judith Rothschild
The Judith Rothschild Foundation, New York

Catalogue

Giacomo Balla

1871 – 1958

Giacomo Balla was the first Italian Futurist painter to practice pure abstraction. He studied painting as a youth in his native city of Turin. Initially working in an indigenous realist manner, Balla taught art in Rome, where his students included Boccioni and Severini. By 1908 he was painting in a Divisionist style based on the separate application of pure colors. This informed Balla's Futurist aesthetic, characterized by a quasi-scientific interest in the optical effects of light and motion. Around 1912, in conjunction with other Futurist painters, he began to experiment with the pictorial means for representing elapsed time. In a series of works that borrow from the visual, sequential language of chronophotography, he "analyzed" various subjects moving through space: the flight of a swallow, the trajectory of an automobile, the passage of the planet Mercury before the sun. By 1913, in paintings and works on paper, Balla had developed his own lyrical abstract style devoted to the principles of velocity, space, and light, now exclusively embodied by luminous colors and arcing lines. Positivist by implication, his philosophy also drew on the esoteric tenets of theosophy, with its reference to the invisible essence of the material world. From the beginning Balla also adapted his abstract motifs to fashion, interior design, and other applied arts. During the 1930s, however, he abandoned Futurist abstraction, which he came to believe was merely decorative, and returned to the realism of his early work. J W

3. Giacomo Balla
Abstract Speed, 1912
Oil on paper mounted on
wood, 5 x 7" (12.7 x 17.8 cm)
Provenance: Galleria d'Arte
del Naviglio, Milan; Herbert
and Nannette Rothschild,
1954; Judith Rothschild
The Judith Rothschild
Foundation, New York

Encounters with Modern Art

4. Giacomo Balla
Portfolio of ten drawings,
12⅝ x 16½" (32 x 42 cm)
(each), except 4 j *(Sea Wind),*
12⅛ x 16⁵⁄₁₆" (30.7 x 41.4 cm)
Provenance: Edwin Bach-
man, New York; Arturo
Schwarz, Milan; Herbert and
Nannette Rothschild, 1959;
Judith Rothschild
The Judith Rothschild
Foundation, New York

4a. Giacomo Balla
Vortex of an Automobile, 1913
Colored pencil on paper
mounted on paper

4b. Giacomo Balla
Lines of Speed, 1914
Pencil and colored pencil
on paper mounted on
paper

4c. Giacomo Balla
Lines of Speed, 1914
Colored pencil on paper
mounted on paper

4d. Giacomo Balla
*Forces of a Caproni
Airplane,* 1915
Pencil and colored pencil
on paper mounted on
paper

4e. Giacomo Balla
Soft Expansion, 1917
Colored pencil on paper
mounted on paper

4f. Giacomo Balla
*Rhythm of Spring
Fountain,* 1917
Pencil and colored pencil
on paper mounted on
paper

4g. Giacomo Balla
Autumnal Decay, 1917
Pencil, colored pencil, and
watercolor on paper
mounted on paper

4h. Giacomo Balla
Lines of a Landscape,
1919
Pencil, colored pencil,
watercolor, and gouache
on paper mounted on
paper

4i. Giacomo Balla
Interpenetration, 1919
Colored pencil on paper
mounted on paper

4j. Giacomo Balla
Sea Wind, 1919
Colored pencil,
watercolor, and
gouache on paper
mounted on
paper

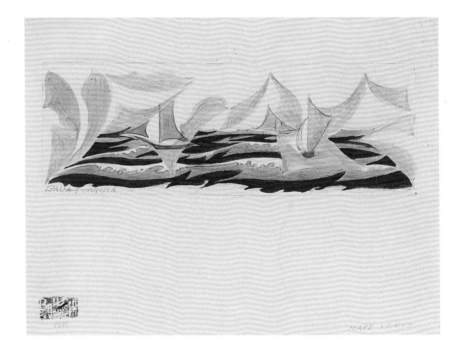

Umberto Boccioni

1882 – 1916

Umberto Boccioni is perhaps the most celebrated of the Italian Futurist painters. In 1907, after a peripatetic youth during which he studied art in Rome (in a school run by Balla) and made excursions to Venice, Vienna, Moscow, and Paris, Boccioni settled in Milan. His early painting joins the Divisionist application of pure colors and the moody atmospherics of *fin de siècle* Symbolism. Boccioni signed the iconoclastic "Manifesto of the Futurist Painters" in 1910, and exhibited with the group in Paris, Milan, and Rome throughout the prewar period. Beginning in 1911, he turned to Cubism for its syntax of transparency and fragmentation in an attempt to capture the dynamism of modern life. Eschewing Balla's sequential representation of movement, Boccioni expressed the effects of dynamic form as a layered experience of perception and memory in which figures appear to merge with their surroundings. As a result, Boccioni's works such as *The Laugh* (pl. 5) possess an emotional intensity that is rare in other Futurist art. The author of the "Technical Manifesto of Futurist Sculpture" (1912), he was the first Futurist to work in this medium, producing a series of dramatic sculptures that were exhibited in Paris in 1913 at the Galerie La Boëtie. Boccioni served in the field artillery during World War I and was killed in a riding accident in 1916. J W

5. Umberto Boccioni
The Laugh, 1911
Oil on canvas, 43⅜ x 57¼"
(110.2 x 145.4 cm)
Provenance: Albert Borchardt, Berlin; Karl Beierling, Bad Soden-Allendorf, Germany; Herbert and Nannette Rothschild, 1955
The Museum of Modern Art, New York. Gift of Herbert and Nannette Rothschild

Constantin Brancusi

1 8 7 6 – 1 9 5 7

Widely considered the father of modern sculpture, Constantin Brancusi initiated a century of sculpture made in basic materials directly worked, and three-dimensional images freed from the obligation of lifelike detail. Brancusi replaced the melodramatic and moralistic weight of the European sculptural tradition with a desire to give "pure joy." His bronzes, such as *The Muse* (pl. 7), all derive from a marble sculpture of the same form. When he made several bronze versions, the differences in patina, degree of polish, and base distinguish these related works. His insistence on the uniqueness of all his pieces reflects the value placed on originality and individuality as standards of avant-garde art in this century. Brancusi treated drawing casually; he was unfussy about his materials and relatively uninventive with motifs. Unlike photography, it was not an integral part of his working process. His linear drawings of female figures seem to have been a means of relaxation; they were handy for small sales and for gifts to friends. Although the Rothschilds received their drawing (pl. 6) in the 1950s, it was probably done many years earlier, as Brancusi had stopped making such works in the 1920s. A T

6. Constantin Brancusi
Reclining Nude, c. 1910–25
Pencil on cardboard,
16½ x 24" (42 x 61 cm)
Provenance: Gift of the artist
to Herbert and Nannette
Rothschild, 1954 or 1955;
Judith Rothschild
The Judith Rothschild
Foundation, New York

7. Constantin Brancusi
The Muse, after 1918
Polished bronze, height
17⅜" (44.2 cm) (limestone
base and turntable mounting
made by the artist in 1953)
Provenance: Acquired from
the artist by Herbert and
Nannette Rothschild, 1953;
Judith Rothschild
The Judith Rothschild
Foundation, New York

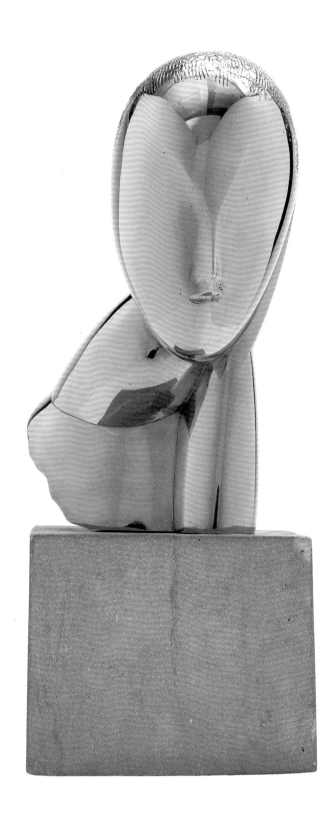

Georges Braque

1882 – 1963

A painter of quiet, poetic still lifes and single figures, Georges Braque was a supreme master of technique and compositional design. His greatest achievement lay in his ability to endow the forms in his compositions with a harmonious order and sense of permanence, accomplished by his unceasing exploration of their complex interrelationships. After an unsettled early career with training as a decorative painter and brief studies of academic painting in Paris at the Ecole des Beaux Arts, Braque found his calling as a progressive artist. In 1906 he painted brightly colored "Fauve" landscapes that were inspired by Matisse and Derain. Soon after, in a one-man exhibition at the Kahnweiler gallery, he showed a series of Cézannesque landscapes with great geometric forms painted in green and ocher that inspired the first use of the term "Cubism." In many ways Braque's famous collaboration with Picasso, when together they forged the theories of Cubism and invented the medium of collage, dominated his reputation for the remaining fifty years of his career. Braque was a printmaker throughout his life; the rare etching with drypoint *Job* (pl. 8), whose title refers to a brand of inexpensive tobacco, is one of his two Cubist prints published by Kahnweiler in 1912. I H S

8. Georges Braque
Job, 1911 (published 1912)
Etching with drypoint,
5⁹⁄₁₆ x 7¾" (14.1 x 19.7 cm)
(plate)
Provenance: Galerie Berggruen, Paris; Herbert and Nannette Rothschild, 1952; Judith Rothschild
The Judith Rothschild Foundation, New York

Catalogue

Patrick Henry Bruce

1 8 8 1 – 1 9 3 6

Animated yet highly distilled, the mature work of Patrick Henry Bruce represents an original variation on the Cubist still life. As an art student, Bruce had joined the community of American realists in New York in 1902. In 1904 he sailed for France, where he remained (but for a brief interruption) for thirty-two years. In Paris, Bruce was closely associated with modernist circles: he attended classes at Matisse's art school and enjoyed a close friendship with Robert and Sonia Delaunay. During the prewar period, Bruce assimilated the lessons of Post-Impressionism and Fauvism before developing large-scale, abstract works based on Delaunay's Orphic Cubism. In 1917 he attained his characteristic geometric style, which he applied almost exclusively to the still-life genre. Distinguished by an unusual palette of unmodulated blues, greens, lavenders, and reds complemented by pure black and white, these pictures all show blocklike forms — cylinders, cubes, wedges, and related shapes — distributed across a tabletop in calculated disarray. The still lifes, or "Forms" as he called them, were exhibited with some regularity in Paris during his lifetime but remained little known in the United States until the 1960s. By the mid-1920s, Bruce painted with growing infrequency, and gradually withdrew from contact with other artists and collectors. In 1933 he destroyed a good deal of his early work but gave some two dozen still-life paintings to his closest friend, Henri-Pierre Roché. In 1936 Bruce left France for New York, where only a few months later, he took his own life. J W

9. Patrick Henry Bruce
Painting (Still Life), c. 1919
Oil and pencil on canvas,
23½ x 36" (59.7 x 91.4 cm)
Provenance: Henri-Pierre
Roché, Paris; Rose Fried
Gallery, New York; Herbert
and Nannette Rothschild,
1954; Judith Rothschild
The Judith Rothschild
Foundation, New York

Catalogue

Carlo Carrà

1 8 8 1 – 1 9 6 6

The work of Carlo Carrà was largely devoted to the theme of the modern city. After being trained as a painter-decorator, Carrà began formal study as an art student in Milan in 1906, developing a Divisionist style in emulation of modern Italian masters, such as Giovanni Segantini and Giuseppe Pellizza. His early subjects, predominantly nocturnal cityscapes, anticipated the artist's Futurist iconography. Carrà was a founding member of the Futurist group; he signed the "Manifesto of the Futurist Painters" in 1910, and in 1912 was one of the organizers of a ground-breaking exhibition of Futurist art in Paris at the Bernheim-Jeune gallery. Beginning in 1911, elements of French Cubism, particularly its fragmented interpenetration of form and space, enabled Carrà to approximate the "dynamic sensation" of modern technology, as well as the invisible life of matter itself. His preferred imagery during this period included streetcars and automobiles in such pictures as *Jolts of a Cab* (pl. 10), which were intended to evoke the physical experiences of vibration and flux. In 1914 Carrà experimented with commercial typography and collage, creating a bold and somewhat abstract hybrid of art and verse. He abandoned Futurism in 1915, and with de Chirico eventually founded the Scuola Metafisica, a realist movement that flourished in the neoconservative climate of postwar Italy. This style, modeled on the paintings of such early Italian Renaissance masters as Giotto and Masaccio, gave way during the 1920s to a softer form of naturalism. J W

10. Carlo Carrà
Jolts of a Cab, 1911
Oil on canvas, 20⅝ x 26½"
(52.3 x 67.1 cm)
Provenance: Albert Borchardt, Berlin; Nell Walden, Bad Schinzach, Switzerland; sale Stuttgarter Kunstkabinett, November 25, 1954, lot 930 (through Heinz Berggruen); Herbert and Nannette Rothschild, 1954
The Museum of Modern Art, New York. Gift of Herbert and Nannette Rothschild

Giorgio de Chirico

1888 – 1978

The long career of Giorgio de Chirico proved to be as enigmatic as his paintings. He is the subject of unending controversy, caused by his surprising repudiation of his early "metaphysical" style, the many variants of his paintings he created over great lengths of time (which he would sometimes retrodate), and a prodigious traffic in fakes of his work. After studying at the academy in Munich, the Greek-born Italian artist settled in Paris in 1911, making his debut at the Salon d'Automne in 1912 and exhibiting at the Salon des Indépendants the following year. De Chirico's figurative "metaphysical" paintings, so different from the abstract work of the Cubist and Futurist avant-garde, brought him to the attention of Picasso and the poet Guillaume Apollinaire, and he soon became part of their circle. His compositions of silent Renaissance piazzas crossed by long shadows and encroached upon by curious, almost naive, motifs—flags flapping, locomotives chugging across the horizon, sailing ships popping up beyond enclosing walls—juxtapose a haunting classicism with the exigencies of modern life. Around 1914 de Chirico began to incorporate mannequins into his works, a theme he continued to develop in Ferrara, where he spent the war years as a military clerk. These smooth featureless figures, similarly placed in steep, unstable spaces and positing mysterious, emotionless encounters—seen in his pencil drawing *The Return of the Prodigal* of 1917 (pl. 11)—had great influence on the Surrealist painters. Beginning in the 1920s, de Chirico elaborated on the classical spirit of his earlier work; he turned to portraiture and to sources in the old masters, fusing a twentieth-century naturalism with borrowed compositions and Antique subjects. This seemingly regressive approach, judged in the context of the modernist canon, continues to evoke considerable critical consternation. G H M

11. Giorgio de Chirico
The Return of the Prodigal,
1917
Pencil on paper, 12⅜ x 8⅞"
(31.4 x 22.5 cm)
Provenance: Romeo
Toninelli, Milan; Herbert
and Nannette Rothschild,
1954; Judith Rothschild
The Judith Rothschild
Foundation, New York

Catalogue

Joseph Cornell

1903 – 1972

Joseph Cornell's constructions and collages have contributed a world outside of historical space and time to the art of this century. Its proportions are miniaturist, but its territory is vast, defined by maps (celestial and terrestrial), soap bubbles, dovecotes, mirrors, and crystals. Born in Nyack, New York, on Christmas Eve 1903, Cornell later moved with his family to Utopia Parkway in Flushing, Queens. This remained his home for the rest of his life; he traveled only to Manhattan for the opera, ballet, cinema, and his researches. There Cornell gathered the maps, toys and novelties, and old books and magazines that made up his palette. This practice began in the early 1930s, and Cornell's art was clearly influenced by what he had learned of Dada and Surrealism. Yet what he went on to do was free of the dogma that ruled those movements; it had no revolutionary aspirations, and was solitary rather than collective. Despite its reliance on imagery from the Renaissance and the Victorian age and from French literature, Cornell's work had a particularly American romanticism. He rarely dated his work, averse to fix it at a particular moment, but his *Sandbox* (pl. 12) was probably created in the early to mid 1950s. Unlike his typical boxes, which stand erect, this is a low horizontal. As the box is shifted the patterns in the sand change—not in an orderly fashion like an hourglass, but randomly and in contradiction to the concentric circles etched beneath. Thus Cornell presents a play between form and flow, pattern and chaos, fixity and surprise. AT

12. Joseph Cornell
Sandbox, c. 1950–55
Painted wood box with blue sand, steel ring, and ball bearing, 2 x 8⅝ x 14½"
(5 x 22 x 36.8 cm)
Provenance: Rose Fried Gallery, New York; Herbert and Nannette Rothschild, 1957; Judith Rothschild
The Judith Rothschild Foundation, New York

Stuart Davis

1892 – 1964

A student in the progressive Robert Henri School of Art in New York early in the century and an ardent admirer of European modernism, Stuart Davis soon evolved his own personal and robust brand of Cubism. His subjects changed little throughout his career, and he found constant and equal inspiration in the modern-day city life of Manhattan and the quiet seaport of Gloucester, Massachusetts. Characteristically, Davis's art and his ideas about his art were contradictory: he treated form in an abstract manner, yet he railed against being called an abstract painter; he was a master of color and even invented his own color theory, yet he claimed that drawing was the basis of his art. There is no doubt that drawing remained fundamental to Davis's practice. He kept many notebooks and frequently made larger, finished drawings in black and white. The bold ink drawing from his "Gloucester Series" composed of wide black lines that touch but rarely cross (pl. 13) exemplifies Davis's advice to "draw as if you were playing with black sticks." Davis repeatedly reused and reworked earlier compositions, and this drawing from about 1932 was the basis for a gouache called *Ivy League* done some twenty years later, as well as for a serigraph that was the Downtown Gallery's Christmas card in 1953. I H S

13. Stuart Davis
Untitled, c. 1932
Ink on paper, 11⅝ x 15⅝"
(29.5 x 39.7 cm)
Provenance: Waddington Galleries, London; Rosa Esman Gallery, New York; Kay Hillman, New York; Judith Rothschild, 1990
The Judith Rothschild Foundation, New York

Robert Delaunay

1885 – 1941

A brilliant colorist, Robert Delaunay was one of the pioneers of abstract art. His formative work was based on Post-Impressionism and Divisionism; from the paintings of Signac and Cézanne he drew lessons in pictorial structure and the use of pure color, which he also pursued through the study of nineteenth-century color theory. Delaunay's early Cubist style reveals a dynamic approach to fragmented imagery and is based on the principle of "simultaneity," or the confluence of multiple sensations. By 1912 this vigorous manner gave way to his "Window" series, evanescent views of Paris distinguished by transparency and prismatic light. Delaunay's original painting style was dubbed "Orphism" by the poet-critic Guillaume Apollinaire. With his "Disk" series of 1912–13, he attained pure abstraction, but other pictures of the same period feature an iconography of modernity that includes sports, early aviation, and the Eiffel Tower. Delaunay's work was widely exhibited in Paris, as well as in Munich and Berlin, and deeply influenced the international avant-garde. During World War I, he and his wife Sonia lived in Spain and Portugal. His *Portuguese Still Life* (pl. 15) dates from this period, and reflects the artist's new interests in subjects and motifs drawn from the marketplace and other folkloric settings. After the war he returned to his early themes, exploring them in new variations, such as depictions of the motorized carousel (fig. 71), which enabled him to reinterpret the structural rhythms of the "Disk" series. Delaunay resumed his work in abstraction in 1930, and over the next decade collaborated with his wife on various mural commissions. J W

14. Robert Delaunay
Composition, 1940
Collage, 10 x 6"
(25.4 x 15.2 cm)
Provenance: Gift of Sonia
Delaunay to Herbert and
Nannette Rothschild, 1956;
Judith Rothschild
The Judith Rothschild
Foundation, New York

15. Robert Delaunay
Portuguese Still Life, 1916
Wax on paper mounted on
canvas, 31 x 36½"
(78.7 x 92.7 cm)
Provenance: Sonia Delaunay,
Paris; Herbert and Nannette
Rothschild, before 1956
Private collection

Sonia Delaunay

1885 – 1979

Sonia Delaunay was an early exponent of abstract art, to which she remained devoted throughout her life. Born in the Ukraine, she was raised in Saint Petersburg. After studying art in Germany, she moved to Paris in 1905, where she soon joined the French avant-garde. In 1910 she married the painter Robert Delaunay, who introduced her to Orphism, a form of Cubism based on principles of pictorial rhythm and the science of color. Orphism ultimately led both artists to geometric abstraction. In a series of boldly innovative works, Delaunay applied this idiom to painting, collage, commercial graphics, textile and fashion design, and other forms of applied art. In 1924 she opened a design studio in Paris, the Atelier Simultané, for the production of fabrics, clothing, and accessories. During World War II, the Delaunays fled Paris for the Midi, where Robert Delaunay died. She returned in 1945, and actively participated in the postwar revival of abstract art in France. The projects that occupied her later years included tapestries for Aubusson and an illustrated edition of *Les Illuminations* of Rimbaud, as well as painting and printmaking on an increasingly intimate scale. J W

16. Sonia Delaunay
Solar Prism (Woman with Sunshade), 1914
Collage, 19½ x 13"
(49.5 x 33 cm)
Provenance: Rose Fried Gallery, New York; Herbert and Nannette Rothschild, 1956; Judith Rothschild
The Judith Rothschild Foundation, New York

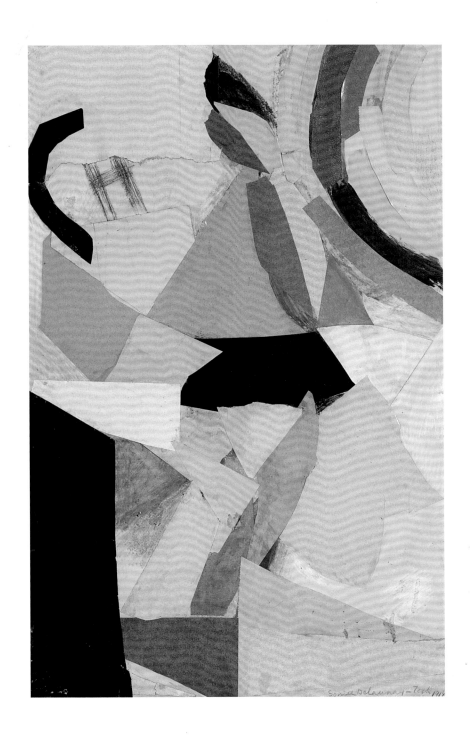

Catalogue

17. Sonia Delaunay
Dress pattern, 1922–23
Gouache on black paper,
6¾ x 6¾" (17.1 x 17.1 cm)
Provenance: Randall
Galleries, Ltd., New York;
Judith Rothschild, 1982
The Judith Rothschild
Foundation, New York

18. Sonia Delaunay
Composition, 1960
Etching and aquatint,
hand-colored, 6½ x 9"
(16.5 x 22.8 cm)
Provenance: Herbert and
Nannette Rothschild, by
1971; Judith Rothschild
The Judith Rothschild
Foundation, New York

19. Sonia Delaunay
Composition, 1960
Etching and aquatint,
6½ x 9" (16.5 x 22.8 cm)
Provenance: Herbert and
Nannette Rothschild, by
1966; Judith Rothschild
The Judith Rothschild
Foundation, New York

Naum Gabo

1 8 9 0 – 1 9 7 7

20. Naum Gabo
Opus 5, 1950
Monoprint, 9½ x 8"
(24.2 x 20.2 cm) (image)
Provenance: Acquired from
the artist by Herbert and
Nannette Rothschild, 1960;
Judith Rothschild
Philadelphia Museum of
Art. Gift of Judith Rothschild

21. Naum Gabo
*Construction: Stone with a
Collar,* 1933
Stone and plastic with slate
base, height 8" (20.3 cm)
Provenance: Probably Owen
Franklin; Winifred Dacre
Nicholson; Harold Dia-
mond, New York; Rose
Fried Gallery, New York;
Herbert and Nannette
Rothschild, 1958; Judith
Rothschild
The Judith Rothschild
Foundation, New York

With his first cardboard construction of intersecting planes, made while he was living in Oslo in 1915, Naum Gabo (born Naum Pevsner) began his lifelong pursuit of the means for expressing space, time, and movement in the construction of sculpture. Two experiences served as catalysts for the development of his own approach to abstraction: his time in Munich, where he trained in medicine, engineering, and natural science (while Kandinsky and others were pursuing ideas of abstraction there), and his visit to Paris in 1912–13, when he was introduced to Cubism. On returning to his native Russia in 1913, Gabo became associated with a group of avant-garde architects, engineers, and painters, which included his brother Antoine Pevsner. In 1920 Gabo wrote the "Realistic Manifesto," which he and his brother signed and posted at an exhibition in Moscow; proclaiming that "the elements of art have their basis in a dynamic rhythm," he never strayed far from this principle throughout his career. His *Construction: Stone with a Collar* (pl. 21) of 1933 (a variant of a larger piece of the same date) typifies Gabo's central concern in the 1930s with the interplay of flowing linear rhythms rather than the transparent planes of his earlier works. The merging lines and shapes of stone, slate, and plastic produce a sense of continuous movement held in perfect balance. After having lived in Germany, Paris, and England, Gabo moved in 1946 to the United States, where he was encouraged by William Ivins, curator of prints at the Metropolitan Museum of Art, to try woodblock printing. He never used a press or produced editioned prints but in typical fashion made the medium his own, creating works of surpassing radiance. *Opus 5* (pl. 20), a monoprint in brown ink on diaphanous paper, includes two constructions falling through space. These forms always seemed to suggest the constellations to Gabo's wife, who called the work by that name. I H S

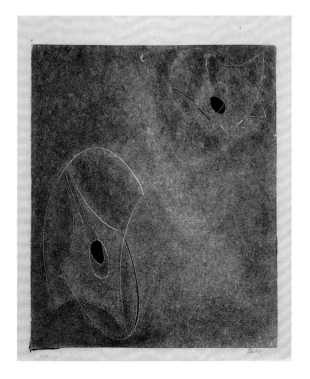

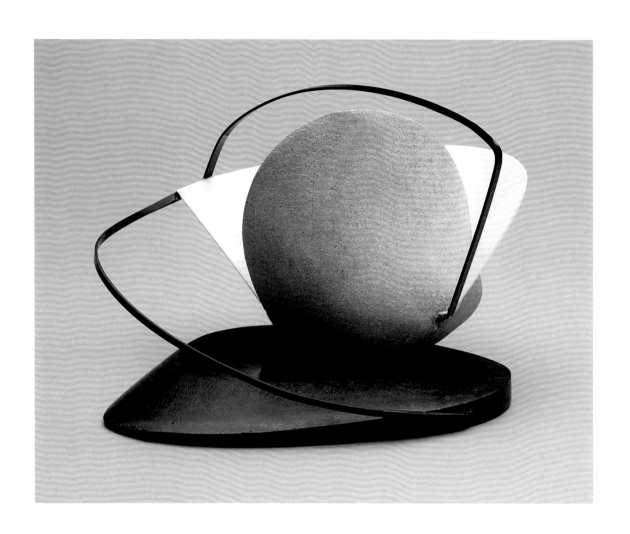

147 *Catalogue*

Natalya Gontcharova

1881 – 1962

Natalya Gontcharova was a vigorous leader of the Russian avant-garde during the first quarter of this century. Her personal and professional identities revolved around her lifelong association with Mikhail Larionov, whom she met while they were both at art school. Together they introduced a modern vocabulary to Russian painting, which they brought to international prominence. Gontcharova was a student of sculpture until Larionov persuaded her to turn to painting. Her first, primitivist style, like the early work of such Russian artists as Chagall and Kandinsky, was heavily influenced by the art of children and folk art, but by 1912, together with Larionov, she had elaborated a distinct Cubist-Futurist idiom called Rayonnism. It drew its logic from the perceptual theory that one sees the light rays that reflect off an object rather than the object itself. Like much of early abstraction, Rayonnist painting aspired to the condition of music, making the tonal relations of composition its sole content, independent of any representational qualities. As exhibition organizers and publishers as well as writers and painters, Gontcharova and Larionov were instrumental in the ferment of artistic activity in Russia on the eve of World War I, and their renown spread throughout Europe. Between 1908 and 1914 Gontcharova participated in exhibitions in Paris, London, Berlin, and Munich. When Diaghilev invited the couple to design sets for his ballet company, she and Larionov moved to Switzerland, and in 1917 settled permanently in Paris. They worked closely with Diaghilev until his death in 1929, and many hard years followed thereafter. It was not until the 1950s that interest in her early accomplishments brought Gontcharova renewed attention and appreciative visits from museum officials and collectors. This spurred her to a burst of creative activity that continued until her death in 1962. AT

22. Natalya Gontcharova
Untitled, 1912
Oil on canvas, 10½ x 18½"
(26.6 x 47 cm)
Provenance: Acquired from the artist by Herbert and Nannette Rothschild, 1956; Judith Rothschild
The Judith Rothschild Foundation, New York

23. Natalya Gontcharova
Skating Rink, 1912
Oil on canvas, 36½ x 29¾"
(92.7 x 75.5 cm)
Provenance: Acquired from the artist by Herbert and Nannette Rothschild, 1956
Private collection

Encounters with Modern Art

24. Natalya Gontcharova
Figure of a Woman, c. 1922
Pencil, crayon, and ink on
paper, 14½ x 10½"
(36.8 x 26.6 cm)
Provenance: Acquired from
the artist by Herbert and
Nannette Rothschild, 1956;
Judith Rothschild
The Judith Rothschild
Foundation, New York

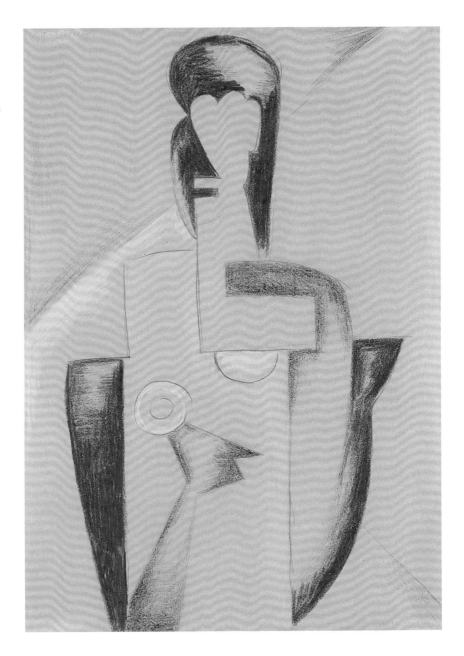

25. Natalya Gontcharova
Half-Length Female Figure,
c. 1922
Color lithograph,
14⁵⁄₁₆ x 9⁷⁄₈" (36.4 x 25.1 cm)
(image)
Provenance: Galerie
Berggruen, Paris; Herbert
and Nannette Rothschild,
1951; Judith Rothschild
The Judith Rothschild
Foundation, New York

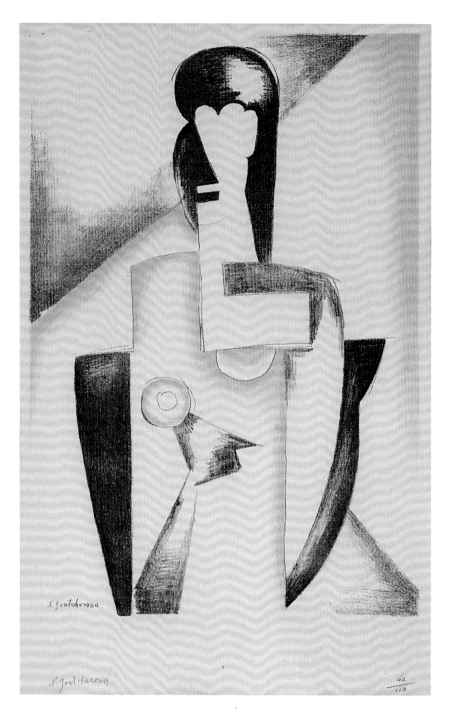

Julio González

1876 - 1942

A pioneer in the medium of forged and welded metal sculpture, Julio González was a major figure in twentieth-century art although he did not achieve this stature until he was fifty-two. Following his father's trade as a jeweler and metalworker, González worked first in Barcelona, and then in Paris after 1900, when the family firm relocated there. He became friendly with Picasso and other important figures in the Parisian avant-garde, and although he himself painted sporadically, he continued to make his living as a craftsman. Working within that field, he learned the technique of oxyacetylene welding, a skill that would prove useful to him later. In 1928 Picasso asked for his help in executing a series of small iron sculptures, the first Picasso had done in almost fifteen years. That experience led González to create his own sculpture, which when it was first shown in 1929, yielded a degree of success in the art world he had not previously known. His *Dancer Called "A La Marguerite"* (pl. 26) typifies the artist's mature style of the 1930s, combining a linear energy with a planarity drawn from Cubist sculpture. Into this mix, González sometimes added a vocabulary of spiky or ominous, Surrealist-inspired forms, or a totemic imagery derived from tribal sources. At other times his sculpture was largely abstract. Although some critics have linked González's work to Surrealism, he remained largely independent of the avant-garde movements; indeed, his only momentary connection with them was to the Cercle et Carré group of abstract artists, co-founded by his friend Joaquín Torres-García in 1929. M R

26. Julio González
Dancer Called "A la Marguerite," 1938
Bronze, height 19¼"
(48.9 cm)
Provenance: Kleeman Galleries, New York; Herbert and Nannette Rothschild, 1957; Judith Rothschild
The Judith Rothschild Foundation, New York

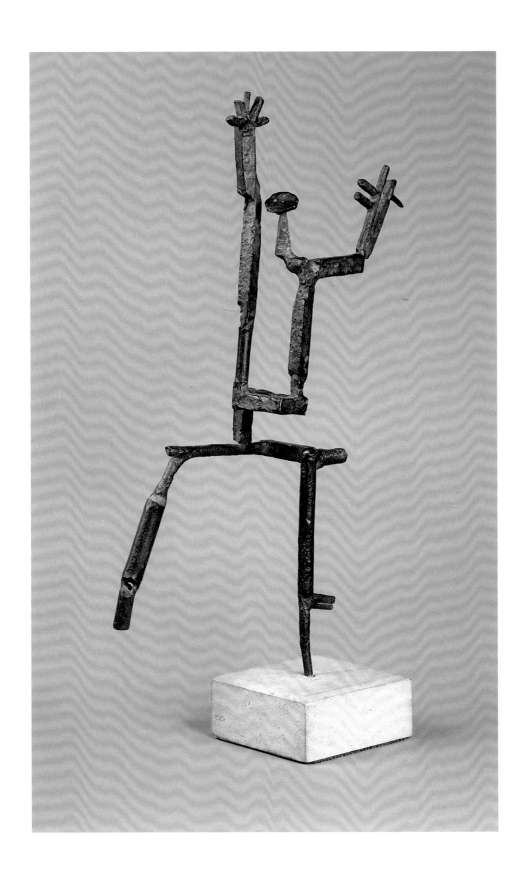

Juan Gris

1887 – 1927

Born and educated in Madrid, Juan Gris left for Paris in 1906 and immediately became part of the circle of his compatriot Picasso. Initially supporting himself by making satirical illustrations for magazines such as *L'Assiette au Beurre* (pls. 28, 29), he was very quick to develop as a painter. Soon he became an original voice in the Cubist group, contributing eery, icy-gray paintings and beautifully eloquent drawings. Gris was the first among his colleagues to realize that Cubism need not be condemned to a monochrome palette consisting solely of earth tones; starting in 1913, his work assumed a lush, sunlit demeanor that would influence many of his fellow Cubists to move in this direction. The same year, Gris followed Picasso's lead and turned to collage, producing incredibly intricate constructions marked by a subtlety unmatched in the work of his colleagues. Compared to Braque and Picasso, Gris would always be more poetic and expressive, his use of black, in particular, recalling a certain Spanish somberness. The series of gouaches made to illustrate *Au Soleil du plafond* (pls. 30–32), a book of poems by his friend Pierre Reverdy, which he did in collaboration with the poet, is a particularly celebrated moment in the artist's career. The pointillist practice of stippled colors he used in these works yields a touch of lightness that typifies Gris's personal version of Cubism. M R

27. Juan Gris
Self Portrait No. I, 1909–10
Charcoal on paper, 17 x 12½"
(43.2 x 31.7 cm)
Provenance: Daniel-Henry
Kahnweiler, Paris; Galerie Louise
Leiris, Paris; Saidenberg Gallery,
New York; Herbert and
Nannette Rothschild, 1967;
Judith Rothschild
The Judith Rothschild
Foundation, New York

155 *Catalogue*

28. Juan Gris
Drawing for *L'Assiette au Beurre,* 1909
Crayon, ink, and pencil on paper, 11 x 11" (28 x 28 cm)
Provenance: Galerie Percier, Paris; Herbert and Nannette Rothschild, 1958; Judith Rothschild
The Judith Rothschild Foundation, New York

29. Juan Gris
Drawing for *L'Assiette au Beurre,* 1908
Crayon and ink on paper, 14 x 11" (35.5 x 28 cm)
Provenance: Galerie Percier, Paris; Herbert and Nannette Rothschild, 1958; Judith Rothschild
The Judith Rothschild Foundation, New York

30. Juan Gris
The Coffee Mill, 1916
Oil and collage on paper,
10⁹⁄₁₆ x 8⅞" (26.8 x 22.5 cm)
(image)
Provenance: Henriette
Reverdy, Paris; Pierre
Chareau, Paris; E. V. Thaw &
Co., New York; Herbert and
Nannette Rothschild, 1961;
Judith Rothschild
The Judith Rothschild
Foundation, New York

31. Juan Gris
The Book, 1916
Gouache on paper,
10¹¹⁄₁₆ x 8½" (27.1 x 21.6 cm)
Provenance: Georges González
(Gris); Saidenberg Gallery,
New York; Herbert and
Nannette Rothschild, 1956;
Judith Rothschild
The Judith Rothschild
Foundation, New York

32. Juan Gris
The Fruit Bowl, 1916
Gouache on paper,
10¹¹⁄₁₆ x 8½" (27.1 x 21.6 cm)
Provenance: Georges González
(Gris); Saidenberg Gallery,
New York; Herbert and
Nannette Rothschild, 1956;
Judith Rothschild
The Judith Rothschild
Foundation, New York

33. Juan Gris
La Carte-Lettre (study for an
illustration for *Ne Coupez-pas
Mademoiselle . . .* by Max
Jacob), 1921
Pencil on paper, 12⅞ x 9⅛"
(32.7 x 23.2 cm)
Provenance: Daniel-Henry
Kahnweiler, Paris; Galerie
Louise Leiris, Paris; Saiden-
berg Gallery, New York;
Herbert and Nannette
Rothschild, 1967; Judith
Rothschild
The Judith Rothschild
Foundation, New York

34. Juan Gris
*Still Life with Mandolin and
Pear,* 1926
Watercolor and gouache on
paper, 8 x 10"
(20.3 x 25.4 cm)
Provenance: Daniel-Henry
Kahnweiler, Paris; Galerie
Louise Leiris, Paris; Saiden-
berg Gallery, New York;
Judith Rothschild and
Anton O. Myrer, 1967
The Judith Rothschild
Foundation, New York

35. Juan Gris
Bottle of Anis del Mono, 1914
Oil, crayon, and collage on
paper mounted on canvas,
16½ x 9½" (42 x 24.1 cm)
Provenance: Ambroise
Vollard, Paris; Daniel-Henry
Kahnweiler, Paris; Sidney
Janis Gallery, New York;
Herbert and Nannette
Rothschild, 1956; Judith
Rothschild
The Judith Rothschild
Foundation, New York

Roger de La Fresnaye

1885 – 1925

Roger de La Fresnaye was a French Cubist painter closely tied to specifics of place and to artistic tradition. His carefully arranged still lifes and distant views, including *Landscape with Bell Tower* (pl. 36) and *Meulan Landscape* (pl. 37), show a direct link to Cézanne. Like Cézanne, he drew constantly, often in the Louvre, and he tackled similar figural subjects, notably card players and bathers. But his large group compositions and portraits of 1912–14 achieved a totally independent voice. These memorable images—harmonious, spacious, and at times whimsical—were structured with flat, rectangular areas of strong color influenced by the Orphism of Robert Delaunay; some, such as his celebrated *Conquest of the Air* (fig. 23), had the striking, unexpected inclusion of the French tricolor. La Fresnaye joined with other Cubist painters in the Section d'Or exhibitions of 1911 and 1912 and in the creation of the notorious Maison Cubiste and Salon Bourgeois at the Salon d'Automne of 1912, for which he also designed the carved interior woodwork. His work was interrupted by World War I, and he enlisted despite the pleurisy he had contracted during military service in his youth. When he could he made sketches and watercolors of his comrades in the trenches, such as *Man with a Moustache* (pl. 38). His sickness flared up again in 1918, and he spent his last seven years in and out of sanatoriums. The paintings and drawings created during his periods of strength were no less vigorous than his earlier work, however, and he revised his approach to include realistic, declamatory portraits and Cubist still lifes in a new, fluid manner. G H M

36. Roger de La Fresnaye
Landscape with Bell Tower,
1911
Oil on canvas, 23¾ x 28¾"
(60.3 x 73 cm)
Provenance: Georges de Miré; Galerie Percier, Paris; Herbert and Nannette Rothschild, 1951
Private collection

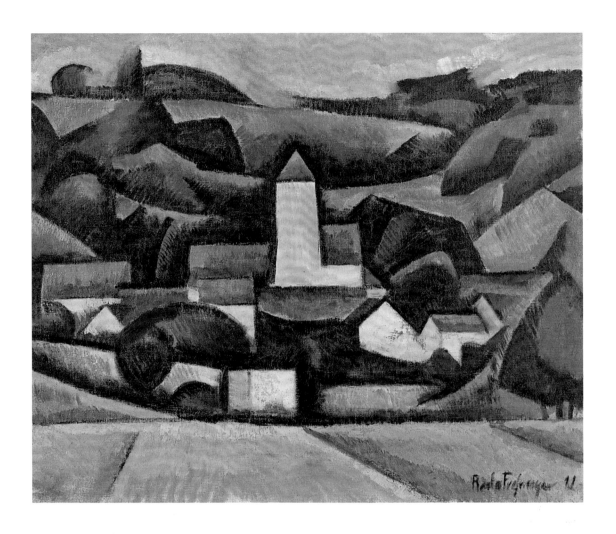

Catalogue

37. Roger de La Fresnaye
Meulan Landscape, 1912
Oil on canvas, 21¼ x 25⅝"
(54 x 65.1 cm)
Provenance: Henri Kapferer,
Paris; Paul Chadourne, Paris;
Herbert and Nannette
Rothschild, 1954; Judith
Rothschild
Private collection

38. Roger de La Fresnaye
Man with a Moustache, 1918
Gouache on paper,
10¼ x 8¼" (26 x 21 cm)
Provenance: Georges de
Miré; Galerie Percier, Paris;
Herbert and Nannette
Rothschild, 1951; Judith
Rothschild
Private collection

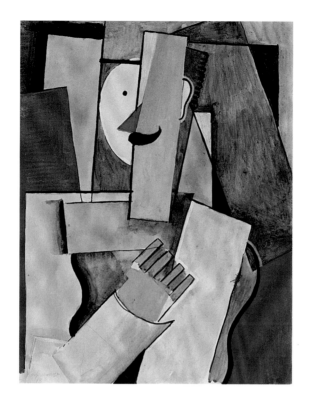

39. Roger de La Fresnaye
The Garden, 1920
Gouache on paper,
9¼ x 6¼" (23.5 x 15.9 cm)
Provenance: Galerie Percier,
Paris; Herbert and Nannette
Rothschild, 1951; Judith
Rothschild
Private collection

Blanche Lazzell

1878 – 1956

Blanche Lazzell was one of a number of American artists who, having returned from Europe on the eve of World War I, took up residence in Provincetown, Massachusetts, and transformed that seaside community into a thriving artists' colony. There Lazzell came to be closely associated with the distinctive one-block, multicolored woodcut known as the "Provincetown print" (exemplified by her views of the seaport's rooftops, dockyards, and wharfs, and by her floral still lifes and abstractions), and for many years she was a teacher of this method. Further study in Paris with Albert Gleizes, André Lhôte, and Léger from 1923 to 1925 allowed Lazzell to learn firsthand the principles of Cubism and abstraction. Lazzell made numerous variant drawings in preparation for her paintings; her carefully and deliberately executed untitled abstraction of 1927 (pl. 40) is related to several abstract paintings she executed the same year (numbers VII, VIII, and IX), all now owned by West Virginia University. During the 1930s Lazzell worked for the Public Works of Art project in her home state of West Virginia, making prints and painting a mural in the courthouse in Morgantown. Although she returned to Provincetown, where in the 1940s she took classes with Hans Hofmann, she died in Morgantown in 1956, leaving a collection of her works to the state university there. J I

40. Blanche Lazzell
Untitled (Abstraction), 1927
Pencil on paper, 10½ x 8¼"
(26.7 x 21 cm)
Provenance: Martin
Diamond Fine Arts, Inc.,
New York; Judith
Rothschild, 1985
The Judith Rothschild
Foundation, New York

Fernand Léger

1881 – 1955

Born and raised in Normandy, Fernand Léger had become a key member of the French avant-garde community by the end of the first decade of the century. As a young artist, he developed an idiom that was derived from an intense study of Cézanne and was closely related to the Cubism of Braque and Picasso. In the years preceding World War I, his style approached abstraction in a group of paintings he called "Contrasts of Form." Léger was profoundly influenced by his service in the war, and he returned to Paris to invent an artistic style based on a celebration of the machine age and the modern city. The noisy rhythms, stark colors, and bold forms of his compositions were intended as salutes to the contemporary environment. In his effort to define the visual world anew, Léger's interests spread to film and ballet, architecture and interior design. During the last two decades of his life (which included a five-year stay in the United States), he developed a style that was much more curvilinear and lyrical and often had a playful character. The monumentality of his works—even when their size was modest—related to Léger's concentration on decorative commissions such as murals and stained-glass windows during this time. A T

41. Fernand Léger
Head with One Hand, 1952
Glazed ceramic, 17¼ x 12"
(43.8 x 30.5 cm)
Provenance: Acquired from
the Brice pottery by Herbert
and Nannette Rothschild,
1954; Judith Rothschild
The Judith Rothschild
Foundation, New York

42. Fernand Léger
Two Nudes, 1932
Pencil on paper, 17 x 11¾"
(43.2 x 29.8 cm)
Provenance: Acquired from
the artist by Herbert and
Nannette Rothschild, 1953;
Judith Rothschild
The Judith Rothschild
Foundation, New York

43. Fernand Léger
The Builders, 1953
Color lithograph,
17⅜ x 23⅜" (44.2 x 59.3 cm)
(image)
Provenance: Galerie
Berggruen, Paris; Herbert
and Nannette Rothschild,
1954; Judith Rothschild
The Judith Rothschild
Foundation, New York

44. Fernand Léger
*Composition with Two
Persons (The Mechanic),*
1920
Lithograph, 11⁵⁄₁₆ x 9⅜"
(28.7 x 23.8 cm) (image)
Provenance: Galerie
Berggruen, Paris; Herbert
and Nannette Rothschild, by
1955; Judith Rothschild
The Judith Rothschild
Foundation, New York

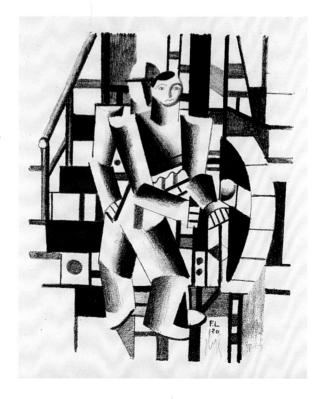

45. Fernand Léger
Sketch for *The Builders,*
1951
Gouache and ink on paper,
29 x 21" (73.6 x 53.3 cm)
Provenance: Acquired from
the artist by Herbert and
Nannette Rothschild, 1953
Private collection

Jacques Lipchitz

1891 – 1973

Against his father's wishes, Jacques Lipchitz made his way from Lithuania to Paris in 1909 to study art at the Ecole des Beaux-Arts. In 1913, following a period of service in the Russian military, he took up residence in Paris, next door to Brancusi. Never particularly identified with one group of artists, Lipchitz included among his colleagues Gris, Picasso, Rivera, Max Jacob, Amedeo Modigliani, and Chaim Soutine. His friendship with Gris was particularly fruitful, as it helped to propel him to the accomplished Cubist style for which he first attained prominence. Beginning in 1916 Lipchitz produced some of the best-known of synthetic Cubist sculptures, among them his *Bather* (pl. 47) done the following year. While Picasso had already explored this area, Lipchitz's sculpture was a sustained endeavor through which he transformed the Cubists' pictorial approach to the rendering of solids and voids into three dimensions. In 1918 Lipchitz began a highly celebrated series of relief compositions, culminating in a major commission for the Barnes Foundation outside Philadelphia in 1922. He continued practicing in the Cubist idiom throughout the 1920s, with *Reclining Figure with Guitar* of 1928 (pl. 46) a notable example of his late work in this style. But with a move in 1925 to Boulogne-sur-Seine on the outskirts of Paris, Lipchitz changed his style and subject matter. That year he began his "Transparents" series, works marked by a more linear approach in which open space replaced the planes and volumes of earlier years. He also started to work with a totemic figuration, a primitivizing approach that led to his choice of mythic themes in the 1930s. These works were accomplished in an archaic style free of the least reference to Cubism; instead, robust—at times deformed—shapes gave the figures a kind of theatrical intensity. Such works brought the artist a number of public commissions and his greatest fame. Except for a brief residence in Paris in 1946 and 1947, Lipchitz spent the years from 1941 to his death in the United States. M R

46. Jacques Lipchitz
Reclining Figure with Guitar, 1928
Bronze, length 27" (68.6 cm)
Provenance: Fine Arts Associates, New York; Herbert and Nannette Rothschild, 1959
Private collection

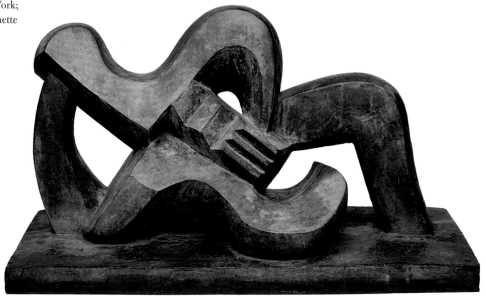

47. Jacques Lipchitz
Bather, 1917
Bronze, height 33½"
(85.1 cm)
Provenance: Fine Arts
Associates, New York;
Herbert and Nannette
Rothschild, 1959
Private collection

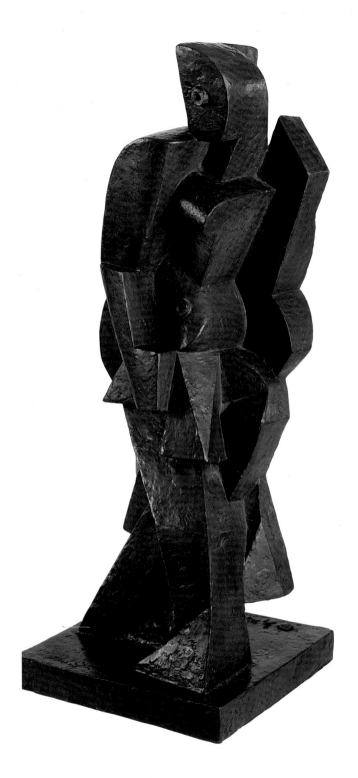

Henri Matisse

1869 – 1954

Henri Matisse is the twentieth-century master most closely associated with the glory of color. Having abandoned his early training in the legal profession, he began his career in art as a student of the Symbolist Gustave Moreau. Matisse rose to fame in the first decade of this century as a leader of the Fauves, so named for their style as savage as "wild beasts." During the following years, however, he created a pictorial paradise of graceful harmonies designed to provide what he likened to the comfort of "a good armchair." After living in or around Paris until the 1920s, Matisse spent the rest of his life in the south of France, where the Mediterranean sun filled his art with languor and warmth. Drawing did not come naturally to him, but he accepted it as fundamental to his work as an artist. His early drawings reflect a rigorous discipline and serious effort to attain technical skill. Yet Matisse's later remarks indicate that he considered this skill valuable only to the extent that it could ultimately be subordinated to the expression of genuine emotion and epiphany. The distance from his early *Nude* of 1900 (pl. 49) to the *Woman* of 1944 (pl. 50) shows the development of a facility that allowed his drawing to progress from a vigorous delineator of form to a symbolic language in which line and subject are inseparable. A T

48. Henri Matisse
Pensive Woman, c. 1906
Ink on paper, 10½ x 8⅜"
(26.7 x 21.3 cm)
Provenance: La Boetie, New York; Henry Reed; Kay Hillman, New York; Judith Rothschild, 1983
The Judith Rothschild Foundation, New York

49. Henri Matisse
Nude, 1900
Charcoal on paper, 10⅜ x 8½" (26.3 x 21.6 cm)
Provenance: Shepherd Gallery, New York; Judith Rothschild, 1989
The Judith Rothschild Foundation, New York

Catalogue

50. Henri Matisse
Woman, 1944
Ink on paper, 20½ x 15¾"
(52.1 x 40 cm)
Provenance: Marc Heinlein,
New York; Kay Hillman,
New York; Judith
Rothschild, 1977
The Judith Rothschild
Foundation, New York

51. Henri Matisse
Study for *Christ before
Pilate,* 1948
Ink on paper, 9¹⁵⁄₁₆ x 7⅞"
(25.2 x 20 cm)
Provenance: Maxwell
Davidson Gallery, New
York; Judith Rothschild,
1985
The Judith Rothschild
Foundation, New York

Encounters with Modern Art

52. Henri Matisse
Marie-José in a Yellow Dress,
1950
Color aquatint, 21⅛ x 16⁷⁄₁₆"
(53.6 x 41.7 cm) (image)
Provenance: Galerie
Berggruen, Paris; Herbert
and Nannette Rothschild,
1954; Judith Rothschild
The Judith Rothschild
Foundation, New York

Carlos Merida

1891 – 1984

Carlos Merida was one of the preeminent artists associated with the renaissance of Mexican painting during the first half of this century. He was born in Guatemala and learned of contemporary European art when Jaime Sabartes, a friend of Picasso from Barcelona, came to live in Guatemala City. Inspired by Sabartes's stories, Merida went to Paris in 1907, where he studied with the Fauve artist Kees van Dongen and became close friends with the Cubists. The onset of war forced Merida's return to Guatemala, where he became interested in developing a genuinely Latin American modern style. He saw a powerful connection between the Cubism of his European colleagues and the abstraction of his Mayan ancestors, and he sought to express the logical combination of the two. Moving to Mexico in 1919, he rejoined many Mexican artists he had known in Paris and became closely involved in the mural movement. Merida never felt wholly comfortable with the processes and goals of this narrative form, however, and in the late 1920s returned to Paris, where he developed an abstract style more allied to his instincts and roots. Once back in Mexico City in 1949, he worked as a museum official, critic, and teacher while continuing to evolve as a painter. A T

53. Carlos Merida
Monterrey, 1916
Oil on canvas, 9¼ x 15¾"
(23.5 x 40 cm)
Provenance: Alberto Misrachi, Mexico City; Herbert and Nannette Rothschild, 1937; Judith Rothschild
The Judith Rothschild Foundation, New York

54. Carlos Merida
Quetzaltenango, 1919
Oil on canvas, 21 x 14½"
(53.3 x 36.8 cm)
Provenance: Alberto Misrachi, Mexico City; Herbert and Nannette Rothschild, 1937; Judith Rothschild
The Judith Rothschild Foundation, New York

Piet Mondrian

1872 – 1944

The steady, elegant evolution of the work of Piet Mondrian over the first half of the twentieth century is a paradigm for the creation of abstract art. Born in Holland in 1872, he was twenty-eight at the turn of the century and already an accomplished artist. As if solving some profound problem in physics, yet through means deeply intuitive rather than deductive, Mondrian moved step by thoughtful step into the realm of pure painting; he constantly studied, criticized, and built upon the composition just painted in order to proceed to the next stage in a lifelong investigation of what a perfect art might be. The works in the Rothschild collection bear eloquent witness to points along Mondrian's trajectory; they begin with his images of the reflective surfaces of canals and the simple dunes of his native land and culminate in the dazzling diamond-shaped *Tableau No. IV* of 1924–25 (pl. 64), in which he had found his full voice. His deeply felt response to Cubism in Paris before World War I is nowhere clearer than in the lyrical curves of *Flowering Trees* of 1912 (pl. 59), which also reconfirms that for Mondrian it was the contemplation of landscape that offered the clearest path to abstraction. His *Composition with Red, Yellow, and Blue* of 1921 (pl. 60) leaves the recognizable world far behind, and perhaps only the delicate, bluish gray rectangles offer a lingering vestige of the airy space suggested in his prewar paintings. In the two decades following his great diamond composition, Mondrian moved with increasing certainty and clarity of purpose through one sequence of abstract paintings after another, reaching a quintessence of reductiveness without ever abandoning his quest for a quiet harmony. In his final years, he achieved an outburst of gaiety and celebration in large compositions painted in New York, which contained his response to the exuberant modernity of that great city. Ad'H

55. Piet Mondrian
The Old Farm, c. 1903–5
Oil on canvas mounted on
cardboard, 10 x 12"
(25.4 x 30.5 cm)
Provenance: Mme van der
Klip, Paris; Galerie Percier,
Paris; Herbert and Nannette
Rothschild, 1958; Judith
Rothschild
The Judith Rothschild
Foundation, New York

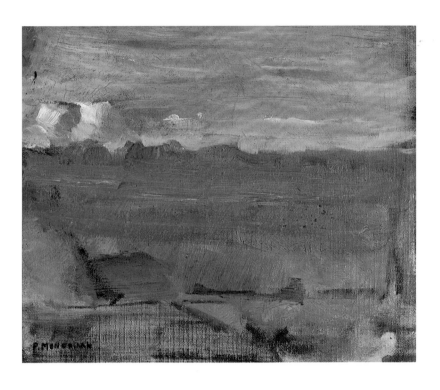

56. Piet Mondrian
Landscape: Field and Sky,
c. 1900–1902 (or possibly
later)
Oil on canvas, 10⅝ x 12½"
(27 x 31.8 cm)
Provenance: S. B. Slijper,
Blaricum, Netherlands;
Harold Diamond, New
York; Fine Arts Mutual,
New York; sale Sotheby's,
New York, May 21, 1981,
lot 613; Judith Rothschild,
1981
The Judith Rothschild
Foundation, New York

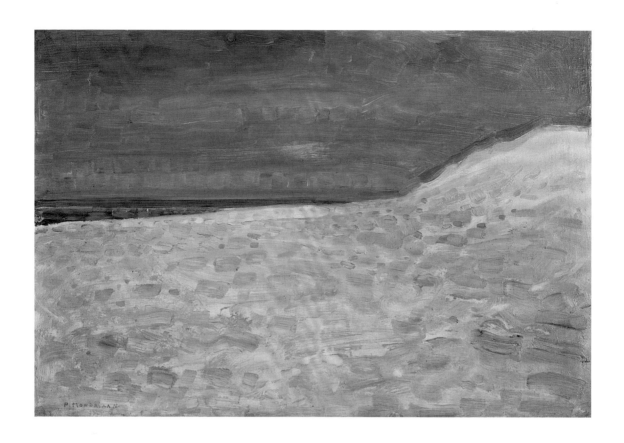

57. Piet Mondrian
Dune, c. 1909–10
Oil on canvas, 18 x 26½"
(45.7 x 67.3 cm)
Provenance: S. B. Slijper,
Blaricum, Netherlands;
Rose Fried Gallery, New
York; Herbert and Nannette
Rothschild, 1957; Judith
Rothschild
The Judith Rothschild
Foundation, New York

58. Piet Mondrian
Sunflowers (or *Eucalyptus
Tree*), 1912
Charcoal on paper, 24¾ x
19½" (62.9 x 49.5 cm)
Provenance: Polleg, Basel;
John L. Senior, Jr., New
York; Sidney Janis Gallery,
New York; Herbert and
Nannette Rothschild, 1956;
Judith Rothschild
The Judith Rothschild
Foundation, New York

59. Piet Mondrian
Flowering Trees, 1912
Oil on canvas, 23⅝ x 33½"
(60 x 85.1 cm)
Provenance: Wobine C. de
Sitter, Domburg, Netherlands;
Mies Elout-Drabbe, Domburg;
Kunsthandel G. J. Nieuwen-
huizen Segaar, The Hague;
Herbert and Nannette
Rothschild, 1958; Judith
Rothschild
The Judith Rothschild
Foundation, New York

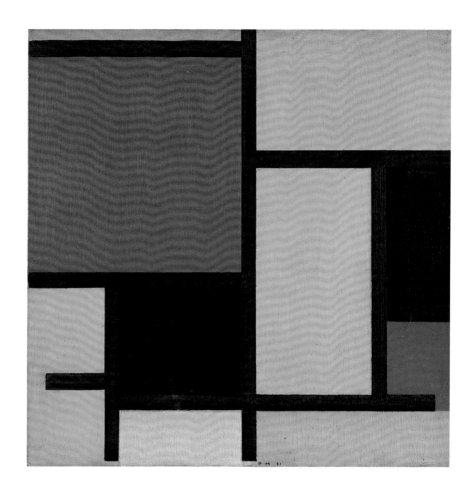

60. Piet Mondrian
*Composition with Red,
Yellow, and Blue,* 1921
Oil on canvas, 18⅞ x 18⅞"
(48 x 48 cm)
Provenance: Emile Lauwers
and Berthe Lauwers-van
Grieken, Brussels; Peggy
Guggenheim, Venice; Nelly
van Doesburg, Meudon;
Herbert and Nannette
Rothschild, 1955; Judith
Rothschild
The Judith Rothschild
Foundation, New York

61. Piet Mondrian
*Composition with Red,
Yellow, and Blue,* 1922
Oil on canvas, 15 x 13¾"
(38.1 x 34.9 cm)
Provenance: Theo and
Nelly van Doesburg,
Meudon; Maurice E.
Culberg, New York; Sidney
Janis Gallery, New York;
Herbert and Nannette
Rothschild, 1953; Judith
Rothschild
The Judith Rothschild
Foundation, New York

62. Piet Mondrian
*Classic Drawing #28
(Diamond Composition),*
1925 (or possibly later)
Pencil on paper, 8½ x 8½"
(21.6 x 21.6 cm)
Provenance: Harry
Holtzman, New York; The
Pace Gallery, New York;
Kay Hillman, New York;
Judith Rothschild, 1980
The Judith Rothschild
Foundation, New York

63. Piet Mondrian
*Classic Drawing #15 (Blue
Line Cigarette Package
Cover),* c. 1939
Pencil on paper, 2⅞ x 3¹⁵⁄₁₆"
(7.3 x 10 cm)
Provenance: Harry Holtz-
man, New York; The Pace
Gallery, New York; Rosa
Esman Gallery, New York;
Kay Hillman, New York;
Judith Rothschild, 1988
The Judith Rothschild
Foundation, New York

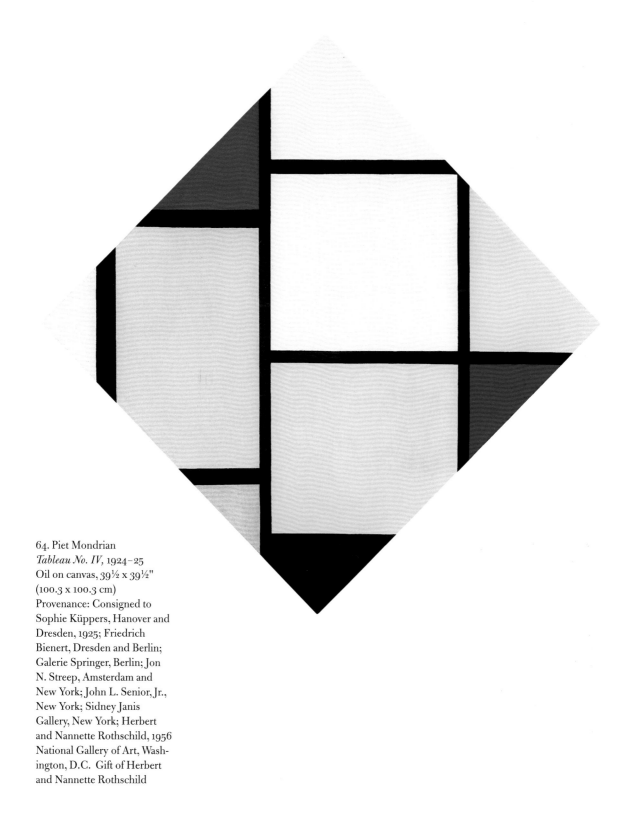

64. Piet Mondrian
Tableau No. IV, 1924–25
Oil on canvas, 39½ x 39½"
(100.3 x 100.3 cm)
Provenance: Consigned to
Sophie Küppers, Hanover and
Dresden, 1925; Friedrich
Bienert, Dresden and Berlin;
Galerie Springer, Berlin; Jon
N. Streep, Amsterdam and
New York; John L. Senior, Jr.,
New York; Sidney Janis
Gallery, New York; Herbert
and Nannette Rothschild, 1956
National Gallery of Art, Wash-
ington, D.C. Gift of Herbert
and Nannette Rothschild

Francis Picabia

1879 – 1953

Iconoclastic and unpredictable, Francis Picabia was a friend of Marcel Duchamp and Guillaume Apollinaire. He absorbed the most advanced tendencies in Paris as they were occurring and synthesized them to produce a sequence of uniquely conceived works. His great *Procession, Seville* of 1912 (pl. 65), for example, although from an early point in his career, demonstrates a highly individualistic approach to Cubism. Conventional in its reduction of a narrative into a composition of flattened planes, the painting is innovative in its combination of mechanistic appearance, Futurist sense of movement, and colorful palette, which was then virtually unknown among the French Cubists. From 1913 to 1915, Picabia moved between Barcelona, the Caribbean, and New York, where he participated in the avant-garde circles of Alfred Stieglitz at the 291 Gallery. In 1918 and 1919 he helped pioneer the Dada movement in Switzerland, and subsequently contributed to its continuing life in Paris. At this time, he reinvented his art, combining words and often abstract images in a characteristically witty, Dadaist fashion. During the 1920s he expanded his oeuvre to include film and ballet, in addition to the poetry that he had been writing for almost a decade. Among his many stylistic modes were the "Transparencies" of the later 1920s, done in collage and watercolor on cellophane; these works, in which conscious and subconscious states were fused, became his inventive contribution to the figurative approach of Surrealist art. M R

65. Francis Picabia
The Procession, Seville, 1912
Oil on canvas, 48 x 48"
(121.9 x 121.9 cm)
Provenance: Marcel
Duchamp, Paris; André
Breton, Paris; possibly
Léonce Rosenberg, Paris;
Prince Igor Troubetzkoy,
Paris; Mme Simone
Collinet; Sidney Janis
Gallery, New York; Herbert
and Nannette Rothschild,
1956
Private collection

Encounters with Modern Art

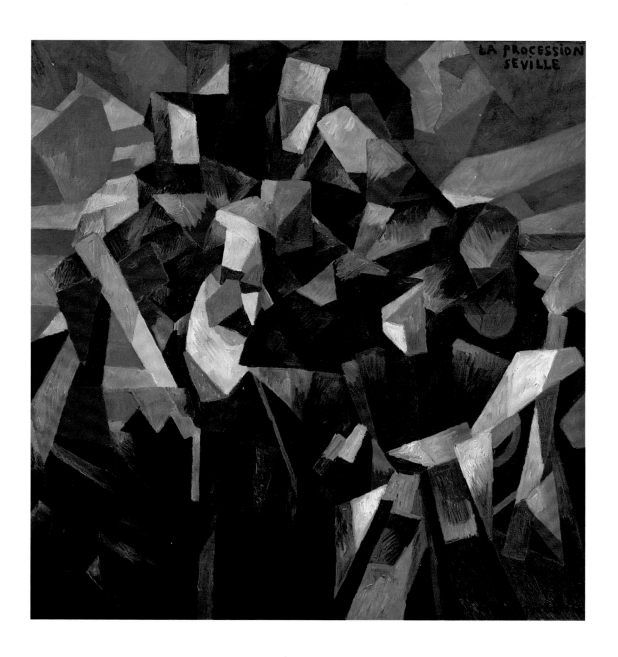

Catalogue

Pablo Picasso

1881 – 1973

Pablo Picasso's presence pervades the history of twentieth-century art. His early development, marked by a rapid assimilation of recent tendencies in Post-Impressionist painting, was followed by an equally dynamic succession of original styles. After joining the Catalan avant-garde in Barcelona in 1898, he made several extended trips to Paris, finally settling there in 1904. During his Blue and Rose periods, Picasso's art revealed itself to be intimately autobiographical, frequently incorporating images of his friends and lovers. In 1906 and 1907, he adapted elements of ancient Iberian and tribal African art to create an aggressively expressionistic approach to the female nude that culminated with the *Demoiselles d'Avignon* (fig. 38). Picasso developed the elements of Cubism during the prewar period; together with Braque, he established a profoundly new language of representation for both painting and sculpture, and created the medium of collage. After World War I, as Cubism grew increasingly monumental, Picasso also pursued a neoclassical style, applying the new naturalism to set and costume designs for the Ballets Russes. In the 1930s he revealed a close affinity with Surrealism through his use of primitivistic techniques and dark themes drawn from classical mythology. During World War II, Picasso lived primarily in Paris, where he painted *Paris: Notre Dame* (pl. 69). Thereafter, the artist spent an increasing amount of time in the south of France. Immensely prolific in painting, drawing, sculpture, printmaking, book illustration, and various decorative arts, he continued to exploit his facility for working simultaneously in multiple stylistic and expressive modes. By this time his celebrity had grown to international proportions, and he became the perpetual subject of books, articles, exhibitions, and films. Taking stock of his place in the history of art, Picasso devoted a good deal of his late work to variations on celebrated paintings by Velázquez, Delacroix, Manet, and other masters. J W

66. Pablo Picasso
The Fauns' Dance, 1957
Lithograph, 16⅛ x 20½"
(41 x 52 cm) (image)
Provenance: Herbert and
Nannette Rothschild, 1957;
Judith Rothschild
The Judith Rothschild
Foundation, New York

67. Pablo Picasso
Nude, c. 1906–7
Oil wash on paper mounted
on canvas, 12¾ x 9¾"
(32.4 x 24.8 cm)
Provenance: Gertrude Stein,
Paris; Perls Galleries, New
York; Herbert and Nannette
Rothschild, 1953; Judith
Rothschild
The Judith Rothschild
Foundation, New York

Catalogue

68. Pablo Picasso
*Head on a Black
Background,* 1953
Lithograph, 27⅜ x 21½"
(69.5 x 54.5 cm) (image)
Provenance: France +
Daverkosen, Ørholm,
Denmark; Herbert and
Nannette Rothschild, 1955;
Judith Rothschild
The Judith Rothschild
Foundation, New York

69. Pablo Picasso
Paris: Notre Dame, 1945
Oil on canvas, 21¼ x 32"
(54 x 81.3 cm)
Provenance: George Isarlov,
Paris; Daniel-Henry
Kahnweiler, Paris; Galerie
Gérald Cramer, Geneva;
Perls Galleries, New York;
Herbert and Nannette
Rothschild, 1957
Private collection

Diego Rivera

1886 - 1957

Having arrived in Europe from Mexico in 1907, Diego Rivera would spend the next decade actively participating in avant-garde art movements in Paris until a fistfight with a French critic in 1917 led to his repudiation of Cubism. Before returning home in 1921, he made an intensive study of Italian Renaissance painting from Giotto to Michelangelo. This affirmed Rivera's belief in the social necessity of art in post-revolutionary Mexico, and in the potential of mural painting to redefine the country's cultural and political identity and to revive its pre-Columbian heritage. Committed to Marxist and Communist ideology, Rivera frequently saw his private and government mural projects in Mexico and the United States suppressed because of their controversial imagery, which focused international political and artistic attention on the Mexican mural movement. Numerous preparatory drawings for projects Rivera began in the 1920s survive, including the pencil study *La Providencia* (pl. 71), which the artist inscribed with color notes and dated 1929. Between 1937 and 1942, Rivera received no new mural commissions in Mexico, and he concentrated instead on producing oils and watercolors, among them two popular genre scenes from 1937, *Man with Lettuce* (pl. 70) and *Man in White Pajamas* (pl. 72). Such subjects expressed his passionate interest in Mexican customs and folklore. J I

70. Diego Rivera
Man with Lettuce, 1937
Watercolor on paper,
15 x 11" (38.1 x 27.9 cm)
Provenance: Alberto
Misrachi, Mexico City;
Herbert and Nannette
Rothschild, 1937; Judith
Rothschild
The Judith Rothschild
Foundation, New York

Encounters with Modern Art

71. Diego Rivera
La Providencia, 1929
Pencil on paper, 8¾ x 6"
(22.2 x 15.2 cm)
Provenance: Alberto
Misrachi, Mexico City;
Herbert and Nannette
Rothschild, 1937; Judith
Rothschild
The Judith Rothschild
Foundation, New York

72. Diego Rivera
Man in White Pajamas,
1937
Watercolor on paper,
15 x 11" (38.1 x 27.9 cm)
Provenance: Alberto
Misrachi, Mexico City;
Herbert and Nannette
Rothschild, 1937
Private collection

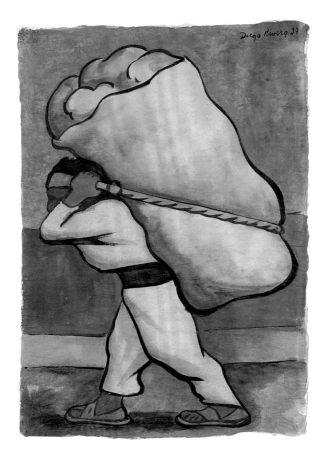

Morgan Russell

1886 – 1953

Morgan Russell developed his innovative colorism in Paris, where he settled in 1909. The artist modeled his early work after Monet and Cézanne, and like other American modernists, he took classes with Matisse. In 1911, when Russell attended lectures on nineteenth-century color theory, he met another American painter, Stanton Macdonald-Wright, and together they developed the movement called Synchromism. Demonstrating his idea that "a painting should be a flat presentation of light," Russell's "Synchromies" are closely related to contemporaneous developments in Cubism and Futurism, especially the work of Picabia and Robert Delaunay. His paintings grew increasingly abstract, following formal principles that he likened to the musical elements of harmony, melody, and rhythm. Largely related to the organization of color, these ideas were also formulated in preliminary sketches and drawings. After World War I, Russell depicted still lifes, interiors, and nudes—all subjects that he had previously abandoned in his paintings—although he continued to pursue Synchromist abstraction into the 1920s. Figuration dominated Russell's late work. Based on both sacred and secular themes, many of these pictures are devoted to the male nude and derive partly from sources in Antique, Renaissance, and Baroque art. J W

73. Morgan Russell
Above: *Untitled*, 1914
Below: Reverse with inscription concerning the relationship of painting and musical composition
Pencil on paper, 6½ x 9¼"
(16.5 x 23.5 cm)
Provenance: Rose Fried Gallery, New York; gift to Herbert Rothschild from Judith Rothschild, 1957; Judith Rothschild
The Judith Rothschild Foundation, New York

Melody - will be several groups or *mesures* of colors - one or several
each - the whole to have a given character + satisfying as a
whole -
It will go a lot from dark to light +
 warm to cold chords or mesures -
 The mesures will be left until end of melody - unless
 it is a very ⟩ ⟩ ⟩ sort of melody - + even
 so at-times it will be left. -
This melodies culminating in a big ensemble order
 or Coda - or Cadento Resume in grand du tutt
Pedals - of one color each - or of blurring white.
For each melody - a cut out block screen -
 + for each isolation desired.
 This eliminate necessity of sliding synchrony up
 + down or side to side
The cut out areas can be covered with a colored note
 (paper) for each measure if desired.
The whole must be done by at least three sheets
 for rich play - part in front. part behind glass

Kurt Schwitters

1887 – 1948

Kurt Schwitters is one of the great masters of what is perhaps the defining medium of twentieth-century art: collage. His stature is belied by the intimate scale, timeworn surfaces, and casual titles of his works. These compact entities exist within a vast and polymorphous enterprise that included painting, sculpture, architecture, poetry, graphic design, and performance. Schwitters was born in Hanover, Germany, and his coming of age as an artist coincided with the era of German Expressionism. But in 1918 he suddenly discovered the collage approach that defined the rest of his life's work. Affiliating himself with the Dada movement, which shared his aversion to traditional artistic boundaries, he elevated the banal into art on the basis of the inherent beauties in found materials. He christened the approach "Merz," from a collage featuring typography excerpted from the printed words "Kommerz und Privatbank." Over the years Schwitters went on to include all of his art endeavors under this name, ultimately even referring to himself as "Merz." A T

74. Kurt Schwitters
Untitled (Grüne Zugabe),
probably 1920s
Collage, 5½ x 4½"
(14 x 11.4 cm)
Provenance: Mrs. Kurt
Schwitters; Rose Fried
Gallery, New York; Herbert
and Nannette Rothschild,
1957; Judith Rothschild
The Judith Rothschild
Foundation, New York

Encounters with Modern Art

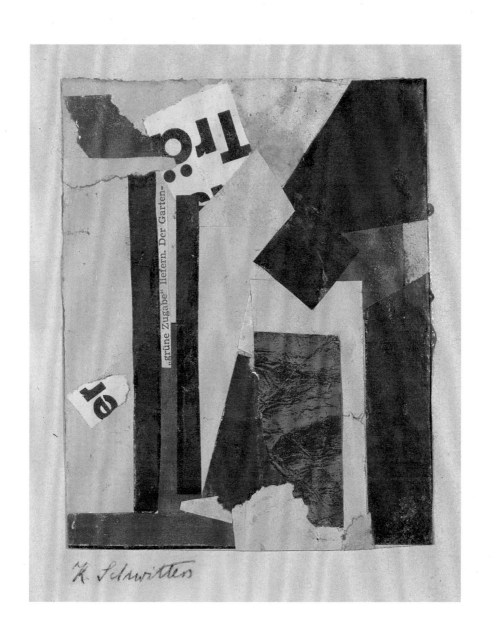

Gino Severini

1883 – 1966

Unlike his fellow Futurists, Gino Severini lived in Paris and was closely associated with the French avant-garde. After studying painting with Balla in Rome, he moved to Paris in 1906. There he developed a Divisionist technique based on the works of Seurat and Signac with a high-key chromaticism that would remain a prominent element in his painting. Severini devoted the prewar period to images of nightlife and the Parisian boulevard, including *Nord-Sud* (pl. 76), which are characterized by the Futurists' dynamic fragmentation of form. The depiction of signboards and other forms of commercial typography further reflects the artist's interest in urban popular culture. Between 1916 and 1920, Severini followed a synthetic Cubist manner, and after the war turned to neoclassical naturalism in subjects drawn from the *commedia dell'arte*. Returning to Italy, the artist produced church decorations and other large-scale commissions with fresco and mosaic in deliberate emulation of the Antique. After World War II, Severini returned to Paris and gradually resumed a decorative modernist style, applying a brightly colored Divisionist technique to abstract Futurist-revival compositions in several mediums, including painted ceramic sculpture. J W

75. Gino Severini
Composition, cast 1955
Porcelain, height 14"
(35.6 cm)
Provenance: Leicester
Gallery, London; Kay
Hillman, New York; gift to
Herbert Rothschild from
his children, 1971; Judith
Rothschild
The Judith Rothschild
Foundation, New York

76. Gino Severini
Nord-Sud, 1913
Charcoal on paper,
17¾ x 21" (45 x 53.3 cm)
Provenance: Galerie
Berggruen, Paris; Herbert
and Nannette Rothschild,
1956
Private collection

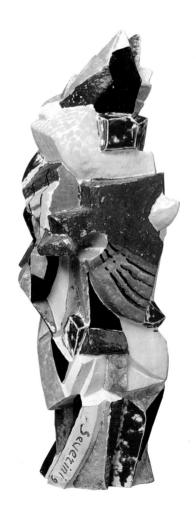

Encounters with Modern Art

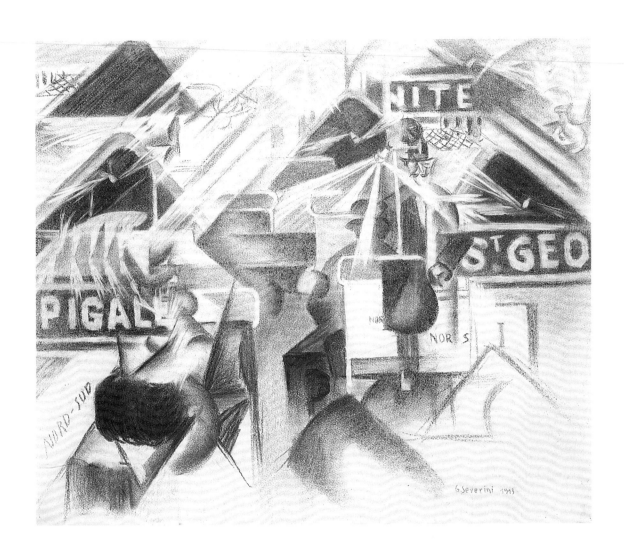

Jacques Villon

1875 – 1963

Systematic and painstaking in approach, masterful in technique, and versatile with respect to medium, Jacques Villon achieved his greatest distinction as a printmaker. Born Gaston Duchamp (he changed his name in homage to the medieval poet François Villon), he remained close in his life and art to his two artist brothers, Raymond Duchamp-Villon and Marcel Duchamp; in their separate but connected ways, all three came to figure prominently in the history of modern art. Jacques Villon began as an illustrator, depicting mothers and children in the elegant style of the Belle Epoque, but by 1910 he and his brothers had embraced Cubism. Villon's studio in the Puteaux section of Paris later became the center for the artists of the Section d'Or, a movement that took its name from Leonardo da Vinci's treatise on mathematical proportion in painting. Villon's own Cubist compositions, whether paintings, drawings, or prints, evolved from naturalistic forms to abstract constructions. He frequently reworked earlier subjects, as he did in two masterful color etchings of 1951, *The Universe* (pl. 77), which loosely derives from *Chessboard*, a 1920 etching showing the fragmented planes of a chess table from above, and *Doll* (pl. 78), which originated in a 1921 drawing of the subject in a circular basin. I H S

77. Jacques Villon
The Universe, 1951
Etching and aquatint,
7³⁄₁₆ x 6⅞" (18.3 x 17.4 cm)
(plate)
Provenance: Galerie
Berggruen, Paris; Herbert
and Nannette Rothshild,
1954; Judith Rothschild
The Judith Rothschild
Foundation, New York

78. Jacques Villon
Doll, 1951
Etching and aquatint,
10½ x 7⅝" (26.7 x 19.3 cm)
(plate)
Provenance: Galerie
Berggruen, Paris; Herbert
and Nannette Rothschild,
1954; Judith Rothschild
The Judith Rothschild
Foundation, New York

Encounters with Modern Art

4/10 Japon Jaques Villon

Appendix

Acquisitions of
The Judith Rothschild
Foundation

Paul Cézanne
French, 1839–1906
Group of Trees, c. 1885–90
Watercolor and pencil on paper,
18⅛ x 12" (46 x 30.5 cm)

Henri-Edmond Cross
French, 1856–1910
Branch with Leaves and Blossoms
Watercolor and pencil on paper,
3¾ x 5⅛" (9.5 x 13 cm)
Gift of Harvey S. Shipley Miller

Otto Dix
German, 1891–1969
Thoughtful Man, 1918
Pencil, crayon, and ink on paper,
15½ x 15½" (39.4 x 39.4 cm)

Marcel Duchamp
French, 1887–1968
Stood Up (Le Lapin), 1909
Charcoal and ink on paper,
21½ x 16¾" (54.6 x 42.5 cm)

Wassily Kandinsky
Russian, 1866–1944
Landscape, 1912
Color woodcut, 4⅞ x 7½"
(12.4 x 19.1 cm)
Gift of Harvey S. Shipley Miller

Paul Klee
Swiss, 1879–1940
Right Unfriendly, 1940
Ink on paper mounted on paper,
8¼ x 14" (21 x 35.6 cm)

Piet Mondrian
Dutch, 1872–1944
*Stadhouderskade near the Amsterdam
House of Detention,* 1899–1900
Oil on canvas, 16⅝ x 25⅛"
(42.2 x 63.8 cm)

Pablo Picasso
Spanish, 1881–1973
Two Nude Figures, 1909
Drypoint, 5³⁄₁₆ x 4⁷⁄₁₆"
(13.2 x 11.3 cm) (plate)

Pablo Picasso
Still Life with a Compote, 1909
Drypoint, 5¼ x 4¼" (13.3 x 10.8 cm)
(plate)

Pablo Picasso
Mademoiselle Léonie, 1910
Plate 1 from Max Jacob, *Saint Matorel*
(Paris, 1911)
Etching, 7⅞ x 5⁹⁄₁₆" (20 x 14.1 cm)
(plate)

Pablo Picasso
The Table, 1910
Plate 2 from Max Jacob, *Saint Matorel*
(Paris, 1911)
Etching, 7⅞ x 5⅝" (20 x 14.2 cm)
(plate)

Pablo Picasso
Still Life with a Bottle of Marc, 1912
Drypoint, 17½ x 12" (44.4 x 30.5 cm)
(plate)

Pablo Picasso
Man with a Guitar, 1915
Engraving, 6 x 4½" (15.3 x 11.5 cm)
(plate)

Pierre-Auguste Renoir
French, 1841–1919
Landscape with a Small Lake
Watercolor on paper, 5¼ x 9⅝"
(13.3 x 24.4 cm)

Myron Stout
American, 1908–1987
Untitled, c. mid 1950s
Charcoal on paper, 25 x 19"
(63.5 x 48.2 cm)

Yves Tanguy
American, born France, 1900–1955
Untitled, c. 1938
Pencil on paper, 12½ x 8½"
(31.8 x 21.6 cm)

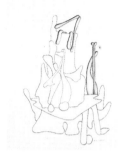

Jacques Villon
French, 1875–1963
Yvonne D., Front View, 1913
Drypoint, 21⅝ x 16⅛"
(54.9 x 41 cm) (plate)

For Further Reading

Annmary Brown Memorial, Brown University, and Museum of Art, Rhode Island School of Design, Providence. *Herbert and Nannette Rothschild Collection.* October 7–November 6, 1966.

Yaacov Agam
Frank Popper. *Agam.* New York, 1990.

Jean (Hans) Arp
Arp, 1886–1966. Stuttgart, 1986.

Giacomo Balla
Marianne W. Martin. *Futurist Art and Theory, 1909–1915,* pp. 173–81. Oxford, 1968.

Umberto Boccioni
Ester Coen. *Umberto Boccioni.* New York, 1988.

Constantin Brancusi
Friedrich Teja Bach, Margit Rowell, and Ann Temkin. *Constantin Brancusi, 1876–1957.* Philadelphia, 1995.

Georges Braque
Jean Leymarie. *Georges Braque.* Munich, 1988.

Patrick Henry Bruce
William C. Agee and Barbara Rose. *Patrick Henry Bruce: American Modernist.* New York, 1979.

Reg Butler
The Tate Gallery, London. *Reg Butler.* November 16, 1983–January 15, 1984.

Carlo Carrà
Marianne W. Martin. *Futurist Art and Theory, 1909–1915,* pp. 79–95. Oxford, 1968.

Giorgio de Chirico
William Rubin, ed. *De Chirico.* New York, 1982.

Joseph Cornell
Kynaston McShine, ed. *Joseph Cornell.* New York, 1980.

Joseph Csaky
Donald Karshan. *Csaky.* Paris, 1973.

Stuart Davis
Karen Wilkin and Lewis Kachur. *The Drawings of Stuart Davis: The Amazing Continuity.* New York, 1992.

Robert Delaunay
Sherry A. Buckberrough. *Robert Delaunay: The Discovery of Simultaneity.* Ann Arbor, 1982.

Sonia Delaunay
Stanley Baron and Jacques Damase. *Sonia Delaunay: The Life of an Artist.* New York, 1995.

Theo van Doesburg
Evert van Straaten. *Theo van Doesburg: Painter and Architect.* The Hague, 1988.

Naum Gabo
Naum Gabo: The Constructive Idea, Sculpture, Drawings, Paintings, Monoprints. London, 1987.

Natalya Gontcharova
Mary Chamot. *Gontcharova.* Paris, 1972.

Julio González
Margit Rowell. *Julio González: A Retrospective.* New York, 1983.

Juan Gris
Christoper Green, with Christian Derouet and Karin von Maur. *Juan Gris.* New Haven, 1992.

Henri Hayden
Musée d'Art Moderne, Troyes. *Henri Hayden, 1883–1970: Rétrospective.* June 29–September 26, 1994.

Wassily Kandinsky
Rose-Carol Washton Long. *Kandinsky: The Development of an Abstract Style.* Oxford, 1980.

Paul Klee
Carolyn Lanchner, ed. *Paul Klee.* New York, 1987.

Karl Knaths
Isabel Patterson Eaton. *Karl Knaths: Five Decades of Painting.* Washington, D.C., 1973.

Gyula Kosice
Museo Nacional de Bellas Artes, Buenos Aires. *Kosice: Obras 1944– 1990.* April–May, 1991.

Roger de La Fresnaye
Germain Seligman. *Roger de La Fresnaye.* Greenwich, Conn., 1969.

Mikhail Larionov
Anthony Parton. *Mikhail Larionov and the Russian Avant-Garde.* Princeton, 1993.

Blanche Lazzell
David Acton, with Clinton Adams and Karen F. Beall. *A Spectrum of Innovation: Color in American Print-making, 1890–1960,* pp. 82–83, 270–71. New York, 1990.

Le Corbusier
Hayward Gallery, London. *Le Corbusier: Architect of the Century.* March 5–June 7, 1987.

Fernand Léger
Christopher Green. *Léger and the Avant-Garde.* New Haven, 1976.

Jacques Lipchitz
A. M. Hammacher. *Jacques Lipchitz.* New York, 1975.

Henri Matisse
Jack D. Flam. *Matisse: The Man and His Art, 1869–1918.* Ithaca, 1986.

Carlos Merida
University Art Museum, University of Texas, Austin. *A Salute to Carlos Merida.* December 5, 1976–January 23, 1977.

Piet Mondrian
Yve-Alain Bois and others. *Piet Mondrian, 1872–1944.* Milan, 1994.

Antoine Pevsner
Pierre Peissi and Carola Giedion-Welcker. *Antoine Pevsner.* Neuchâtel, Switzerland, 1961.

Francis Picabia
William A. Camfield. *Francis Picabia: His Art, Life and Times.* Princeton, 1979.

Pablo Picasso
Pierre Daix. *Picasso: Life and Art.*
New York, 1993.

Odilon Redon
Douglas W. Druick and others. *Odilon Redon: Prince of Dreams, 1840–1916.*
Chicago, 1994.

Diego Rivera
Diego Rivera: A Retrospective. Detroit, 1986.

Judith Rothschild
Richard H. Axsom. *Beyond the Plane: The Relief Paintings of Judith Rothschild.* New York, 1992.

Morgan Russell
Marilyn S. Kushner. *Morgan Russell.*
New York, 1990.

Kurt Schwitters
John Elderfield. *Kurt Schwitters.*
London, 1985.

Gino Severini
Marianne W. Martin. *Futurist Art and Theory, 1909–1915,* pp. 96–103, 138–47. Oxford, 1968.

Victor Vasarely
Werner Spies. *Victor Vasarely.*
New York, 1971.

Jacques Villon
Daniel Robbins, ed. *Jacques Villon.*
Cambridge, Mass., 1976.

Index of Names

WITHDRAWN

Photographic Credits